The Amazing World of
Dinosaurs

An Illustrated Journey Through the Mesozoic Era

Written and illustrated by James Kuether

Adventure Publications
Cambridge, Minnesota

Dedication

For Jon, for encouraging me to follow my dreams.

And for Rickie and John, who sparked the dream by giving me my first dinosaur book when I was 8 years old.

Acknowledgements

The images in this book would not have been possible without the enormous talents of Raul Lunia (*Dinoraul*) of Estonia, who built the base computer models of most of the animals. Raul's work has been seen in books, magazines and apps all over the world, but he rarely gets the credit he deserves. Thank you, Raul!

Luca Massini is a dinosaur lover and gifted computer artist from Florence, Italy, and though I've never met him face-to-face, I count him among my good friends. The contribution of his plant models, his images, his knowledge and his friendship inspire me and challenge me to improve.

Special thanks to my early readers: Ann Hinnenkamp and Ian Ressler. Your gentle advice and encouragement are valued beyond belief.

Special thanks to Allesandro Mastronardi for his caiman and alligator models.

Cover design by Lora Westberg
Book design by Jonathan Norberg

10 9 8 7 6 5 4 3 2

The Amazing World of Dinosaurs: An Illustrated Journey Through the Mesozoic Era
Copyright © 2016 by James Kuether
Published by Adventure Publications
An imprint of AdventureKEEN
(800) 678-7006
www.adventurepublications.net
All rights reserved
Printed in China
ISBN 978-1-59193-645-9 (pbk.); ISBN 978-1-59193-659-6 (ebook)

Table of Contents

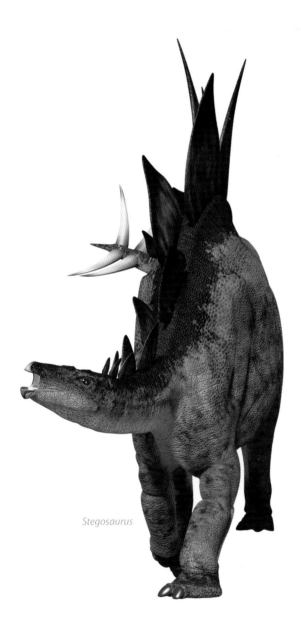

Stegosaurus

The Dinosaurs

"I am enough of an artist to draw freely upon my imagination. Imagination is more important than knowledge. Knowledge is limited. Imagination encircles the world."

ALBERT EINSTEIN

The Dinosaurs, or as they are more formally known, The Dinosauria, have filled us with wonder, amazement and excitement for thousands of years. Ever since the first monstrous bones were pulled from the earth, we've constructed myths and legends and stories to explain them. Once science got involved in the early nineteenth century, the struggle was to explain these creatures with modern analogies. They were first dubbed "terrible lizards," and the idea soon caught the public's imagination. In 1852, life-sized re-creations of dinosaurs and other prehistoric creatures were installed in London's Crystal Palace Park. This was the first large-scale dinosaur art ever produced and represented the cutting edge of scientific thinking. In the Crystal Palace sculptures, dinosaurs are depicted as gigantic, lumbering, sprawling lizards.

Today, we know that dinosaurs are much more than sluggish lizards, and we've come to understand that no living analogies for these great creatures exist. We can point to no living model to show us how *Brontosaurus* moved and fed and breathed, or to tell us whether it was warm- or cold-blooded, or something else entirely. Now you might think that since we've come to accept that birds are descended from dinosaurs, there should be an analogy there, right? But there are no seven-ton birds frequenting our backyards to give us an idea of how *Tyrannosaurus* raised its young, built nests, or for us to estimate just how fast it could run.

No creatures alive today can match the architectural perfection of *Diplodocus*, with its balanced, dual-beamed design, or the size, athleticism, stealth and power that made *Allosaurus* the perfect hunter. Dinosaurs weren't just rampaging monsters. They were living, breathing animals that had moments of great power and ferocity but also periods of quiet beauty.

In recent years, science has made remarkable strides, analyzing dinosaurs at the microscopic level to gain a better understanding of how they functioned. We can examine isotopes stored in fossilized bones and estimate how much time an animal spent in water and what it ate. We can identify fossilized pollen grains contained in coprolites (fossilized animal droppings) and determine what plants they ate (but not necessarily who left the dropping). By analyzing the damage done to neck vertebrae and skulls, we can get an idea of how a *Tyrannosaurus* fed on a *Triceratops*. Sometimes we get really lucky and find a dinosaur that has soft-tissue remains—imprints of skin or feathers, or even the remains of its last meal fossilized in its stomach region, or even rarer, fossilized remains of its internal organs. In these cases, we gather a lot of information about what dinosaurs looked like, how they fed and how they functioned. Technology can help too; computer simulations can approximate dinosaur postures and help us project how dinosaurs walked and moved—and these simulations are interesting, informative and convincing—but without the actual, living animal around to observe, they're ultimately mere conjecture.

And all of this research doesn't tell us how dinosaurs behaved or how they interacted with their environments or with the other animals in their ecosystems.

For that, we need our imaginations.

The best paleoart (the term we use for reconstructions of extinct animals) is based on good science, and a great deal of discipline goes into making sure that the artwork accurately reflects current knowledge. But good paleoart also relies on the artist's imagination to bring these magnificent creatures to life. It's easy to understand why: We don't know what color most dinosaurs were, or if they were striped or spotted or one single color. Science can't tell us how dinosaurs fought with each other or how it looked when *Tyrannosaurus* went for a swim. There aren't many scientists figuring out what an *Edmontosaurus* looked like when it took a nap or how the sun glinted off its beak at sunset. But by speculating—taking the facts we have and extrapolating—we can make an educated guess as to what could have been. We might not always be right. In fact, it's a foregone conclusion that, for the most part, we'll be wrong. As proof, consider the famous murals produced by paleoartists like Charles R. Knight and Rudolph Zallinger. Even though they were painted nearly 100 years ago, they still decorate major museums, and the dinosaurs they depict are tail-dragging, awkward beasts. The sauropods in the murals are shown in water, as early paleontologists assumed that was the only way these beasts could have supported their immense weight. Similarly, scientists generally held that dinosaurs were cold-blooded, slow-moving creatures that lacked social structures and maternal care. Today we know that many of those assumptions are wrong, but those murals are still up on the walls because

they inspire us. As clumsy as those recreations appear now, they still manage to evoke a sense of awe and reverence. They spark our imagination to think about these ancient landscapes and the animals that lived there, and they inspire us to want to know more. And it's there, at that intersection where imagination and knowledge meet, that science can leap forward and great discoveries can be made.

As a writer and illustrator, I take great pains to accurately recreate the prehistoric creatures and the landscapes in which they lived. But I also rely on imagination to bring these animals to life. The behaviors depicted and the outward appearance of the animals—the patterns on their skins, scales, feathers and fur—are, admittedly, conjectural. Just ten years ago, it would have been seen as outrageous to depict *Tyrannosaurus* with feathers. Today, it's almost as outrageous not to. My desire as an illustrator is to invite you, the reader, to join me in thinking about these animals differently than we may have before. To think of them, not as static museum reconstructions, but as living, breathing animals with behaviors and appearances as varied and exciting as the animals that surround us today. To take some risks in how they're depicted, knowing that we might... rather, that we *will* be wrong. And being okay with that. Because ultimately, it doesn't really matter if *Stegosaurus* had spots or stripes or feathers or scales. What matters is that we want to know more. We want to keep exploring and deepening our understanding of the amazing world of dinosaurs.

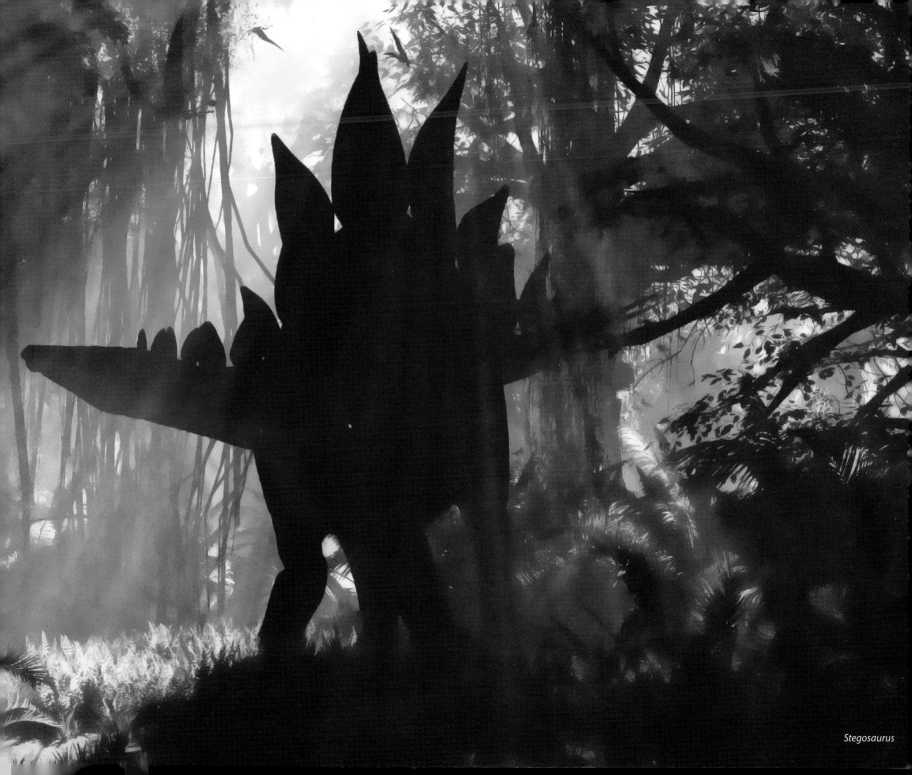

Stegosaurus

The Geologic Time Scale

When examining the history of life on Earth, the expanse of time is so vast as to be incomprehensible. In order to help our human minds make sense of it, science has developed a scale that breaks down the history of the Earth into sections based on major events in the planet's past. The Mesozoic Era, also called "The Age of Reptiles," is the time when dinosaurs ruled. It begins with the Permian/Triassic extinction (see page 11) and ends with the K-Pg extinction (page 159). The Mesozoic is separated into three periods: The Triassic, The Jurassic and The Cretaceous. Within each period, there are shorter stages that identify specific time periods in Earth's history.

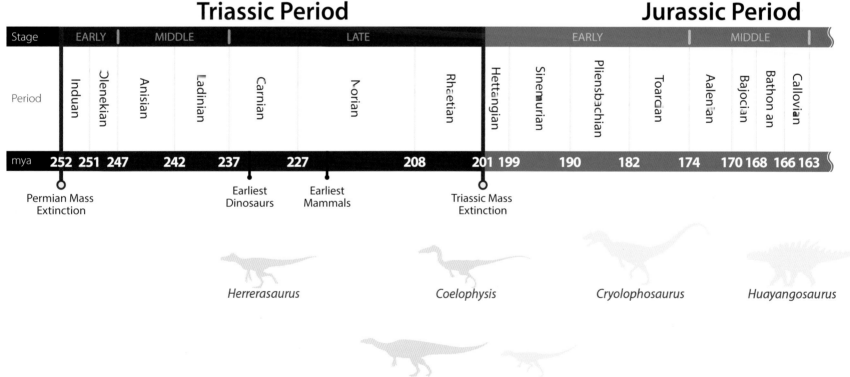

Triassic Period

Jurassic Period

| Stage | EARLY | MIDDLE | LATE | EARLY | MIDDLE |

Period: Induan, Olenekian, Anisian, Ladinian, Carnian, Norian, Rhaetian, Hettangian, Sinemurian, Pliensbachian, Toarcian, Aalenian, Bajocian, Bathonian, Callovian

mya: 252 251 247 242 237 227 208 201 199 190 182 174 170 168 166 163

Permian Mass Extinction

Earliest Dinosaurs

Earliest Mammals

Triassic Mass Extinction

Herrerasaurus

Coelophysis

Cryolophosaurus

Huayangosaurus

Plateosaurus

Dracoraptor

Cretaceous Period

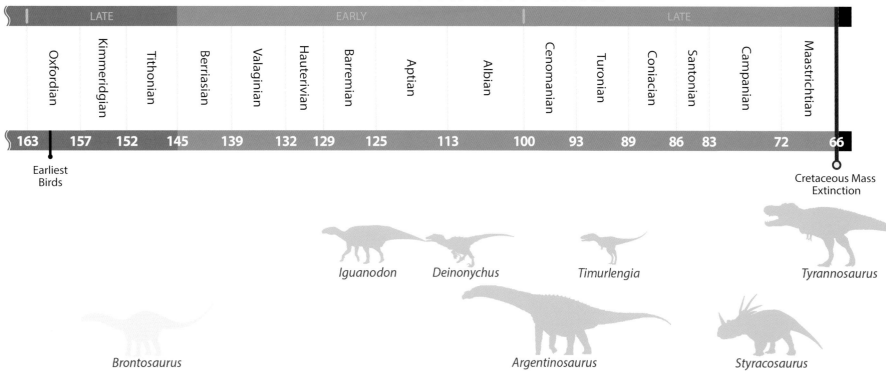

| | LATE | | | | EARLY | | | | | | LATE | | | | |

Oxfordian | Kimmeridgian | Tithonian | Berriasian | Valaginian | Hauterivian | Barremian | Aptian | Albian | Cenomanian | Turonian | Coniacian | Santonian | Campanian | Maastrichtian

163 157 152 145 139 132 129 125 113 100 93 89 86 83 72 66

Earliest Birds

Cretaceous Mass Extinction

Iguanodon *Deinonychus* *Timurlengia* *Tyrannosaurus*

Brontosaurus *Argentinosaurus* *Styracosaurus*

The Mesozoic Era:
The Age of Reptiles

The Mesozoic Era covers the period in Earth's history from 251 million years ago to 66 million years ago, and it is marked on both ends by major extinction events. The Mesozoic Era begins with the Triassic Period and is preceded by the Permian Period, which saw the greatest mass extinction event the world has ever experienced. Nearly 95 percent of all life on Earth perished in the event, and as such, it is often referred to as "The Great Dying."

At this time in Earth's history, all of the continents were grouped together into a supercontinent. This grouping occurred because the location of the Earth's continents is not static. They are constantly moving across the surface of the planet very slowly in a process called plate tectonics. Near the end of the Carboniferous Period, about 298 million years ago, this process brought all of the continents together into one single landmass called Pangea.

Apatosaurus

The Big Five Mass Extinctions

Mass extinctions like the Permian aren't unheard of; on five separate occasions, life on Earth was largely wiped out.

ORDOVICIAN MASS EXTINCTION

This is the first recorded mass extinction. It took place at the end of the Ordovician Period, around 440 million years ago and resulted from a series of events that ranged from increased volcanism to an ice age, all of which had a devastating effect. At the time, nearly all life was found in the oceans, and 85 percent of all species on Earth went extinct.

DEVONIAN MASS EXTINCTION

The late Devonian extinction was a long-term event that lasted anywhere between 500,000 and 25 million years. Like the Ordovician extinction, it may have also been caused by a series of cataclysmic events. The extinction, which occurred between 375 and 359 million years ago, affected marine life most, but land vertebrates also saw a 44 percent drop in diversity.

PERMIAN MASS EXTINCTION "THE GREAT DYING"

The greatest mass extinction event in history, The Great Dying occurred 252 million years ago. Up to 97 percent of all marine species and 70 percent of land vertebrates on the planet went extinct.[1,2,3]

TRIASSIC MASS EXTINCTION

The extinction event that marks the end of the Triassic period wiped out the rauisuchids (crocodile-like reptiles), the temnospondyls and the mammal-like reptiles 201 million years ago. The dinosaurs, which appeared near the end of the Triassic, survived.

END-CRETACEOUS MASS EXTINCTION

About 66.5 million years ago, an asteroid that was six miles in diameter slammed into Earth; this impact, coupled with massive volcanic eruptions in India at the same time, wiped out the non-avian dinosaurs, the pterosaurs, the giant marine reptiles and many other large forms of life. Nonetheless, mammals, which were tiny, shrew-like animals at the time, survived, as did small birds, and both groups began to flourish.

The Triassic

251–200 MILLION YEARS AGO

The Triassic Period was a time of renewal. Life struggled to recover from The Great Dying, and for around 30 million years after the extinction event, there was little biological diversity on Earth. All around the world, ecosystems were on the mend. In the Triassic, the continents were still grouped together into the supercontinent Pangea, whose center was so far from the ocean that virtually no moisture was present beyond the coasts, essentially making it one enormous desert. But along the shores of the global sea, conditions were humid and more tropical. It was there that life rebounded and began to flourish.

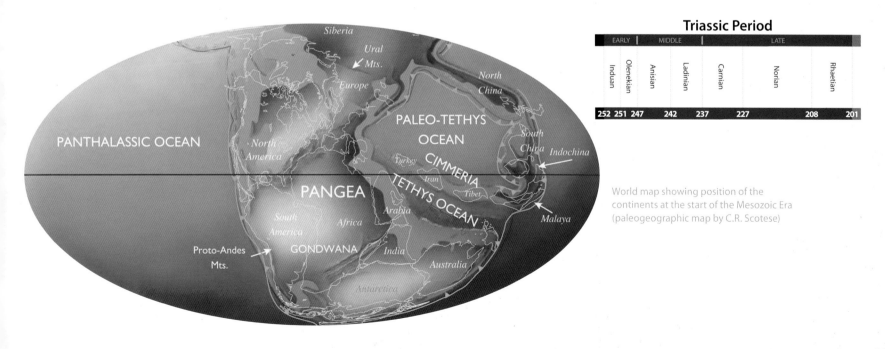

Triassic Period

EARLY		MIDDLE		LATE		
Induan	Olenekian	Anisian	Ladinian	Carnian	Norian	Rhaetian

252 251 247 242 237 227 208 201

World map showing position of the continents at the start of the Mesozoic Era (paleogeographic map by C.R. Scotese)

LIFE IN THE TRIASSIC
PLANTS

At the end of the Permian, land animals weren't the only organisms to go extinct. Many plants also disappeared. Some plants, such as *Calamites*, *Bjuvia* and ginkgoes, did survive. As the planet began to mend itself, plants began to diversify once again. Seed ferns like *Dicroidium* and *Pachypteris* became common during the Early Triassic, as did the cycads. The bennettitales are relatives of the cycads, which developed during the Triassic and became a common feature throughout the Mesozoic. *Williamsonia* is one of the best-known cycads, and it appears for the first time in Late Triassic rocks. Marsh and water plants diversified, including the single-leafed *Macrotaeniopteris*. The conifers developed during the Triassic, and would go on to become the dominant type of tree in the Mesozoic. The genus *Araucaria* was one of the most common. The cycads, ginkgoes and conifers all fall under the classification of "gymnosperms," plants whose seeds (like pine cones) are not enclosed in a protective shell. The angiosperms, which includes all flowering plants and grasses, would not evolve until much later.

TRIASSIC PLANTS

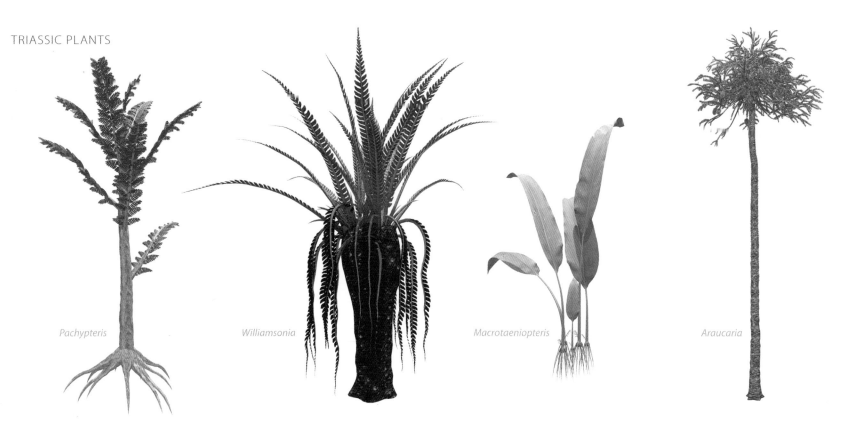

Pachypteris

Williamsonia

Macrotaeniopteris

Araucaria

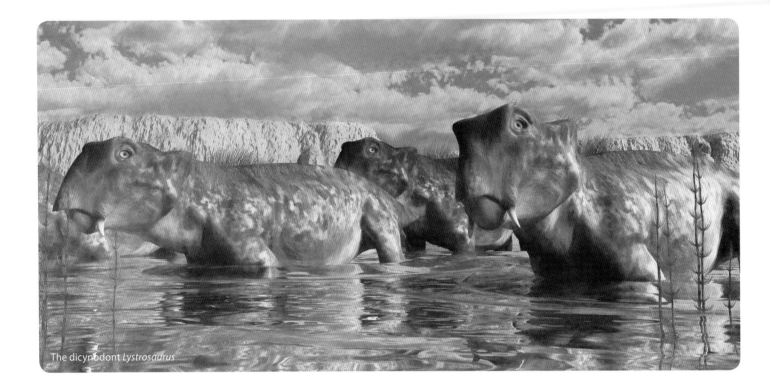
The dicynodont *Lystrosaurus*

PERMIAN SURVIVORS

Dicynodonts were one of the few "mammal-like" reptiles to survive the end-Permian extinction and into the Triassic. Their short, pig-shaped bodies and little tusks made them look almost comical, but these adaptations seem to have worked well for them, as they were incredibly widespread animals. One form, *Lystrosaurus*, thrived in the barren new world, accounting for a large percent of all animals during the early Triassic. *Lystrosaurus* may have spent much of its time in water. Elsewhere, the openings left by the lack of competition allowed for whole new organisms to evolve.

THE RISE OF THE DIAPSIDS

The mammal-like reptiles that dominated in the Permian were nearly wiped out in The Great Dying, but another group of reptiles—the diapsids—survived and continued to evolve. Throughout the early Triassic, the diapsids would diversify, with one group, the archosaurs, becoming dominant. With life concentrated along the shores, it was inevitable that some would develop lifestyles to take advantage of the ocean's resources. *Tanystropheus* is an extreme form that developed an incredibly long neck that accounted for more than half of its 20-foot body length. Its mouth was full of long, sharp, interlocking teeth that formed an effective fish trap, and its tail was flattened side to side, making it a powerful and effective swimmer.

A group of *Tanystropheus* sun themselves on rocks near a shore

BACK TO THE OCEAN

One branch of diapsid reptiles went even further, abandoning land completely and returning to life in the sea. The ichthyosaurs belong to a group of reptiles separate from the archosaurs, and they first appeared in the Triassic. Instead of their ancestors' hands and feet, they evolved paddle-like flippers and took on a more streamlined shape. The first forms developed long, eel-like bodies and tails, like the 33-foot-long *Cymbospondylus*. Some of them became giants. *Shonisaurus* was one of the biggest ichthyosaurs on record, up to 50 feet in length and sporting a long, toothless snout.

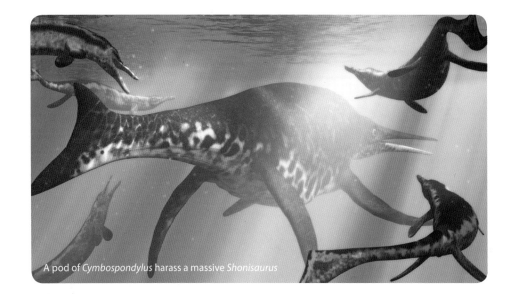

A pod of *Cymbospondylus* harass a massive *Shonisaurus*

BRANCHING OUT

The pseudosuchians were a line of reptiles that split off from the diapsids, evolving into the crocodilians (the ancestors of the crocodiles living today) and their cousins: the rauisuchids, the aetosaurs and the phytosaurs. By the mid-to-late Triassic the rauisuchids became the dominant land predators; they were large terrestrial animals that looked a bit like crocodiles but they walked differently. Crocodiles primarily walk with a "belly crawl" with their legs off to the side. Rauisuchids, on the other hand, walked on upright legs that they held directly beneath their body. Sporting heavy protective armor and a mouth full of blade-like teeth, rauisuchids were the top predators of the Triassic and were found worldwide. One of the best-known examples is the 15-foot-long *Postosuchus*, which lived in what is now the American Southwest.

Another group of pseudosuchians, the aetosaurs, were potential prey for *Postosuchus*. Aetosaurs were herbivores with pig-like snouts that they likely used to dig for roots. Some forms, like *Desmatosuchus*, which was found in North America, developed huge spikes on their sides for defense.

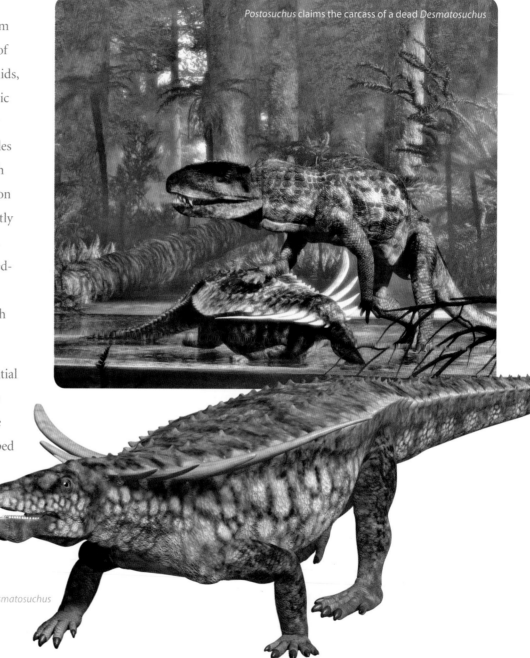

Postosuchus claims the carcass of a dead *Desmatosuchus*

Desmatosuchus

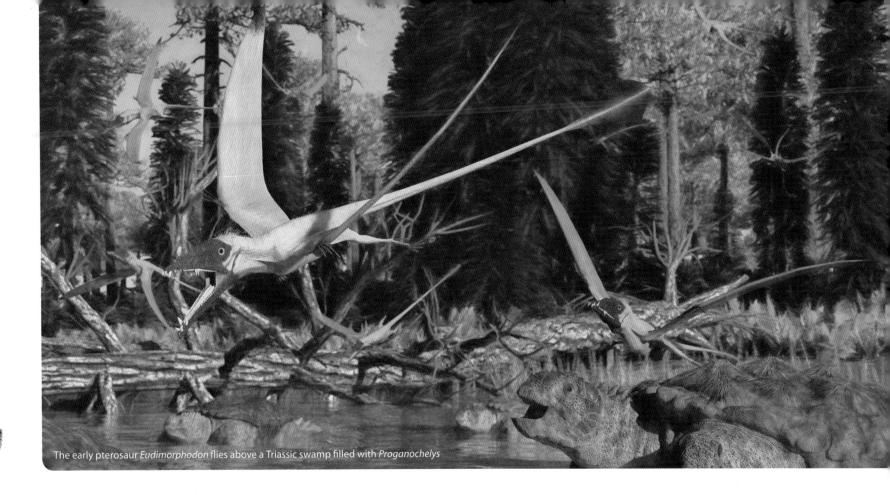

The early pterosaur *Eudimorphodon* flies above a Triassic swamp filled with *Proganochelys*

THE PTEROSAURS

In the Late Triassic, one group of reptiles began experimenting with new forms of locomotion. The pterosaurs were the first verte-brates to develop powered flight. Despite what you may have seen, heard or read, pterosaurs are not dinosaurs. We're not sure which reptiles gave rise to the pterosaurs, but it's believed to be the same group that led to the dinosaurs. Pterosaurs radically changed the reptilian body plan, developing long arms and extending their fourth finger to support a membrane that formed their wings. Primi-tive pterosaurs like *Eudimorphodon* filled an area of the environment that was previously the sole domain of insects.

The first turtles evolved during the Triassic, and their form has changed little since. *Proganochelys* was nearly three feet long and made its home in the swamps and wetlands of the Late Triassic.

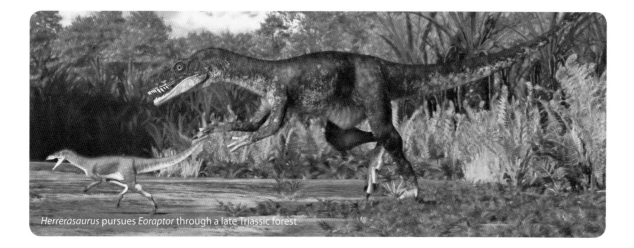

Herrerasaurus pursues *Eoraptor* through a late Triassic forest

RISE OF THE DINOSAURS

Dinosaurs first appear in the fossil record in the Late Triassic, about 220 million years ago. Exactly which reptiles the dinosaurs descended from is still unclear, but there are a number of small, bipedal reptiles from the middle Triassic that are very similar to dinosaurs, lacking only a few characteristics we now attribute to dinosaurs.

Early dinosaurs weren't very remarkable; they were small animals and weren't especially widespread. And there's something about them that just seems a bit…off. Physically, they don't look as well balanced as the later dinosaurs and their proportions don't seem quite right. It's as if nature has been experimenting with a design but hadn't quite figured it out yet.

The earliest known dinosaur fossils were unearthed in South America. *Eoraptor* is one of the earliest and most primitive dinosaurs. This small creature has created quite a bit of confusion among scientists, because not everyone agrees on what kind of dinosaur it is. At just three feet long, *Eoraptor* has traits of several different types of dinosaurs. While this might be expected for an animal near the base of its family tree, it's led some scientists to think it's a meat eater, while others think it's an ancestor of the long-necked, plant-eating sauropods.

The much larger *Herrerasaurus* lived at the same time and place as *Eoraptor*, but with its long claws and a mouth full of sharp teeth, it was clearly a meat eater, and it probably pursued *Eoraptor* as prey. Both *Eoraptor* and *Herrerasaurus* lived in what is now Argentina, and were found in one of the finest Triassic paleontological sites in the world, a formation called *Valle de la Luna*, which translates to "the Valley of the Moon."

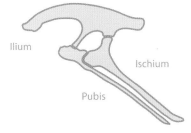

SAURISCHIAN HIP

Ilium

Ischium

Pubis

ORNITHISCHIAN HIP

Ilium

Ischium

Pubis

THE DINOSAUR FAMILY TREE

It's hard to talk about individual dinosaurs without talking about which groups of dinosaurs they belong to. As we begin to look at specific animals, there are some terms that describe which line of dinosaurs they come from; the following is a very simplified explanation of the dinosaur family tree.

All dinosaurs belong to one of two groups: the saurischians or the ornithischians. These groups, and their names, refer to how each group's hip bones are structured. The saurischians have lizard-like hip bones. This doesn't mean they walked like lizards, but rather that a certain bone in their hip, the pubis bone, points forward, just as it does in lizards. Saurischians are broken into two groups: the theropods, which includes all the two-legged, meat-eating dinosaurs (big and small), and the plant-eating sauropodmorphs, which includes the sauropods, the titanosaurs and the prosauropods.

The ornithischians are the other group of dinosaurs, and they have bird-like hip bones, meaning that the pubis points backward toward the tail. The ornithischians include many of the most famous plant eaters, including iguanodonts, hadrosaurs, ceratopsians, pachycephalosaurs, stegosaurs, ankylosaurs, and a few other groups.

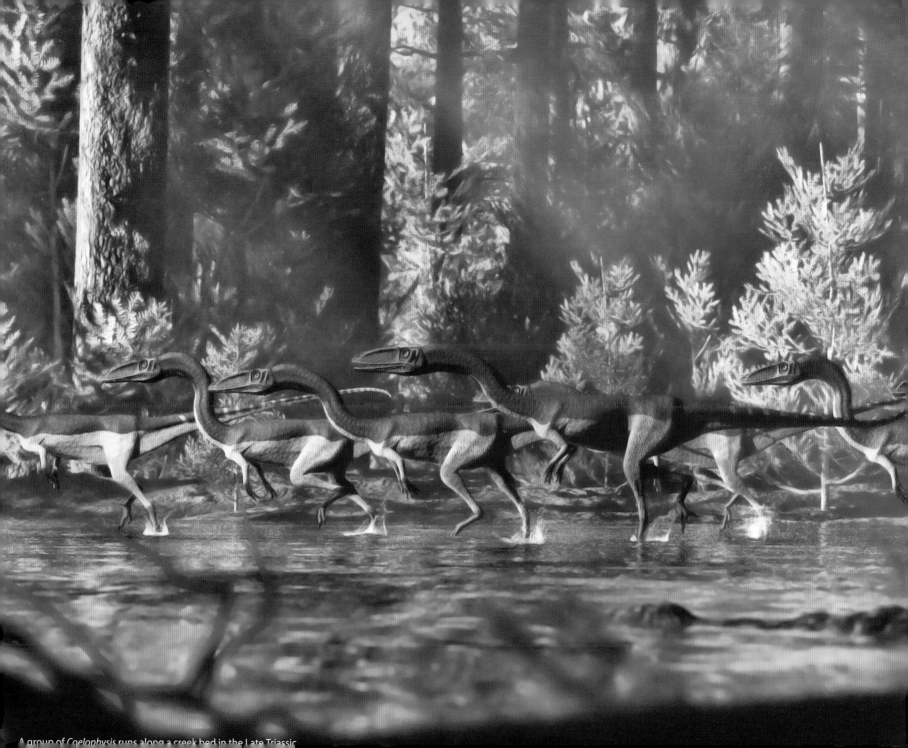

A group of *Coelophysis* runs along a creek bed in the Late Triassic.

Surprisingly, birds are descended from the lizard-hipped group of dinosaurs, the saurischians. As it happened, two groups of theropods—the therizinosaurs and the birds—independently evolved to have backward-facing pubic bones. This change first appeared fairly late in the Mesozoic, and it was likely an adaptation related to diet: Birds and therizinosaurs were herbivores or omnivores; both groups needed bigger guts to process food, so over time, their pubic bone rotated backward, providing more room.[4]

COELOPHYSIS AND BONE BEDS

Coelophysis was a small, streamlined hunter around 10 feet long. A widespread genus, species of *Coelophysis* have been found from South Africa to New Mexico, where hundreds of *Coelophysis* skeletons were discovered all in one spot. When we find accumulations of skeletons like this we call them bone beds or dinosaur graveyards. Dinosaur bone beds are exciting because they give us the opportunity to study a lot of different individuals of the same species. This tells us how they varied, and it can also show how they grew and changed throughout their life. In the case of *Coelophysis*, it's unclear how or why all the animals died together. They may have gathered around a drying watering hole during a drought and died of thirst, or the accumulated remains may represent deaths that occurred over many years. But how they died is less important than how they lived, and bone beds are especially important because they show us that these animals lived in social groups. This opens up all sorts of possibilities. For example, if there are very young animals present, it may indicate that parents nurtured their young. And if there are many carnivores along with a prey species, it might suggest that they engaged in communal hunting behavior.

THE PROSAUROPODS

The prosauropods were the largest herbivores during the Late Triassic. At 27 feet long, *Plateosaurus* was one of the largest members of the group. Living in what is now northern Europe, *Plateosaurus* was a bipedal herbivore (or possibly an omnivore). With its long, heavy torso, it appears ready to topple forward, but its broad hips and thick, heavy tail helped to balance it. *Plateosaurus* had a huge claw on the thumb of its five-fingered hand, which it may have used to defend itself.

Liliensternus is one of the largest known carnivorous dinosaurs from the Late Triassic; it was a swift, bipedal hunter around 20 feet long. Its remains have also been found in Germany, where it would have stalked the forests in search of prey like *Plateosaurus*.

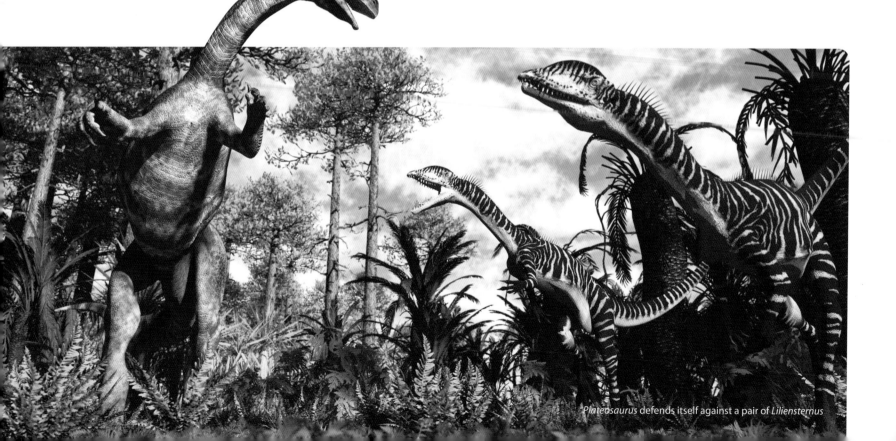

Plateosaurus defends itself against a pair of *Liliensternus*

Coelophysis

THE END-TRIASSIC MASS EXTINCTION

At the end of the Triassic Period, around 201 million years ago, the world saw another mass extinction event. While not as devastating as the Permian extinction, this one still had an enormous impact. Nearly half of life on land disappeared and a third of all life in the oceans went extinct.

On land, the rauisuchids went extinct along with the aetosaurs. The large temnospondyls that had been around since the Permian all but disappeared. In geologic terms, the extinction event happened fast, occurring in "just" 10,000 years.[5] We're not really sure what caused it. Climate change, asteroid impact and volcanic eruptions have all been put forward as potential causes, but so far, there's no smoking gun.

Whatever the cause, and for whatever reason, the dinosaurs survived, and the ecological niches left behind by the mass extinction allowed them to become the dominant land animals of the Mesozoic Era.

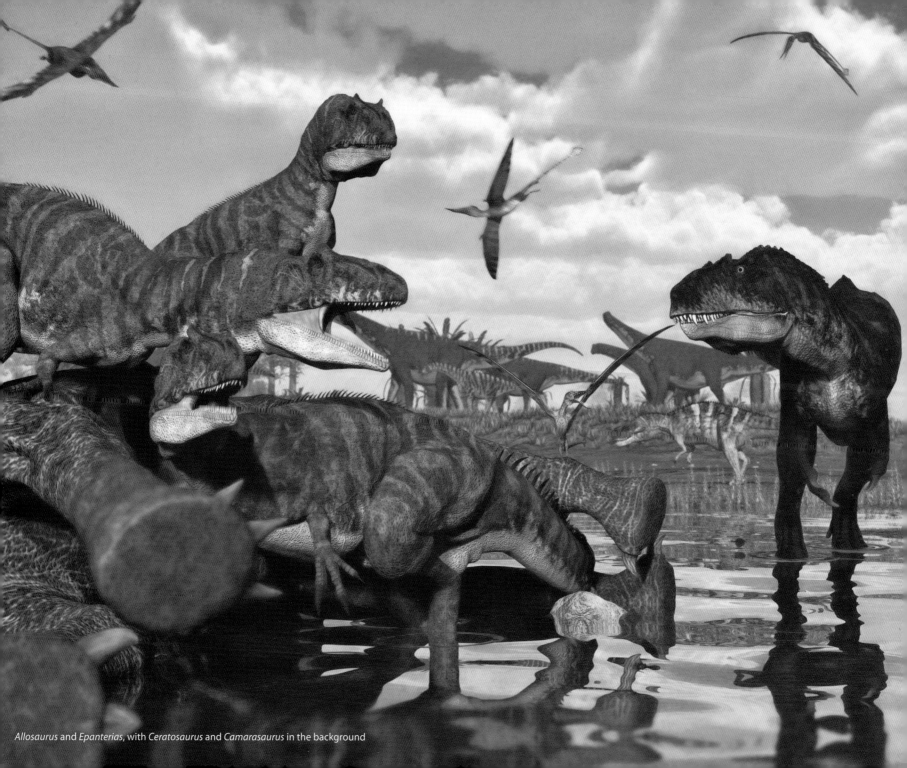

Allosaurus and *Epanterias*, with *Ceratosaurus* and *Camarasaurus* in the background

The Jurassic Period

201–145 MILLION YEARS AGO

At the beginning of the Jurassic, all of the continents were still massed together into the supercontinent Pangea. There were no oceans or seas separating the landmasses, so dinosaurs were free to roam across great distances and disperse. But Pangea's demise was already in the works. Through a process called rifting, Pangea's tectonic plates began to literally split apart at the seams. As the process began, seawater inundated the land, producing profound changes in local climates; areas that were once land-locked and arid became coastline that was humid, tropical and habitable.

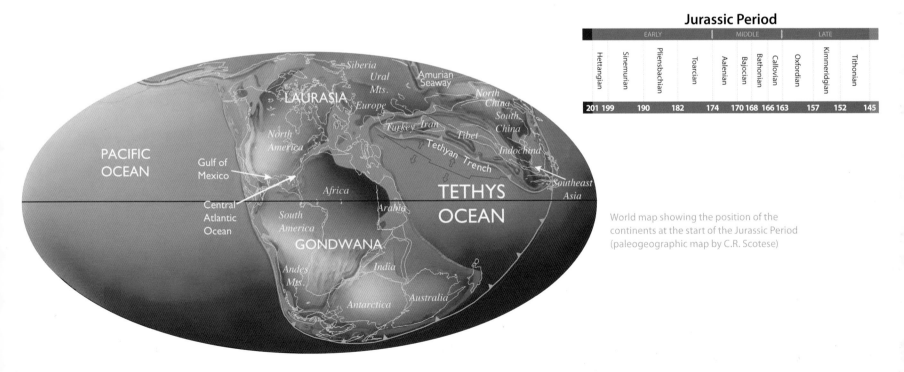

World map showing the position of the continents at the start of the Jurassic Period (paleogeographic map by C.R. Scotese)

LIFE IN THE JURASSIC
PLANTS

Conifers became common in the Jurassic and represented the majority of the large trees. *Araucaria* survived the Triassic extinction, but was somewhat limited in its range until later in the Jurassic when it became widespread. The *Wollemia* is a related conifer that first appeared in the Early Jurassic and was assumed to be extinct until some were discovered in 1994 living in a remote part of Australia.[6] Ginkgoes persisted, as did the seed ferns, the *Calamites* and the bennettitales. *Bjuvia* survived, but disappeared in the early Jurassic. Ferns were still the dominant ground cover, while tree ferns like *Dicksonia* became common in the forests.

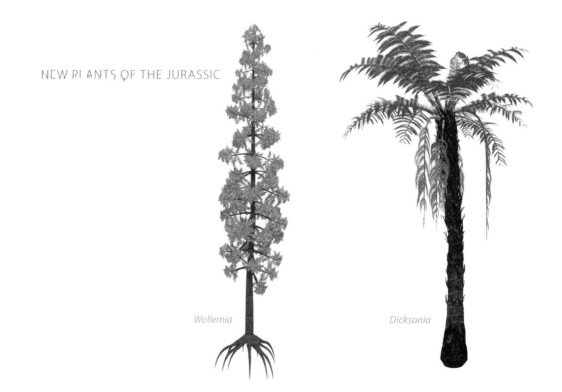

NEW PLANTS OF THE JURASSIC

Wollemia

Dicksonia

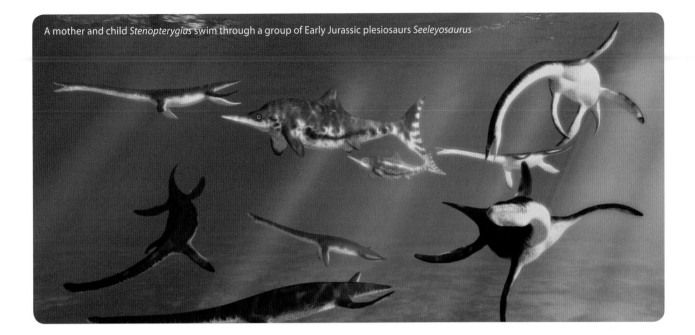

A mother and child *Stenopterygius* swim through a group of Early Jurassic plesiosaurs *Seeleyosaurus*

MARINE REPTILES

Marine reptiles proliferated and diversified in the Jurassic seas. The ichthyosaurs survived the Triassic extinction and developed into a more streamlined, dolphin-like shape. *Stenopterygius* is known from a number of fossils, including one in which a mother died as she gave birth to an infant. The infant, unable to free itself from its mother, died shortly thereafter. Their bodies settled on the seabed and eventually fossilized just as they had died, with the infant still partly inside its mother. This is an amazing find that shows that ichthyosaurs gave birth to live infants and did not lay eggs.

Plesiosaurs first appeared in the Triassic and also survived the extinction. Plesiosaurs, like *Seeleyosaurus*, had long necks and broad, turtle-like bodies (but without a shell). During the Jurassic, one line evolved shorter necks and larger heads, becoming the pliosaurs, some of the largest marine predators ever known. *Liopleurodon* has been called "the *T. rex* of the oceans," and understandably so. It was a 30-foot-long monster with enormous, conical teeth, and it cruised the Jurassic seas looking for prey.

A pod of the Middle Jurassic pliosaurid plesiosaur *Liopleurodon*

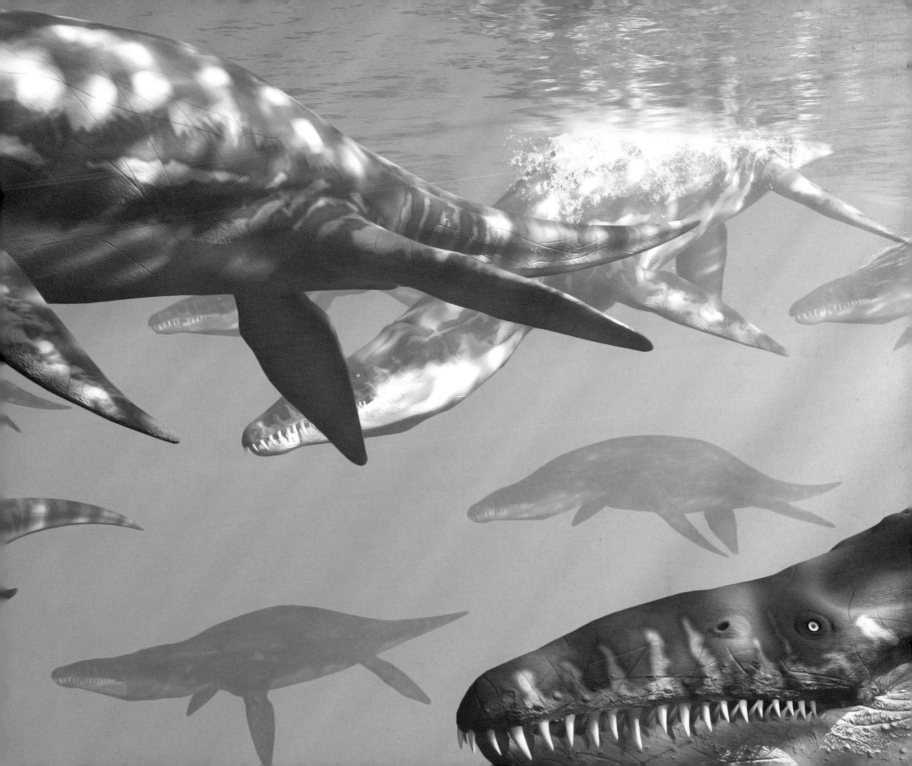

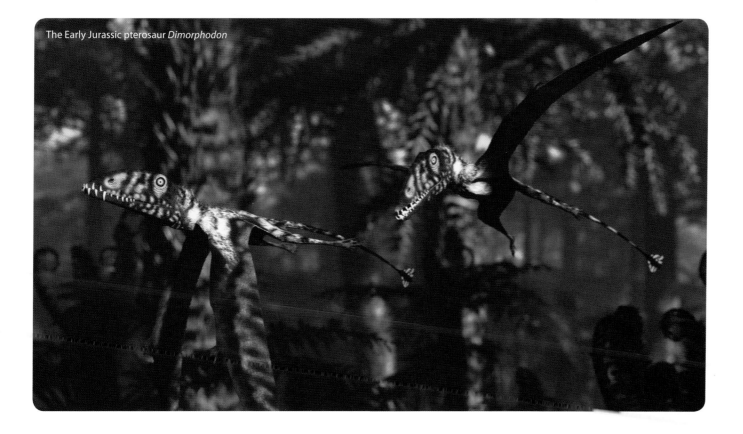
The Early Jurassic pterosaur *Dimorphodon*

PTEROSAURS FILL THE SKIES

In the Jurassic, pterosaurs conquered the skies. They expanded their range around the world, and in the process, several forms evolved. The early pterosaurs were nasty-looking little creatures, with sharp, protruding teeth and long tails that sported strange, diamond-shaped paddles on the end. Their remains have been found on all continents except Antarctica (they probably existed there too, but most fossil-bearing rocks on the continent are buried under miles of ice). Pterosaurs remained relatively small during the Jurassic; few had wingspans exceeding two meters. Still, they were an integral part of the ecosystem, feeding on fish and insects. *Dimorphodon* is an Early Jurassic example of a long-tailed variety, and it also had a four-foot wingspan.

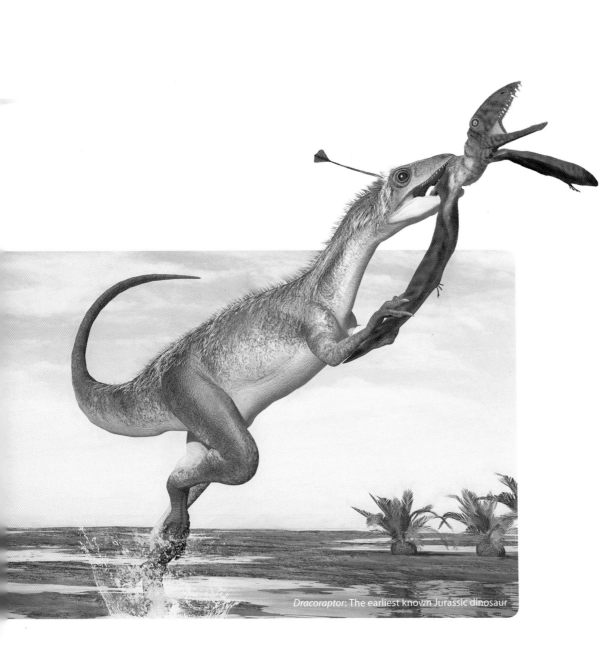

Dracoraptor: The earliest known Jurassic dinosaur

EARLY JURASSIC DINOSAURS

The dinosaurs of the Early Jurassic were still fairly similar to those from the end of the Triassic Period. When we see little outward change in the appearance of a group of animals over a long period of time, we say that they have a conservative body plan. This is the case with most of the early dinosaurs. There was not a lot of variation in the habitats around Pangea, so there was little need for radical physical adaptation.

The earliest Jurassic dinosaur that has been discovered was described in 2016. It was found in the same cliffs of southern England that yielded remains of the flying reptile *Dimorphodon*.

Dracoraptor was a small predator that probably hunted along the shore, feeding on small lizards and possibly insects, but it may also have taken on more challenging prey on occasion.

Prosauropods from the Early Jurassic don't look very different from prosauropods of the late Triassic, even though, by this time they were quite common and had developed a cosmopolitan distribution. At 14 feet long, *Massospondylus* was a medium-sized prosauropod that was smaller and more lightly built than its ancestor *Plateosaurus*, but it still had its awkward, front-heavy look.

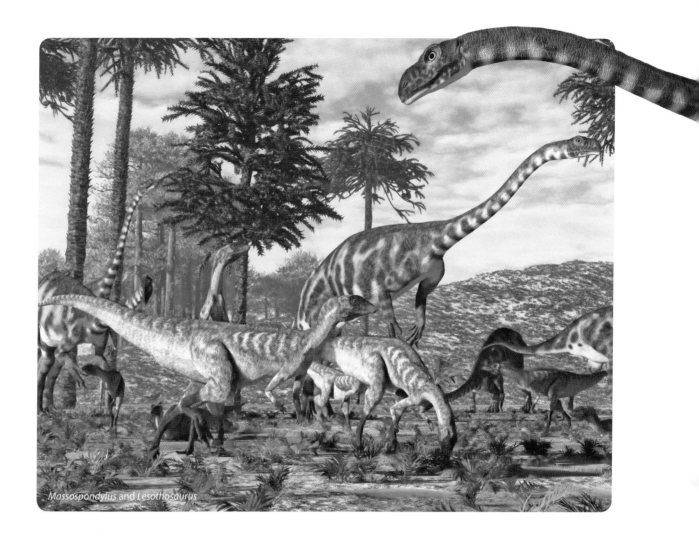

Massospondylus and *Lesothosaurus*

Lesothosaurus was one of the most primitive of all ornithischians—the bird-hipped dinosaurs. Just over three feet long, *Lesothosaurus* was a small bipedal herbivore. It had long legs for its size, and was probably a fast, athletic animal.

Remains of *Massospondylus* and *Lesothosaurus* have been found in South Africa, where they lived amid an environment of meandering streams and rivers.

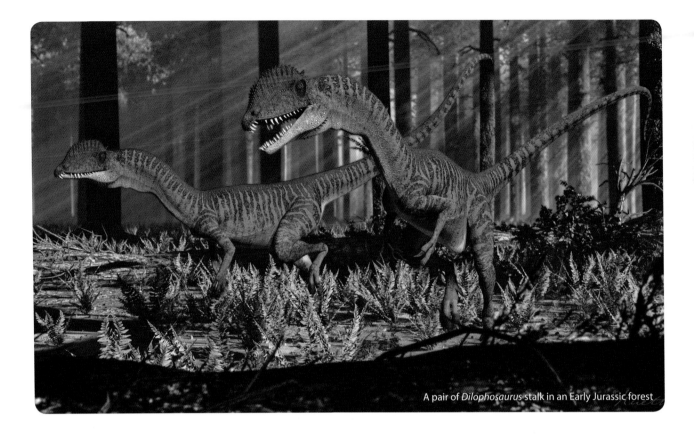

A pair of *Dilophosaurus* stalk in an Early Jurassic forest

DILOPHOSAURUS

By the early Jurassic, the theropods had arrived at an elegant but powerful body plan that would continue to be perfected over the next 150 million years. *Dilophosaurus* was a 23-foot-long carnivore and one of the largest predators of its time. It was distinguished by a pair of tall, thin crests at the front of its skull. Unlike the fictional depiction of *Dilophosaurus* in *Jurassic Park*, it did not have an expandable neck frill, and it probably wasn't venomous. It was also much larger than the animal shown in the movie.

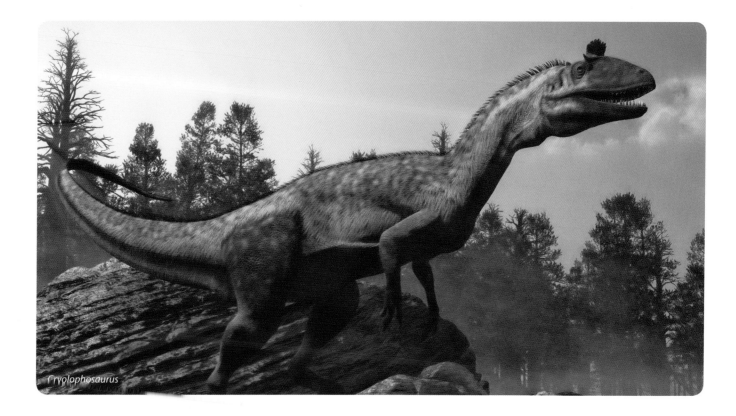
Cryolophosaurus

DINOSAURS IN ANTARCTICA?!

Today we know Antarctica as a frozen continent, but in the Early Jurassic it was still connected to Gondwana, the southern half of the supercontinent Pangea, and it was located much farther north than it is now. Back then, Antarctica was sub-tropical and supported a huge variety of life. So far, there have been very few dinosaurs found in Antarctica, but that's not because they didn't live there. It's because the present-day conditions are so harsh and the rocks are buried under so much snow and ice that it's very difficult to locate fossils, let alone excavate them.

Nonetheless, scientists have found some dinosaur fossils in Antarctica. Without question, the most famous is *Cryolophosaurus*, which was about 21 feet long and weighed around 1,000 pounds. Along with *Dilophosaurus*, it was one of the largest meat-eating dinosaurs of its time. And like *Dilophosaurus*, *Cryolophosaurus* sported an elaborate crest, but in this case, it stretched across its forehead between its eyes. The name *Cryolophosaurus* means "frozen crested lizard."

MIDDLE AND LATE JURASSIC DINOSAURS

In the Middle Jurassic, the rifting of Pangea continued and the continents in the north began to break apart. Pangea split down the middle from the north and seawater flooded into the resulting basin, forming what would eventually become the Atlantic Ocean. There are very few locations around the world where good, dinosaur-bearing rocks of Middle Jurassic age have been found. However, there have been enough discoveries made to give us an idea of how dinosaurs had evolved.

Throughout the remainder of the Jurassic, the big, meat-eating dinosaurs developed a body plan that was lean, athletic and nightmarishly efficient, all perfect traits for predators. These large, bipedal carnivores had long tails, short necks, three- or four-fingered hands and large mouths filled with sharp teeth. Outwardly, many of these dinosaurs look the same, however, there are subtle differences in their bones that show a great deal of diversification was occurring.

Although Middle Jurassic fossil sites are rare, the south of England and a few other locations across Europe provide glimpses into life during this time. *Megalosaurus* is only known from partial remains, but it is especially important because it is one of the first dinosaurs to be described. In fact, it was one of the three dinosaurs that Sir Richard Owen referenced in the nineteenth century when defining the Dinosauria. Ranging from 23 to 26 feet long, *Megalosaurus* was a large, predatory dinosaur that weighed around a ton. It was discovered in the Oxfordshire beds of southern England.

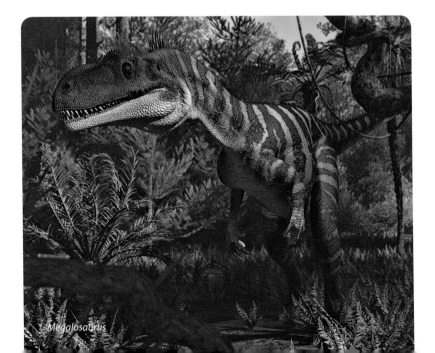

Megalosaurus

THE WHALE LIZARD

By the mid-Jurassic, the famous sauropods had evolved and taken over many of the ecological niches that had been the domain of the more primitive prosauropods. It was around this time the sauropods developed the extreme dimensions and longer necks and tails that we associate with them today. These changes were probably a response to competition over food, whereby their longer necks extended their feeding range, both horizontally and vertically.

Cetiosaurus was the first large sauropod to be studied and named; it was described in 1841. The name means "whale lizard" because the remains were so large that the discoverers thought the remains had to be from a whale.

The tongue-twisting name *Eustreptospondylus* means "true reversed vertebrae" and is a reference to the shape of the animal's backbone. *Eustreptospondylus* was a small, stealthy carnivore measuring around 15 feet long. *Eustreptospondylus* and *Cetiosaurus* come from the same area of southern England as *Megalosaurus*.

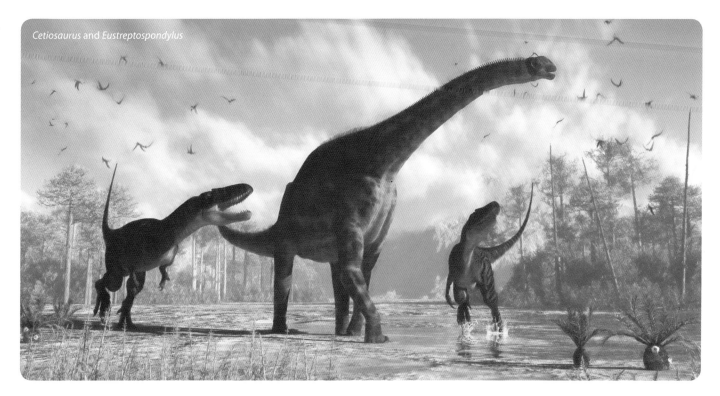
Cetiosaurus and *Eustreptospondylus*

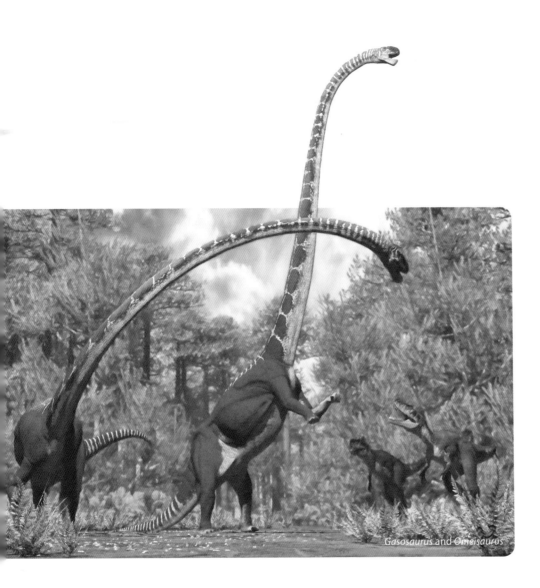
Gasosaurus and Omeisaurus

JURASSIC DINOSAURS OF CHINA

The Dashanpu Formation of central China is one of the most prolific dinosaur sites in the world. The first dinosaur discovered there is known (really!) as *Gasosaurus*, which literally means "gas lizard" and is a reference to the gas and petroleum mining company that originally came upon the fossil. *Gasosaurus* was a relatively small predator at 11 to 13 feet long, and is only known from partial remains, but its discovery was just the first of many at the site. So far, the remains of 38 different species of dinosaur have been found there, and the site also contains fossils of pterosaurs, crocodilians, amphibians and turtles.[7]

All in all, the finds at the Dashanpu Formation span a period of 10–15 million years and encompass both the Middle and Late Jurassic. The animals that have been pulled from the rocks show us a remarkable cross-section of life among the dinosaurs: The site has produced vicious theropods, majestic sauropods and some of the earliest stegosaurs. But it is the Dashanpu Formation's sauropods have done the most to expand our knowledge. A whopping 16 different species have been found there, including several species of the sauropod *Omeisaurus*. It ranged in length from 30–50 feet, relatively small by sauropod standards, but almost all that length was in its neck. And while it's true that sauropods are known for their long necks, *Omeisaurus*, and the line of sauropods it belonged to (the mamenchisaurs), took this to absurd dimensions.

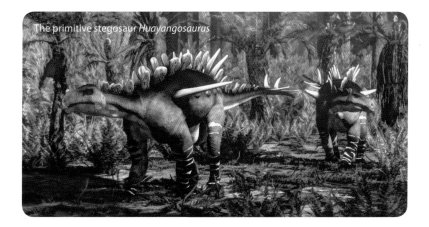
The primitive stegosaur *Huayangosaurus*

THE FIRST STEGOSAURS

In the Middle Jurassic, the stegosaurs (part of the group of armored dinosaurs called thyreophora, which also includes the ankylosaurs) developed the outlandish body armor that would make them famous. Stegosaurs are especially well known for their huge shoulder spikes; the formidable weaponry at the end of their tail; and of course, the plates that famously ran down their backs, all of which combined to make an imposing display and served important defensive purposes as well.

Huayangosaurus was one of the most primitive stegosaurs. Its body hadn't fully developed the sloping profile that most stegosaurs displayed, but it had evolved a modest set of plates along its back and two pairs of short spikes on its tail. At just under 15 feet long, it was relatively small for a stegosaur.

ADVANCED STEGOSAURS

Over time, the stegosaurs grew larger and their displays more striking. *Gigantspinosaurus* existed a few million years after *Huayangosaurus*. Many stegosaurs had large spikes on their shoulders (scientists call them *spinae parascapulares*), but in the case of *Gigantspinosaurus*, they became massive, wing-like projections twice the length of its shoulder blades, and they extended back and over the body. China was host to a number of stegosaurs during the mid and late Jurassic, including *Tuojiangosaurus*, *Chialingosaurus* and *Chungkingosaurus*.

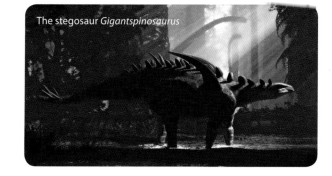
The stegosaur *Gigantspinosaurus*

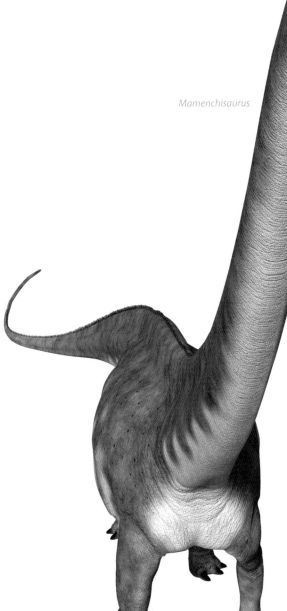

Mamenchisaurus

MAMENCHISAURUS

The mamenchisaurs are the sauropods that (literally) went to the greatest lengths with their necks. *Mamenchisaurus* has the distinction of possessing the greatest neck-to-body-length ratio of any animal.[8] Seven species of *Mamenchisaurus* have been described. One, *Mamenchisaurus sinocanadorum*, was one of the largest dinosaurs that ever lived, reaching lengths of 115 feet. Its neck made up approximately 55 feet of the fossil.

Gigantic sauropod remains are not uncommon, but they usually consist of an isolated bone or two. The remains of *Mamenchisaurus sinocanadorum* are the most complete gigantic dinosaur yet found, and they even include some skull fragments (a rarity among sauropods). This makes it the best known of the giant sauropods.

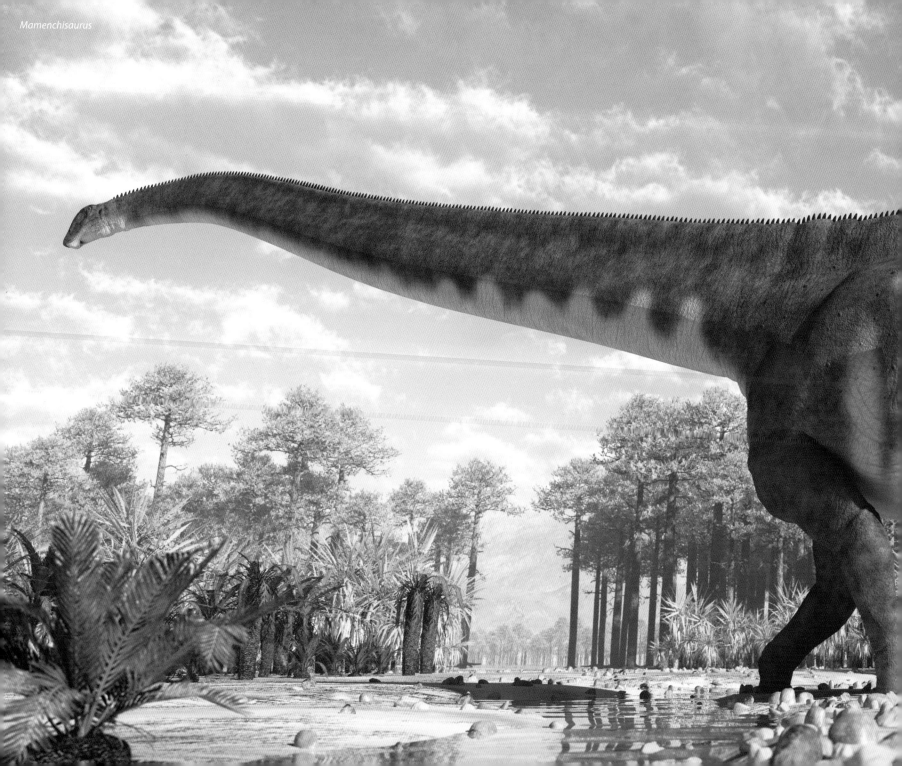

Mamenchisaurus

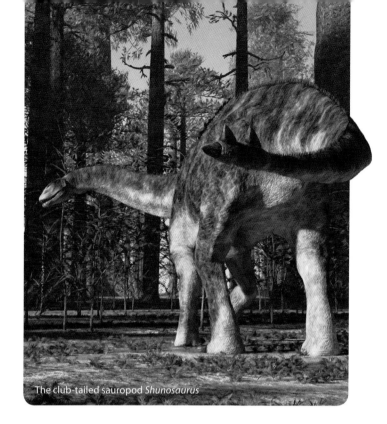
The club-tailed sauropod *Shunosaurus*

ARMORED SAUROPODS

Size wasn't the only defensive adaptation seen in Jurassic sauropods. A few developed defensive weapons. *Shunosaurus* wasn't large by sauropod standards–only about 30 feet long–but its spiked tail club made it unique. The tail was sort of a cross between the tail club of the later ankylosaurs and the spiked tail of the stegosaurs. *Shunosaurus* wasn't the only sauropod to take an active approach to defense. Some species of *Mamenchisaurus* had a small tail club, and the Late Jurassic African sauropod *Spinophorosaurus* had four tail spikes, like a stegosaur. Just as with the stegosaurs, these adaptations were most certainly in response to the vicious predators in the area, like *Gasosaurus* and *Yangchuanosaurus*.

Leshansaurus

PREDATORS

Defensive adaptations among sauropods only make sense if there were predators about. *Leshansaurus* is just one such predator. It's a relatively new find, having been described in 2009. It was a medium-sized theropod some 20 feet in length, but fairly lightly built, marking it as a fast hunter. *Leshansaurus* had a long snout filled with knife-like teeth and strong arms that ended in razor-sharp claws, effective weapons for hunting the many stegosaurs and small sauropods of the Dashanpu Formation.

THE FIRST TYRANNOSAURS

Guanlong was a lithe, nimble predator around 10 feet long, and it is one of the earliest members of the tyrannosaur family, the line that would eventually lead to *Tyrannosaurus rex*. *Guanlong* had a very different look from the later tyrannosaurs. It was a small, light-footed creature with long arms and three-fingered hands. It wasn't until much later in the Cretaceous that the tyrannosaurs would adapt to the shortened arms and two-fingered hands found in the likes of *T. rex*. *Guanlong* was adorned with a thin, delicate crest that stretched the length of its head. The name *Guanlong* means "five colored crowned dragon" and is a reference to both the dinosaur's crest and the rocks in which it was discovered, as they contained five different bands of color.

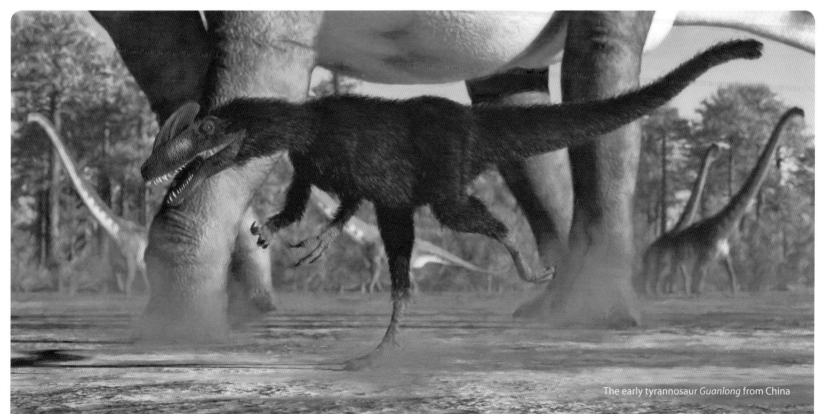

The early tyrannosaur *Guanlong* from China

MONOLOPHOSAURUS

Monolophosaurus was an 18-foot-long theropod that is easy to identify thanks to its distinctive head crest. The crest, which ran down the length of its snout, was roughly rectangular in profile and covered with irregular bumps and ridges. We know *Monolophosaurus* from a fairly complete skeleton that was discovered in 1981.

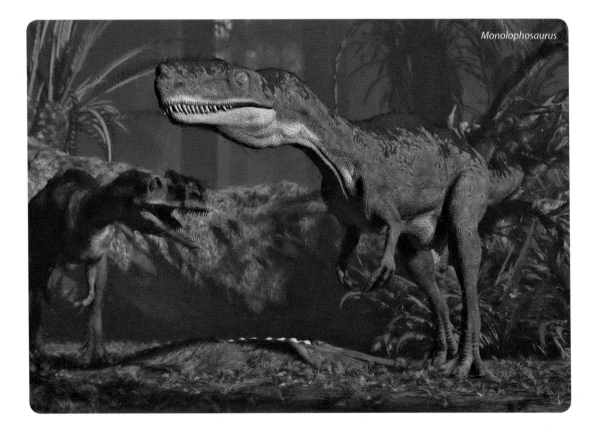

Monolophosaurus

THE TOP PREDATOR OF JURASSIC CHINA

Yangchuanosaurus was the apex predator of China in the Late Jurassic. Up to 35 feet long, it was an enormous hunter and similar in appearance to the allosaurs of the American West and the megalosaurs from Europe. At this time in prehistory, many of the large predators looked a lot alike; this is partly because the continents were still quite close together, so there wasn't a lot of diversity in the ecosystems that were present. But it's also because the basic theropod body plan—long legs, strong arms tipped with ripping claws, short, powerful necks and large heads loaded with flesh-tearing teeth—was so effective and efficient, there wasn't much need to adapt.

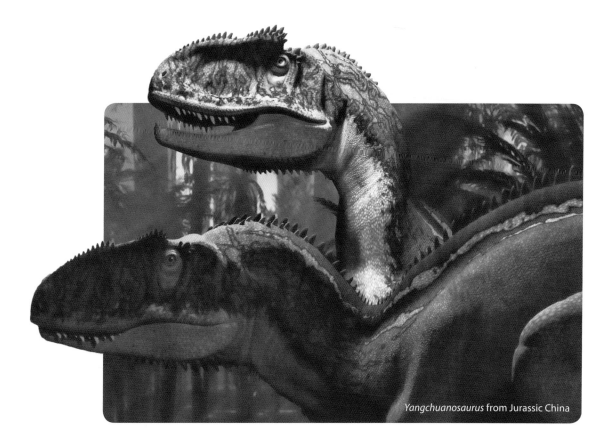

Yangchuanosaurus from Jurassic China

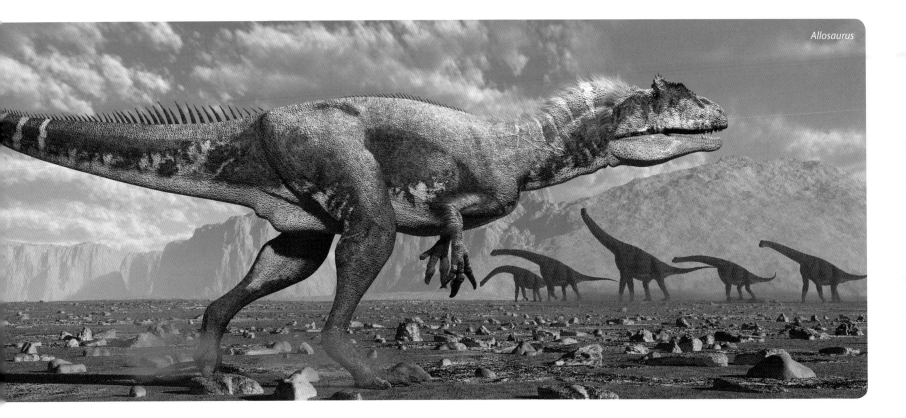

THE WESTERN UNITED STATES

The Morrison Formation is one of the most expansive and important dinosaur-bearing sites ever discovered. Dating from the Late Jurassic, it stretches across Wyoming, Montana, North Dakota, South Dakota, Colorado, Idaho, Utah, Arizona, New Mexico, Oklahoma, Texas, Nebraska and Kansas. The site became famous in the late nineteenth century as the site of *The Bone Wars*—the dinosaur collecting competition that took place between Othniel Charles Marsh and Edward Drinker Cope—two pioneers of dinosaur hunting. Their competition made dinosaurs a household name, and it was here they discovered some of the most familiar dinosaurs we know today, including *Allosaurus*, *Brontosaurus*, *Stegosaurus*, *Diplodocus* and *Brachiosaurus*.

Allosaurus is the most famous predator from the Late Jurassic, and it's also the most common carnivore of the Morrison Formation. At 27 feet long, *Allosaurus* was smaller and more lightly built than the later *Tyrannosaurus*, but it was a breathtaking creature, nonetheless.

THE PERFECT PREDATOR

Allosaurus may have been the perfect predator. It was armed with blade-like teeth, powerful arms and three-fingered hands that ended in razor-sharp claws, and its long, heavily muscled legs enabled it to reach speeds nearing 35 mph. Sporting an enormous head atop a bull-dog-like neck, *Allosaurus* could open its jaws an amazing 79 degrees.[9] For all its size, *Allosaurus's* head was amazingly light and unable to withstand the thrashing of large prey. It likely used a "slash and wait" approach, driving its teeth deeply into its prey, then patiently waiting for it to pass out from blood loss.

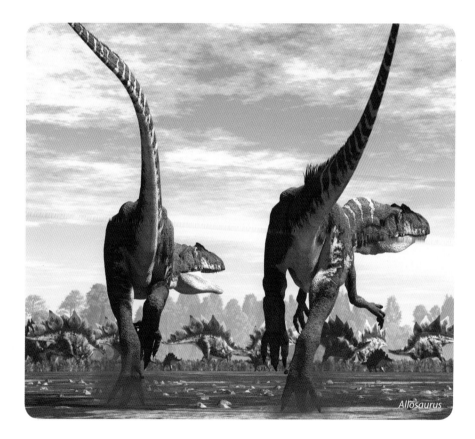

Allosaurus

Allosaurus is one of the most wide-ranging predators, with remains found from North America to Europe and Africa. One spot in the Morrison Formation, the Cleveland-Lloyd Dinosaur Quarry in Utah, records a "predator death trap." This is a location where prey animals became trapped or mired in mud from which they couldn't escape. Predators flocked to the scene to feast on what appeared to be easy prey, but in the process, became trapped themselves. The Cleveland-Lloyd Quarry has yielded the remains of dozens of individual *Allosaurus* so far, and digging is still underway.

Torvosaurus

TORVOSAURUS

Allosaurus was big, but it wasn't the biggest predator of its day. That honor goes to *Torvosaurus*. *Torvosaurus* was more than 35 feet long and carried two tons of bone-crushing power. Heavier, bulkier and slower than *Allosaurus*, some people believe it must have been a scavenger exclusively. It's not hard to imagine a brute like this waiting for some smaller carnivore to take down prey, then stealing the kill. But it may have been an effective ambush predator, lying in wait then giving short chase. *Torvosaurus*, like *Allosaurus*, seems to have had a cosmopolitan distribution, with remains having been found in Portugal as well as North America.

INTER-SPECIES BATTLES

Over the years, we've found lots of evidence showing that large, predatory dinosaurs engaged in battles within their own species. Often, this evidence comes in the form of tooth marks on fossilized skulls. As it's possible to match the teeth marks to individual species, researchers can conclude that a dinosaur of the same species must have inflicted the wounds. In many cases, these bite marks show evidence of having healed, indicating that the animal survived the attack. We don't know whether these battles were over territory, mates, superiority or simply instances of cannibalism, but it must have been an amazing site to see two predators the size of *Torvosaurus* take each other on.

A pair of *Torvosaurus* battle over supremacy

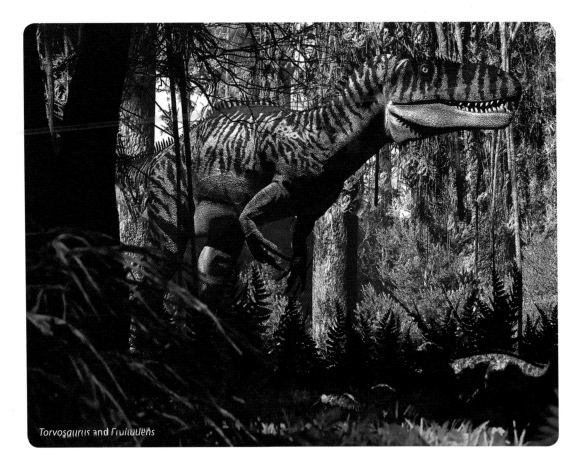

Torvosaurus and Fruitadens

FRUITADENS

Fruitadens is one of the tiniest ornithischians we know of—the group of small, bipedal, beaked herbivores. It measured less than three feet long and weighed only a couple of pounds. As it was so tiny, it probably was too small to be prey for *Torvosaurus*, but it would have spent time hiding about in the undergrowth, trying to avoid detection or being inadvertently stepped on.

THE MORRISON SAUROPODS

As impressive as the Morrison predators were, it was the sauropods that ruled the domain. To date, more than 15 different species of sauropods have been found there, including *Amphicoelias*, possibly the biggest land animal to have ever existed.

Amphicoelias is only known from a single vertebra, and unfortunately that bone disappeared more than 100 years ago. Luckily, the paleontologist who found the fossil published a description of it and made detailed drawings of the bone so we have a good idea of what it looked like. Based on its dimensions, *Amphicoelias* may have been the largest land animal that ever existed, dwarfing even the other sauropods of the time. Using that original drawing and the dimensions of the bone, we can estimate how big *Amphicoelias* was in life, and the figures are staggering. At 190 feet in length, *Amphicoelias* was longer (though probably not heavier) than a blue whale and more than half the length of a football field.

Because its remains are lost, many people do not consider *Amphicoelias* to be a valid dinosaur. That's a fair argument. Dinosaurs with a much more substantive fossil record than *Amphicoelias* have been classified as invalid later. But the sheer potential for an animal that size is worth recognizing and contemplating.

Amphicoelias appears to have been pretty rare in its environment, and no additional remains of it have been found. That's not the case, however, with many of the other sauropods from the Morrison Formation.

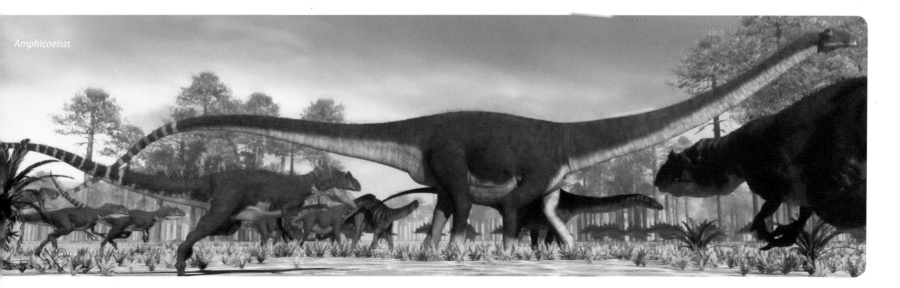

Amphicoelias

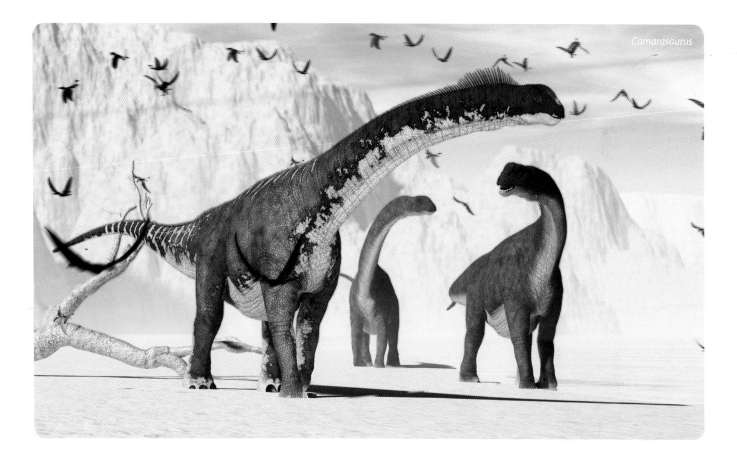
Camarasaurus

CAMARASAURUS AND THE MACRONARIANS

Camarasaurus is one of the most common sauropods of the American West. Most *Camarasaurus* were between 60 and 75 feet long. It was a member of a group of sauropods called macronarians. The name means "big nose" and refers to the enlarged nasal cavities that created a big, arched profile to their snouts. Other macronarians include *Brachiosaurus*, *Giraffatitan* and *Sauroposeidon*. The 1998 finding of three *Camarasaurus* skeletons buried together, consisting of two adults and one juvenile, is an indicator that *Camarasaurus* may have traveled in small herds or family groups.

THE DIPLODOCIDS

If the early sauropods were stately in their appearance, then the diplodocids were downright elegant. With their "double beam" design of a long, graceful neck perfectly balanced by a delicately tapering tail of unimaginable length, they were nearly architectural in their beauty.

The diplodocids were common sauropods, and their representatives are among the most familiar to us. *Apatosaurus* grew to about 80 feet long, and may be most famous as being the dinosaur that "knocked *Brontosaurus* off its perch." Over 100 years ago, it was determined that *Apatosaurus* and *Brontosaurus* were the same animal but they had been discovered and named by different people. The way things work in science, when this happens, the name that was applied first takes precedence, and so even though *Brontosaurus* had become popular with the public, *Apatosaurus* became the animal's official name. More than 100 years later that would all change.

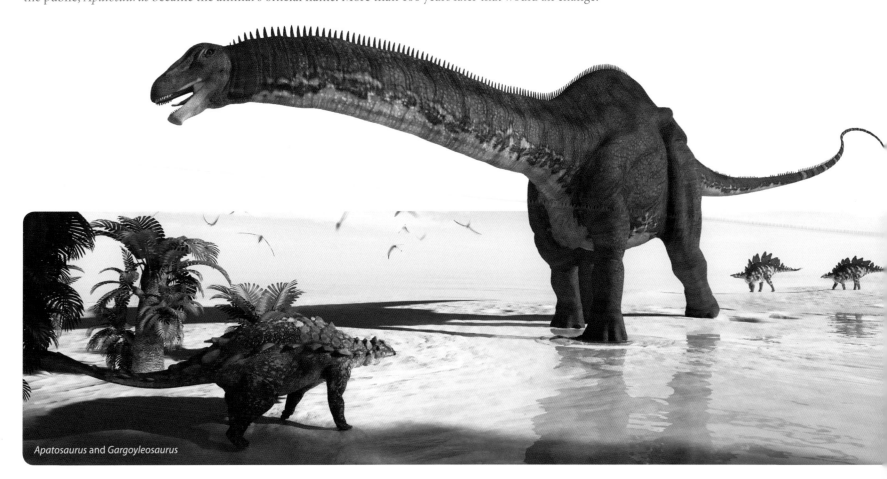

Apatosaurus and *Gargoyleosaurus*

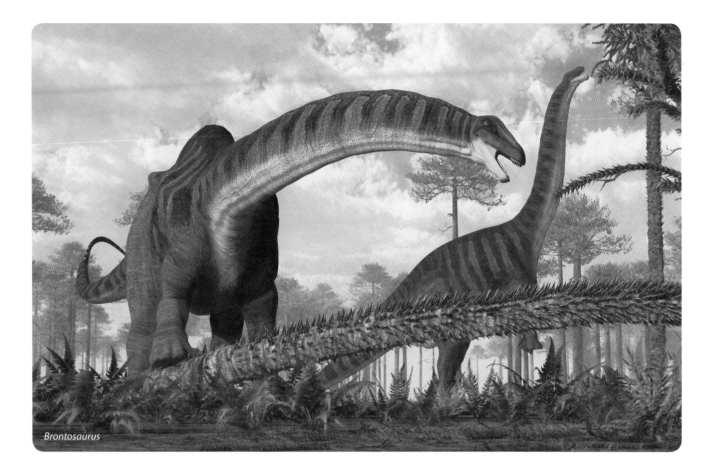

Brontosaurus

THE THUNDER LIZARD

The Thunder Lizard is back! Long relegated as a *nomen dubium*—what paleontologists call an animal's name if it's determined to be scientifically invalid—*Brontosaurus* has been reinstated after more than 100 years.

By using new methods and techniques to analyze subtle differences in dinosaur bones, researchers have provided compelling evidence that *Apatosaurus* (see page 56) and *Brontosaurus* really are distinct animals. Still, *Apatosaurus* and *Brontosaurus* are very, very similar in their outward appearance, and may have been distinguished by their coloration or skin pattern.

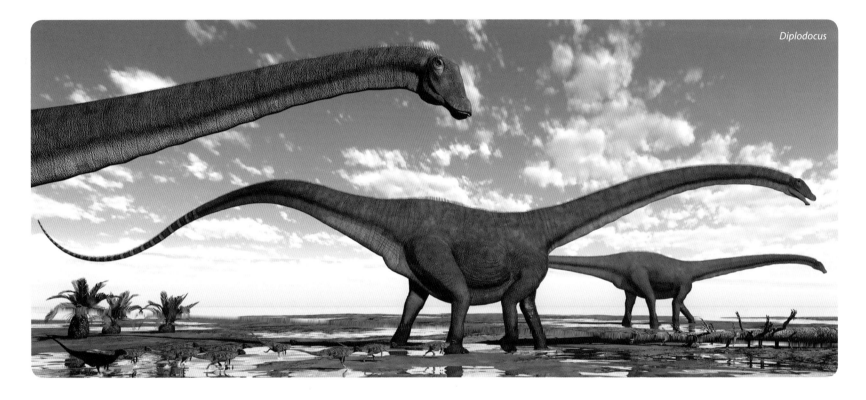

Diplodocus

DIPLODOCUS

Over the years, there have been a number of animals found that looked a lot like *Diplodocus* but were a bit larger. Some people consider these to be distinct species, and they've given them dramatic names like *Supersaurus* and *Seismosaurus*. Others think these are just really big specimens of *Diplodocus*. Some people think that *Amphicoelias* isn't actually a separate genus, but a really, *really* big *Diplodocus*. All of this makes it a little tough to say exactly how big *Diplodocus* got. Most of the specimens that you see in museums are around 75–85 feet long. The specimen known as *Seismosaurus* may have reached 100 feet, and *Supersaurus* was a whopping 110 feet.

In the past, much has been made of how the earth must have shook when these great "thunder lizards" walked. And yet it's just as easy to imagine these enormous animals moving in near silence, their slow footsteps treading gracefully across arid plains, their sinuous tails looping and waving behind them.

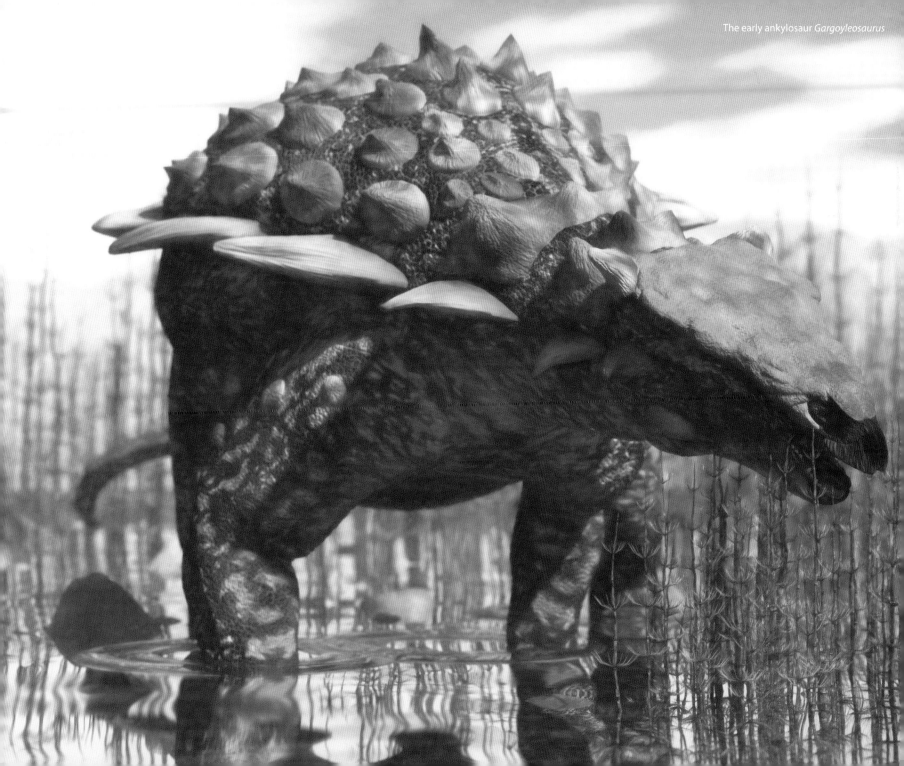

THE ANKYLOSAURS

There's no doubt that the sauropods were dramatic, impressive creatures. But the thyreophorans—the stegosaurs and ankylosaurs—took dinosaur looks to a whole new level. What they lacked in size (most were less than 30 feet long), they made up for in ornateness.

Often referred to as "living tanks," ankylosaurs were squat, wide herbivores best known for their extensive armor that included spikes, bony plates and tail clubs. The earliest ankylosaurs evolved in the Jurassic, and while these early ankylosaurs had the heavy body armor we expect, they had yet to evolve the tail club. *Gargoyleosaurus* is one of the earliest ankylosaurs for which we have complete remains. It was just 10–13 feet long, but like most ankylosaurs, it was heavy for its size, probably weighing about a ton.

Ankylosaurs are covered in hard bony plates known as osteoderms, which are essentially pieces of bone that are embedded in the animal's skin. Osteoderms are found in many other animals. For example, the backs of modern alligators and crocodiles are covered in osteoderms. In some cases, they are attached directly to the animal's skeleton, but in most cases, they are held in place by soft tissue. The bony portion of an osteoderm is typically covered in keratin, a relatively soft tissue (it's the same thing your fingernails are made of). Keratin doesn't fossilize very often, or very well when it does. When ankylosaurs died, the soft tissue that held their osteoderms in place decayed, and they often fell out. As the osteoderms were lighter and smaller than many of its other bones, they often washed away or were destroyed before they were fossilized. This makes reconstructions of ankylosaurs and their armor especially difficult.

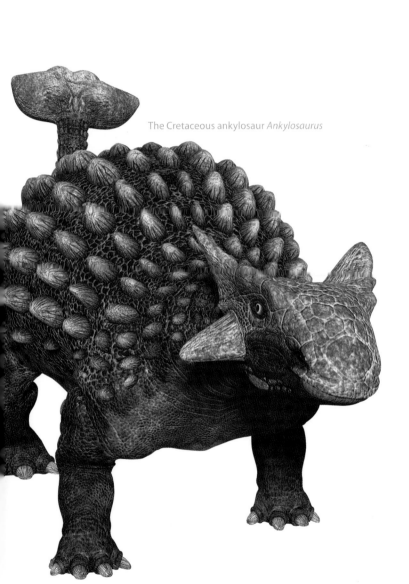

The Cretaceous ankylosaur *Ankylosaurus*

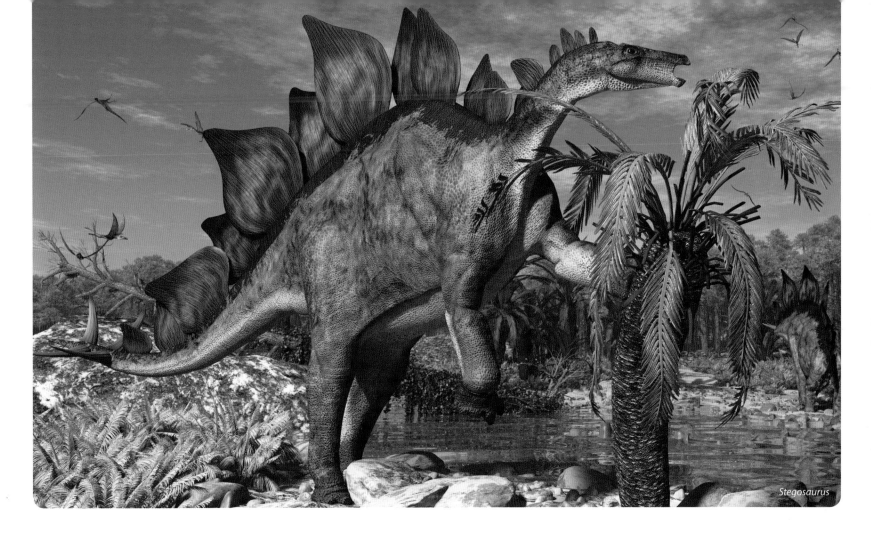

Stegosaurus

STEGOSAURUS

Stegosaurus is one of the most familiar of all dinosaurs. Its most recognizable feature, the tall pointed plates on its back, were not actually attached to its backbone, but floated in its skin. *Stegosaurus's* powerful tail, with its four long tail spikes, called a thagomizer, was a powerful and effective weapon against predators. We know this because remains of an *Allosaurus* have been found with damage that appears to have been inflicted by a *Stegosaurus* thagomizer.

OTHER PLANT EATERS

Compared to the thyreophorans, other plant eaters of the Morrison appear pretty plain and almost downright boring. Herbivores, such as the cow-like *Camptosaurus*, *Dryosaurus* and tiny *Fruitadens*, lacked plates and spikes. Their only defense was to run or hide (some of them may have dug burrows). Generally speaking, they stuck to a pretty conservative body plan, but in the case of *Camptosaurus*, there were some changes taking place that hint at more interesting things to come. *Camptosaurus* was an ornithopod, a line of ornithischian dinosaurs that were mostly bipedal herbivores. *Camptosaurus* had grown larger than most of the other ornithopods of its time, nearly 26 feet in length and 6 feet wide at the hips. It was one of the early iguanodonts, the line of animals that would eventually lead to the crested hadrosaurs. And while it was a rather bulky animal, it may have been surprisingly light on its feet, and capable of outrunning the large carnivores of the time.

The ornithischian *Drinker* is named in honor of the famed fossil hunter Edward Drinker Cope, one of the two participants in the notorious Bone Wars of the nineteenth century. The other paleontologist (and Cope's sometime-combatant) was Othniel Charles Marsh. *Drinker* was a six-foot-long biped and had long legs that were well adapted for running and short forearms that ended in five-fingered hands.

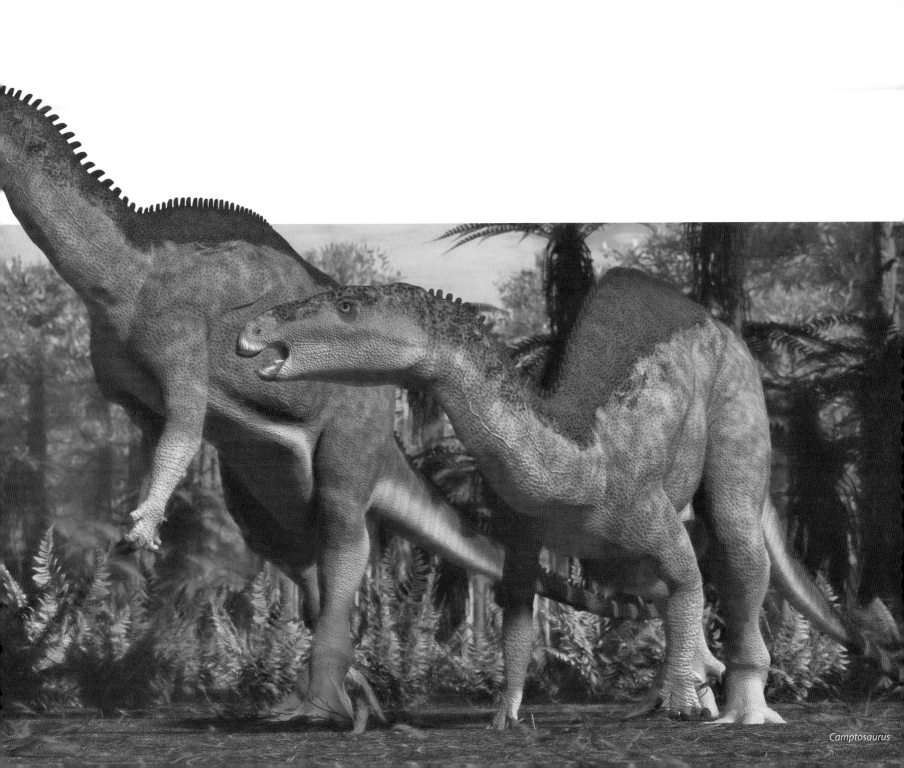

Camptosaurus

Brachiosaurus—a member of the same sauropod group as *Camarasaurus*, the macronarians—was one of the largest sauropods of the Morrison, attaining lengths of 80–90 feet. *Brachiosaurus* is well known for its appearance in the film *Jurassic Park*, but that animal is actually a closely related species from Africa that now goes by the name *Giraffatitan*. *Brachiosaurus* itself is known from the American West, but it was only known from very partial remains until recently. Skull material that belongs to *Brachiosaurus* was discovered in 1883, but was misassigned for over 100 years. It wasn't until 1998 that it was recognized as a *Brachiosaurus* skull, and proved to be different from the traditional view of the animal, with a shallower, more gently sloping forehead.

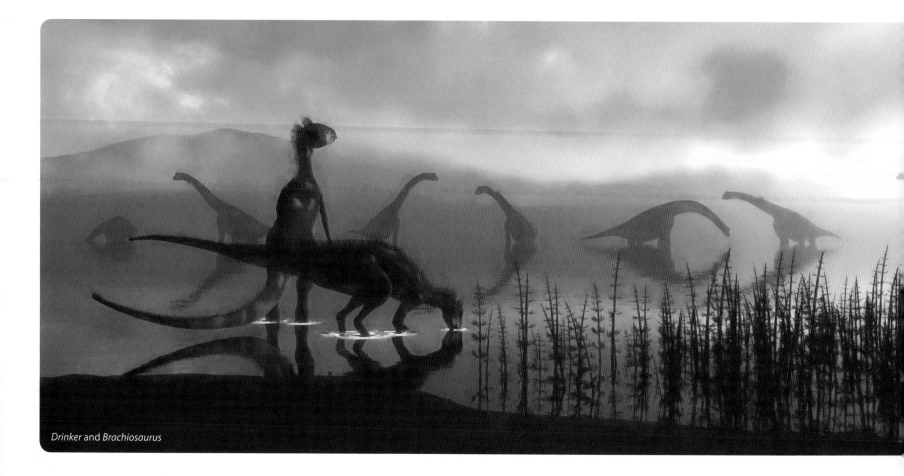

Drinker and *Brachiosaurus*

JURASSIC DINOSAURS FROM AFRICA

North America wasn't the only land where the sauropods ruled. As far away as Africa, there were equally impressive dinosaurs. *Giraffatitan* (once called *Brachiosaurus*, but that turned out to be a different animal) was 85 feet long, and it has become one of the most iconic of the sauropods. *Giraffatitan*, like other brachiosaurs such as *Sauroposeidon* and *Brachiosaurus*, were built "uphill." That is, their front legs were longer than their back legs. This allowed them to stretch their necks up, instead of out, giving them enormous height. *Giraffatitan* may have held its head 30 feet above the ground, high enough to look into a three-story building. This would have given it an advantage when feeding, as it allowed it to reach higher into the trees than other sauropods. With that said, its center of gravity was farther forward in its body, and this means it probably could not rear up and stand on its hind legs as you may have seen in the movies.

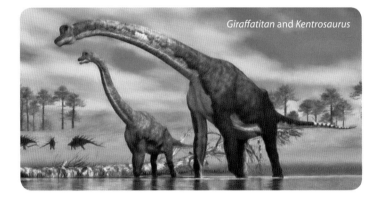

Giraffatitan and *Kentrosaurus*

Kentrosaurus is the only stegosaur so far that has been found in Africa, and it was quite an impressive animal. Though not quite as big as *Stegosaurus*, the plates on *Kentrosaurus's* back were narrower and more pointed, and they transitioned to long spikes over its hips. In addition, the spikes on its tail were much larger than those of *Stegosaurus*, and *Kentrosaurus* also retained the long shoulder spikes seen in the Chinese stegosaurs (see page 40). Essentially, it was a walking armory. Of course it would have needed those defenses against the predators of the Tendaguru Formation, which included allosaurs and ceratosaurs.

DIFFERENT CONTINENTS, SIMILAR FAUNA

Both *Giraffatitan* and *Kentrosaurus* are found in the Tendaguru Formation of Tanzania in Africa. The fauna of the Tendaguru is remarkably similar to the Morrison Formation of the Western US, only with slightly different species. At this time in history, when the continents were interconnected, ecosystems were relatively similar around the world, so there was less pressure to adapt to survive. The positions of the continents at the time was such that Africa and North America were also much closer together than they are today. It would take millions of years before the continents would drift apart, diversifying the ecosystems and thereby producing some remarkable variations.

EUROPE IN THE LATE JURASSIC

In the Late Jurassic, Europe was a series of islands with shallow lagoons and beaches. And it is there, in the area that is now Germany, that we find some remarkable animals that are strikingly different from those found elsewhere. The Solnhofen Limestones provide a record of quiet lagoons that existed 150 million years ago during the Tithonian Stage, the last part of the Jurassic era. An incredible variety of fossils are found there, including invertebrates, fish, ichthyosaurs, lizards, pterosaurs and dinosaurs.

ARCHAEOPTERYX

Archaeopteryx has long been described as "the first bird," but that title was given before scientists had discovered all sorts of small, bird-like dinosaurs. So the question is: What made *Archaeopteryx* so special and what caused it to be classified as a bird for so long? The answer: the impressions of feathers preserved along with the skeleton. The fine-grained sediments of the Solnhofen area, along with its extremely placid, anoxic (devoid of oxygen) waters, preserved not just the skeletons, but also impressions of the soft tissues of many animals, including the imprints of jelly fish that floated in the waters, and *Archaeopteryx's* feathers. But at the time of its discovery in 1861, feathers were only known to exist on birds. So although *Archaeopteryx* had fingers with claws and teeth and a long tail, since it had feathers, scientists decided it must be a bird. If *Archaeopteryx* were discovered today, we wouldn't call it a bird, but rather a theropod dinosaur.

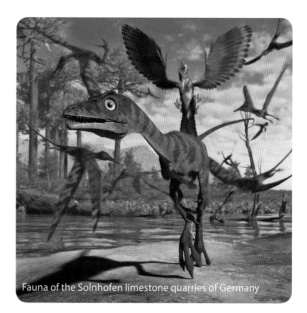
Fauna of the Solnhofen limestone quarries of Germany

Archaeopteryx lived alongside a number of other small animals, including *Compsognathus*, a three-foot-long carnivore that fed on the small lizards and insects that populated the area. Pterosaurs have also been found at Solnhofen, and they too show amazing preservation, including the presence of their wing membranes, a fur-like covering, and webbing between their toes and between their legs and their tails. *Rhamphorhynchus* had a six-foot wingspan, a turned-up beak, and a mouth full of long, sharp teeth that helped it catch fish. It also had the long tail that is typical of many early pterosaurs. *Pterodactylus* was a common pterosaur from Solnhofen, and it is known from more than 30 fossils. It was a little smaller than *Rhamphorhynchus*, with a three-foot wingspan. *Pterodactylus* was a short-tailed pterosaur and most likely fed on fish and other small animals.

INSULAR DWARFISM

During the late Jurassic, Germany and the whole of Europe consisted of a series of disconnected islands linked by a shallow sea. The animals that populated these islands became isolated and developed adaptations that suited their environments. Some forms, like the sauropod *Europasaurus*, evolved on small islands with restricted food resources. As a result, they became smaller versions of much larger animals. In fact, *Europasaurus* looks like a miniaturized version of *Giraffatitan* from Africa, and that's essentially what it is. Scientists call this process "insular dwarfism." *Europasaurus* grew to 19 feet in length (compared to 80 feet for *Giraffatitan*) and lived in what is now Germany.

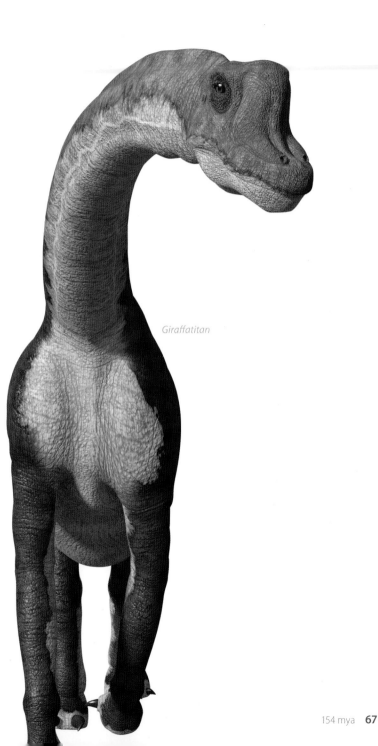

Giraffatitan

A herd of the "dwarf" sauropod *Europasaurus*

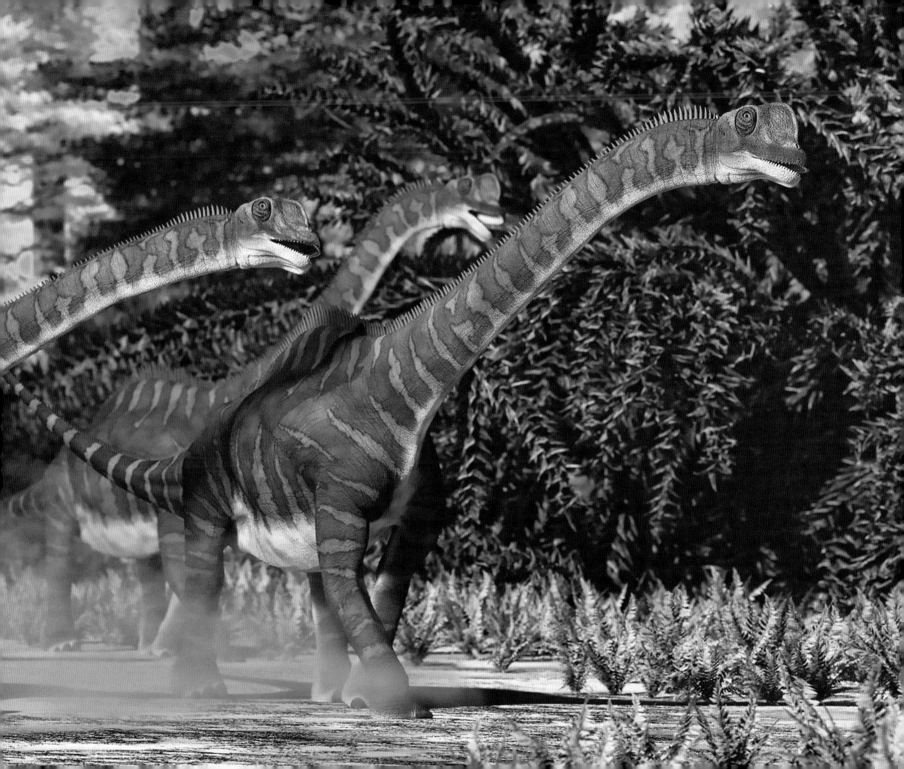

METRIACANTHOSAURUS

Elsewhere across the European Archipelago, as the string of islands is known, some animals were strikingly similar to those found on the other landmasses. *Metriacanthosaurus* was a moderately sized predator whose remains have been found in southern England, and it was closely related to the Chinese *Yangchuanosaurus*. *Metriacanthosaurus* is another dinosaur that has undergone numerous name changes over the years; it was first thought to be an example of *Megalosaurus*, and then a specimen of *Yangchuanosaurus* before it was finally determined to be a distinct genus.

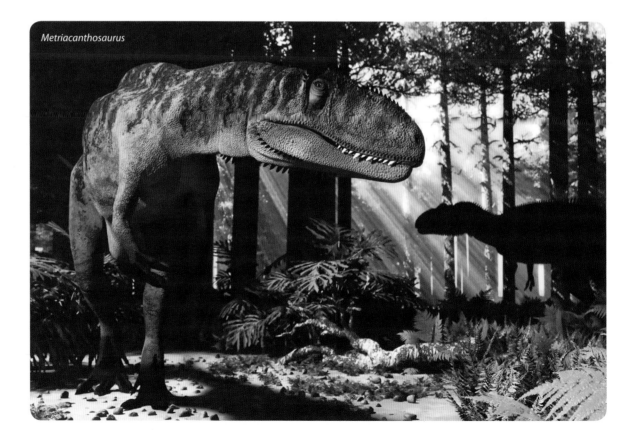

Metriacanthosaurus

EUROPEAN STEGOSAURS

Over the years, remains of stegosaurs have been found across Europe, but these have mostly been partial, scrappy remains that haven't given us a good picture of the entire animal. Most of the remains have been assigned to an animal named *Dacentrurus*. What we know of *Dacentrurus* comes from the back half of the animal, mainly its hips and hind legs. Then in 1999, a stegosaur was discovered in Portugal, but it primarily consisted of the front half of the dinosaur. There were only a few bones from this new dinosaur that overlapped with those from the *Dacentrurus* find, so the discoverers couldn't really compare the new find to *Dacentrurus*. Eventually they classified it as a different animal and named it *Miragaia*. It's possible that *Dacentrurus* and *Miragaia* are synonymous (the same animal), but until better remains of both animals are found, they'll remain separate. *Miragaia* is a fairly standard stegosaur, with a length of 18–20 feet, but has one feature that makes it remarkable. *Miragaia* has the longest neck of any stegosaur. It's even known by the nickname "the sauropod-necked stegosaur," though that's a bit of a stretch. *Miragaia's* long neck was possible because it had more vertebrae in its neck than other stegosaurs. It had up to 17, the same number that the long-necked mamenchisaur sauropods (see page 41) had.

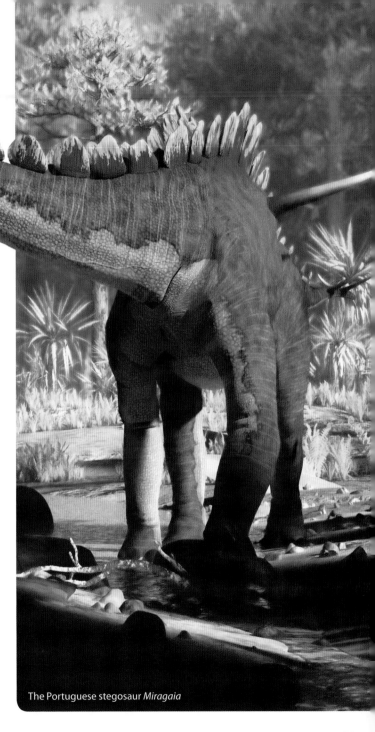

The Portuguese stegosaur *Miragaia*

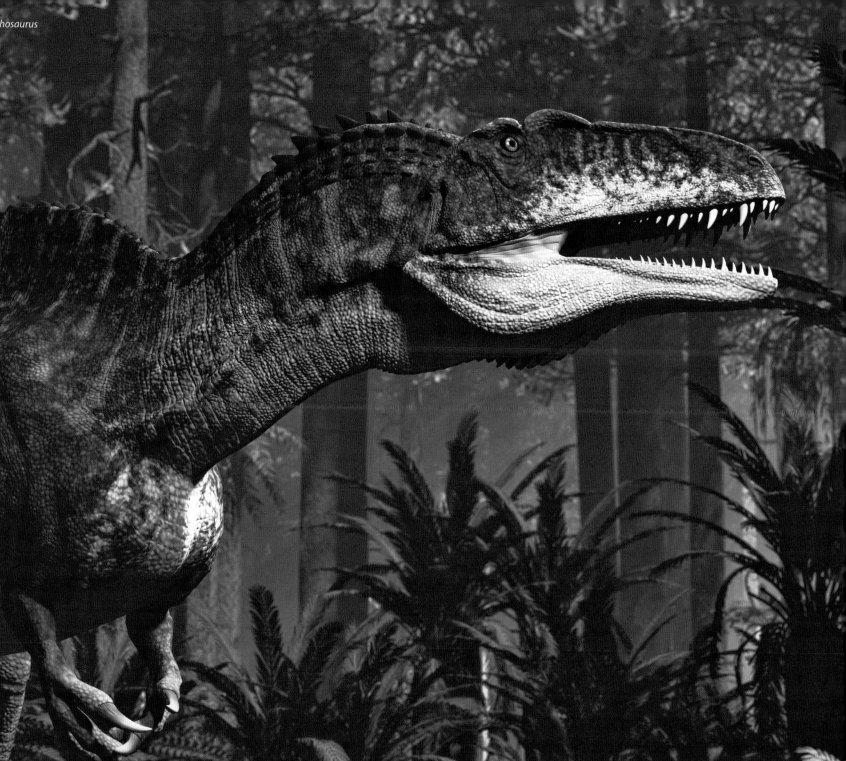

Acrocanthosaurus

The Cretaceous Period

145–66.5 MILLION YEARS AGO

Unlike the Triassic and Jurassic periods, which both ended with extinction events, there was no huge catastrophe separating the Jurassic and the Cretaceous. Throughout the Cretaceous, the supercontinent of Pangea continued to break apart, and the landmasses began to form the continents we're familiar with today. The ancient Atlantic Ocean continued to rip the land apart from north to south, eventually splitting Gondwana into the continents we know as South America and Africa. Antarctica, Australia, India and Madagascar all separated from Africa, with Antarctica moving south to its polar location, Australia heading off to the east and India and Madagascar traveling north. Eventually, in the later Cenozoic Era, India slammed into Asia, and the Himalayan Mountains began rising.

As these changes occurred, temperatures warmed and sea levels rose, creating numerous inland seas. In North America, the ocean overtook the land from the north, dividing the whole of North America into two separate island continents: Laramidia to the west, and Appalachia to the east. The waterway, known as the Western Interior Seaway, stretched from the Arctic all the way to the Gulf of Mexico. All of these geologic and climactic changes led to an explosion of diversity and evolution, both on land and in the oceans.

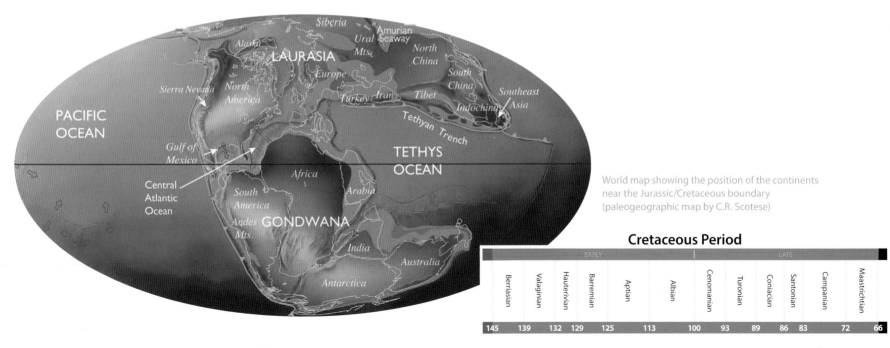

World map showing the position of the continents near the Jurassic/Cretaceous boundary (paleogeographic map by C.R. Scotese)

Cretaceous Period

	EARLY						LATE					
Berriasian	Valaginian	Hauterivian	Barremian	Aptian	Albian	Cenomanian	Turonian	Coniacian	Santonian	Campanian	Maastrichtian	
145	139	132	129	125	113	100	93	89	86	83	72	66

LIFE IN THE CRETACEOUS
PLANTS

One of the most important developments in the history of life on Earth occurred in the Cretaceous. Angiosperms—flowering plants, which includes grasses, flowers and leafy trees—became common in the Early Cretaceous, around 120 million years ago (they first appeared around 160 million years ago in the Jurassic). Early forms included *Magnolia*s, figs and plane trees. Grasses existed in the Cretaceous, but weren't common; there weren't fields of grasses or prairies until after the Cretaceous ended. Many scientists believe it was the explosive expansion of the flowering plants that led to the evolutionary changes that took place in the animals of the Cretaceous. Angiosperms developed seeds and fruits, which contain more nutritional value than the leaves, barks and fronds of gymnosperms, and as such, provided a whole new food source for Mesozoic life: Animals ate the seeds and fruit of these new plants, and in the process became covered in the plant's pollen. The animals moved about, sometimes great distances, and in the process, dispersed both the pollen, which fell or was blown off their skin, and the seeds, which were deposited in the animals' droppings (along with a healthy dose of fertilizer!). The plants took root and adapted to take advantage of their new environment. The animals then evolved to take advantage of these new food resources, possibly developing specialized mouths and beaks, and perhaps gaining metabolic advantages in the process. Animals ate the newly evolved plant's seed and fruits and the cycle continued.

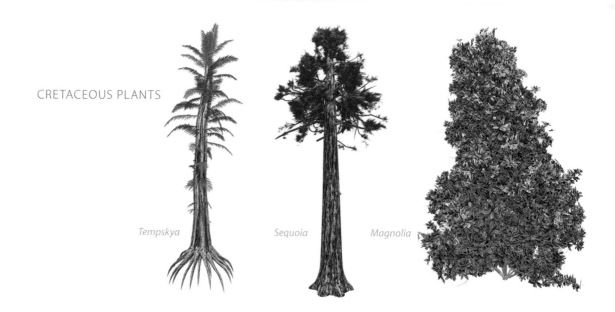

CRETACEOUS PLANTS

Tempskya *Sequoia* *Magnolia*

THE GYMNOSPERMS CARRY ON

Ferns and gymnosperms, such as *Araucaria*, *Sequoia*s and bald cypress, continued to be the dominant plants until the Campanian period of the Cretaceous, about 100 million years ago. That's when plane trees (hardwood angiosperms) became more common. *Tempskya* was a common, tree-like fern that populated the northern continents during the Cretaceous. Despite what you might have seen in paintings, with Jurassic dinosaurs surrounded by tropical palm trees, palms only evolved around 90 million years ago, during the Cretaceous. *Calamites* continued into the Cretaceous, but in smaller forms, similar to what we know today. The bennettitales still existed, but they died out by the end of the period.

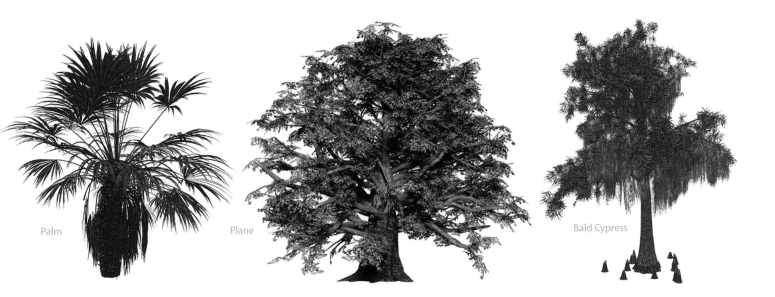

Palm

Plane

Bald Cypress

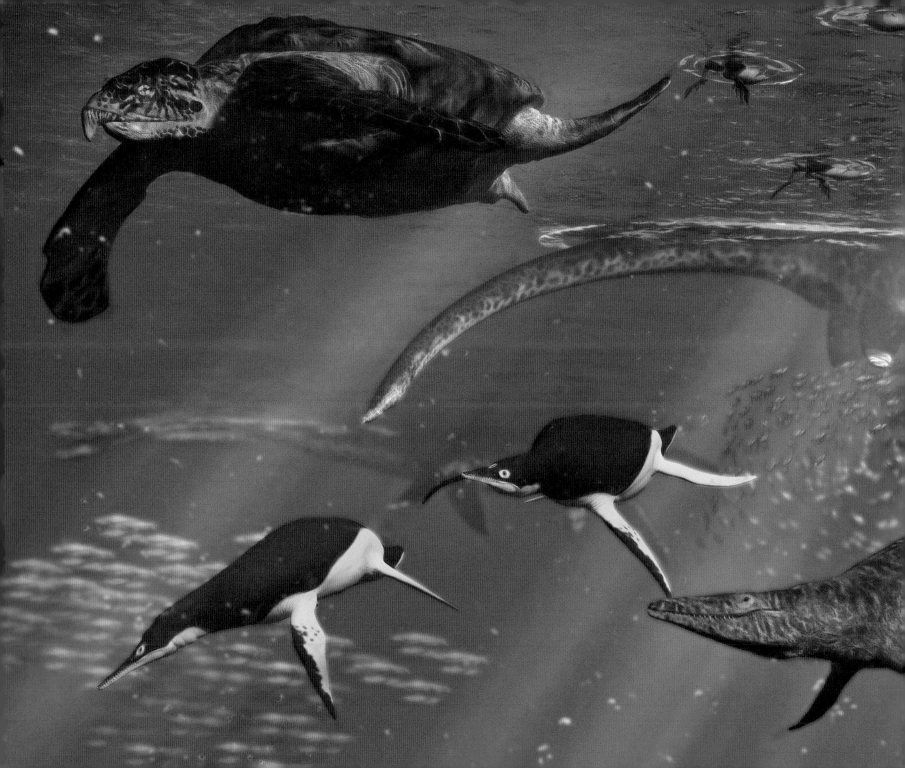

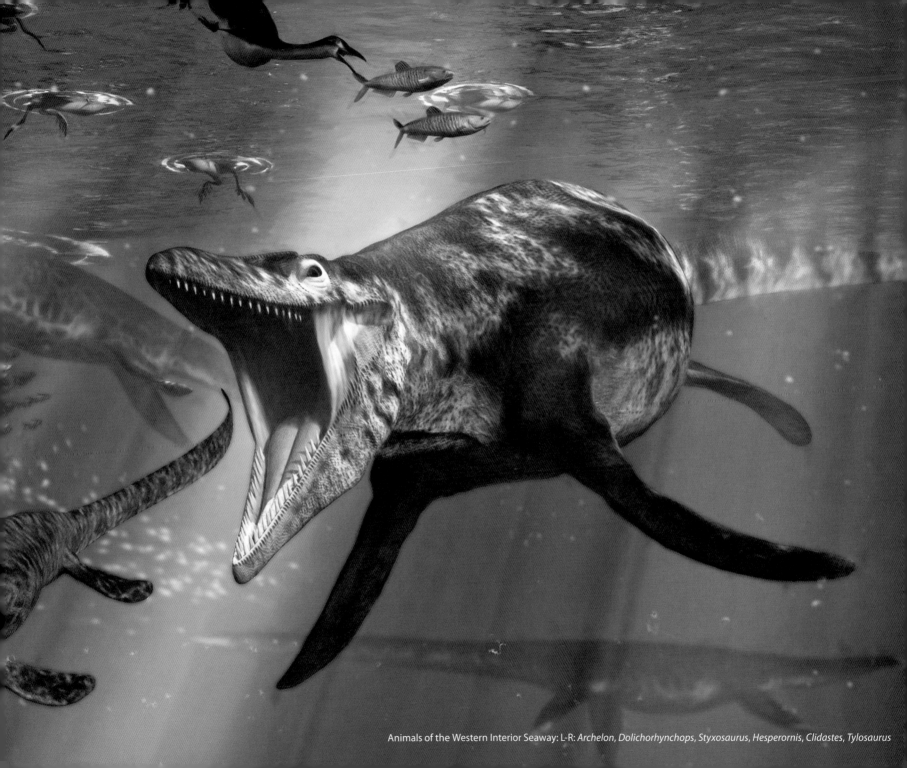

Animals of the Western Interior Seaway: L-R: *Archelon, Dolichorhynchops, Styxosaurus, Hesperornis, Clidastes, Tylosaurus*

LIFE IN THE OCEANS

During the mid—late Cretaceous, a shallow sea split North America in half, creating two island continents: Laramidia to the west, and Appalachia to the east. Over time, this sea has gone by a number of names, including the Niobaran Seaway, The Cretaceous Seaway and the North American Inland Sea. Its most common name today is the Western Interior Seaway. It was a shallow, tropical sea with warm waters and abundant life. It teemed with a variety of fish, marine reptiles, pterosaurs and birds:

Archelon was a gargantuan marine turtle—the largest ever found—with a shell that was up to 14 feet wide. *Archelon* was an omnivore; it ate plants but also feasted on jellyfish and other marine invertebrates.

Clidastes was a mosasaur—a branch of marine reptiles whose closest living relatives are the terrestrial monitor lizards. At just 10–15 feet in length, *Clidastes* was one of the smaller mosasaurs, and it had a wide distribution, with remains found in North America and Europe.

Dolichorhynchops was one of the pliosaurs, a group of plesiosaurs that had big heads and short necks. At just 16 feet long, it was much smaller than some of its earlier pliosaurid cousins and probably behaved much like a modern porpoise. The dimensions of its body and the structure of its flippers indicate that it was highly maneuverable in the water.

Styxosaurus was a plesiosaur that reached enormous sizes thanks to the length of its neck. It stretched about 36 feet long, and a whopping half of that was neck.

Hesperornis was a six-foot-tall, flightless bird that lived along the shores of the Western Interior Seaway. It was built much like modern diving birds and probably had a similar lifestyle. Its wings had been reduced to mere stubs, meaning that *Hesperornis* most likely used its legs to swim, kicking them out behind it as it dove for fish.

Tylosaurus was the *T. rex* of the Western Interior Seaway. It was a forty-foot-long mosasaur that fed on fish, sharks, mollusks, and other marine reptiles, including other mosasaurs. Like most mosasaurs, *Tylosaurus* had an extra set of teeth on the roof of its mouth and an extra hinge in its lower jaw that allowed it to open wider side-to-side. These adaptations meant that it could rip huge chunks of flesh from its victims and swallow them whole.

Quetzalcoatlus feasts on a juvenile tyrannosaur

Pteranodon

LIFE IN THE SKIES

In the air, evolution was going wild as well. Pterosaurs, which had stayed small and more or less unchanged for nearly 100 million years, grew enormous and developed outrageous head crests:

The late Cretaceous azhdarchids, like *Quetzalcoatlus*, sported wingspans of up to 36 feet, growing as big as small planes.

The *Pteranodon*s, which soared above the seas, were slightly smaller, at 25 feet, with tall crests and long, toothless beaks. They are one of the most common pterosaur fossils found, and they seem to have spent much of their time soaring above the Western Interior Sea, looking for fish.

Thalassodromeus hailed from Brazil and was related to *Quetzalcoatlus*, but it came from a line that developed lavish head crests.

Zhenyuanopterus was a pterosaur from China, and it sported a low crest on its snout and had long, needle-like teeth for catching fish.

Like the non-avian dinosaurs, the plesiosaurs, the mosasaurs and the pterosaurs were all casualties of the K-Pg extinction.

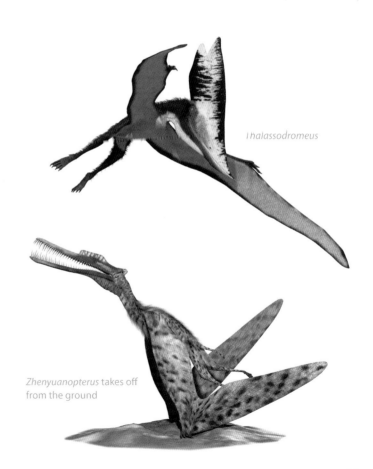

Thalassodromeus

Zhenyuanopterus takes off from the ground

EARLY CRETACEOUS DINOSAURS

The Cretaceous saw the most dramatic changes in dinosaur adaptation in all of the Mesozoic. Entirely new forms of ornithopods appeared, including such iconic groups as the iguanodonts and the hadrosaurs. The ceratopsians, the horned and frilled dinosaurs, went from small, ornithischian-like forms to massive, rhinoceros-like animals that sometimes rivaled elephants in size and boasted elaborate horns and neck shields. Early in the Cretaceous, the stegosaurs disappeared, but the nodosaurs and ankylosaurs filled the gap, and they took body armor to entirely new levels, sporting enormous spikes on their backs and sides as well as massive, bone-crushing tail clubs. Sauropods continued to flourish, though primarily in the southern Gondwanan continents. Some of them became as heavily ornamented as the ankylosaurs and bore plates, spikes and horns. Others simply kept growing, becoming the most massive land animals to walk the Earth. The theropods, which had seen only minor changes during the Jurassic, were totally transformed. It is in the Cretaceous that we first see evidence of the long-snouted spinosaurs, the massive carcharodontosaurs, the fleet-footed, talon-bearing raptors, the short-faced, four-fingered abelisaurs, the ostrich-like ornithomimids, the strange, bird-like oviraptors and ultimately, the nightmarish tyrannosaurs.

Deinonychus

The entire eastern coast of Laramidia (the western half of North America) was dotted with forested flood plains etched with rivers and streams. This type of environment resulted in sediment being carried downstream and collecting in low-lying areas, the perfect conditions for fossilization. Not surprisingly, we've uncovered a number of rich, dinosaur-bearing formations in this area of North America, including one that spreads across present-day Montana, Wyoming, Colorado and Utah: the Cloverly Formation. It was there that *Deinonychus*, one of the most important dinosaurs ever discovered, was found.

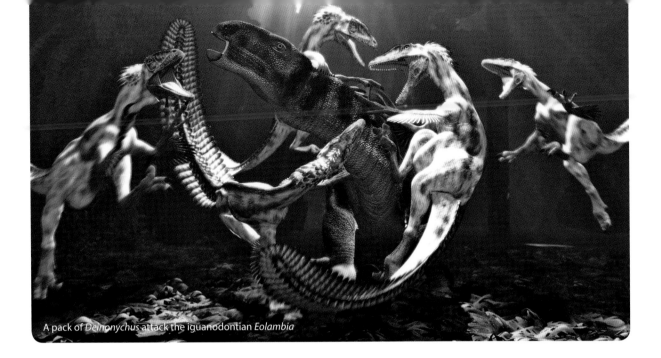

A pack of *Deinonychus* attack the iguanodontian *Eolambia*

DEINONYCHUS

Deinonychus is famous and important for a number of reasons. First, it was the basis for the *Velociraptors* seen in the *Jurassic Park* movies, although that depiction took quite a few liberties with the facts and made it about twice the size it really was (and about three times the size of actual *Velociraptors*). More importantly, *Deinonychus* is the animal that prompted a rethinking of the relationship between dinosaurs and birds, inspiring the Dinosaur Renaissance of the 1970s. The first skeleton of *Deinonychus* was discovered in 1931 by Barnum Brown, but these were partial remains and were largely ignored. Some thirty years later, paleontologist John Ostrom would find additional *Deinonychus* skeletons. In 1969 he published his description of an animal that was active and bird-like. Ostrom's description of a warm-blooded dinosaur with many bird-like traits and behaviors was revolutionary, and it opened the door for Robert Bakker (who was Ostrom's student) to publish a paper on warm-bloodedness in dinosaurs, and thereafter, *The Dinosaur Heresies*, the work that forever changed the way dinosaurs are viewed.

THE HUNTER AND THE HUNTED

There were a number of medium- and large-sized herbivores across Laramidia, including a number of ornithopods. *Eolambia* was an iguanodont that shows some features of the earliest hadrosaurs. At around 30 feet long, it was a big animal and it may have lived a fairly solitary lifestyle. If *Deinonychus* was a pack hunter, as suspected, *Eolambia* would have made easy prey.

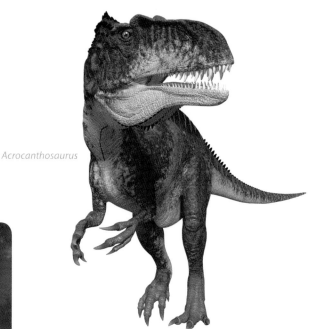

Acrocanthosaurus

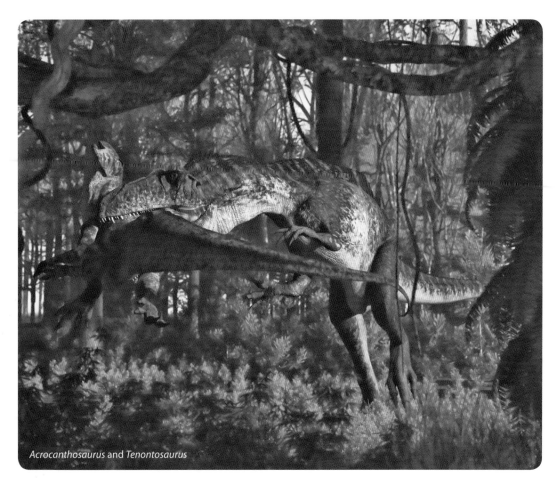

Acrocanthosaurus and *Tenontosaurus*

OTHER HUNTERS OF THE CLOVERLY FORMATION

But the moderately sized *Deinonychus* wasn't the only predator in the area. There were giants roaming the forests, too. At 40 feet long, *Acrocanthosaurus* was almost as big as a *T. rex* and carried a short sail on its back. *Acrocanthosaurus* was a powerful hunter that would have tackled ornithopods such as *Eolambia* or *Tenontosaurus*. It belonged to a group known as carcharodontosaurids, a new line of predators that likely evolved from the allosaurs of the Jurassic.

TENONTOSAURUS

Tenontosaurus is one of the most common herbivores from the Early Cretaceous. A distinguishing feature is its extremely long and broad tail. Interestingly, *Tenontosaurus* remains are almost always found along with teeth from *Deinonychus*, indicating that there was a strong predator-prey relationship between the two, and that *Deinonychus* was the primary predator of *Tenontosaurus*, though it was also likely preyed upon by *Acrocanthosaurus*.

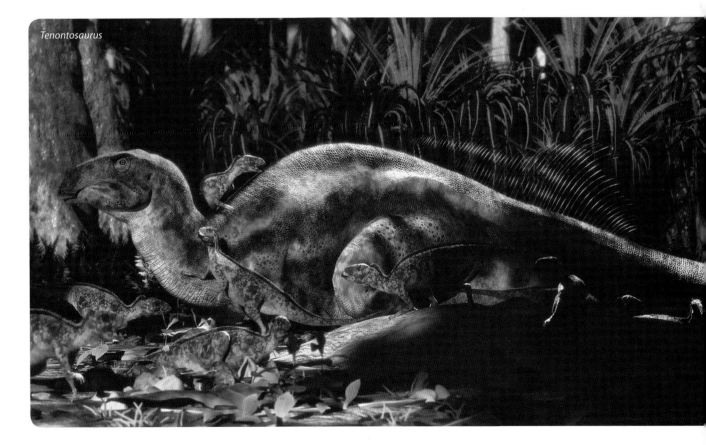

Tenontosaurus

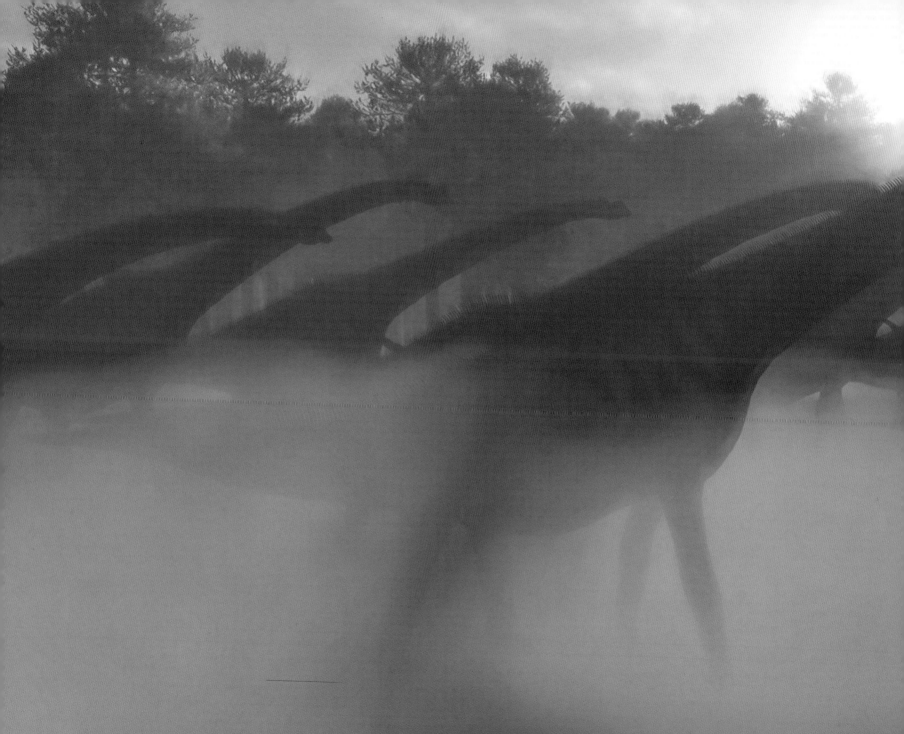

A herd of *Sauroposeidon* stroll through morning fog in early Cretaceous Oklahoma

SAUROPOSEIDON

An animal as big as *Acrocanthosaurus* may also have attempted to attack some sauropods, though likely only very young, old, or infirm individuals. *Sauroposeidon* is one of the latest and largest brachiosaurs discovered. Although only a few bones have been found, they're enough to show us this enormous animal would have topped out at 59 feet tall, high enough to look into a six-story building and making it the tallest dinosaur on record.

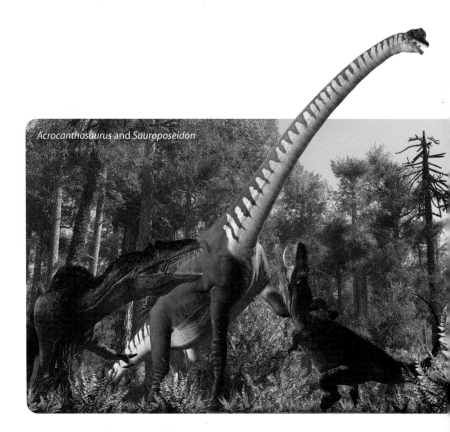

Acrocanthosaurus and *Sauroposeidon*

EARLY RELATIVES OF *TRICERATOPS*

All across North America and Asia we've found evidence of light-footed little dinosaurs with modestly sized neck shields. Called the neoceratopsia, these dinosaurs were the forerunners of the later ceratopsians such as the famous *Triceratops*. *Aquilops* is a small, recently discovered example that would have scampered beneath the feet of *Sauroposeidon* and *Tenontosaurus*, and probably served as easy prey for *Deinonychus*. At just three feet long, it may have been too small for *Acrocanthosaurus* to bother chasing. At this point in dinosaur evolution, the neck shields were little more than a broadening of the back of the skull, which may have served as anchors for the muscles of these animals' powerful, plant-cropping jaws. We only have one example of *Aquilops*, so we're not sure if the spur at the tip of its beak is a pathology (something resulting from illness or injury), or if it's an actual feature of the animal. Whatever the case may be, *Aquilops* is important, as it's the earliest known member of the horned dinosaur lineage from North America.

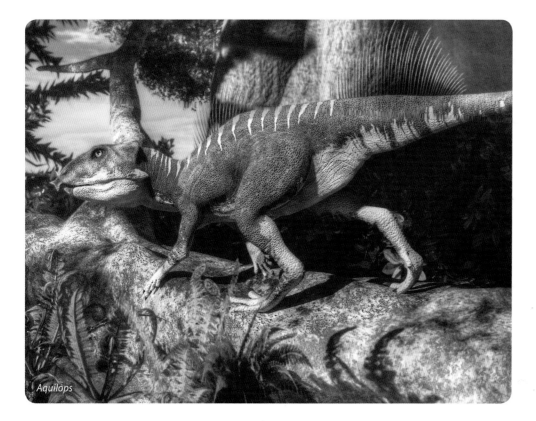

Aquilops

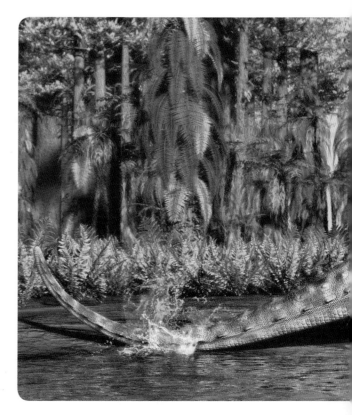

THE TANKS OF THE DINOSAUR WORLD

Nodosaurs such as *Sauropelta* were striking in their adornment and were covered in a veritable armory of ossified plates and spikes. Nodosaurs are the group of ankylosaurs that lack the familiar tail club. Their heads were also narrower than the true ankylosaurs, and it's assumed this indicates they adopted a more selective feeding strategy. *Sauropelta* was heavily armored, with large spikes on its neck, shoulders and flanks, and a pavement of bony osteoderms across its back. The spikes were undoubtedly a defensive weapon against predators such as *Acrocanthosaurus*, but they may have also played a role in intra-species battles for dominance or mates, with two animals locking their shoulder spikes together in a shoving match. All of the ankylosaurs were incredibly wide-bodied, heavy and low-slung animals, making them difficult prey for any but the very largest of predators.

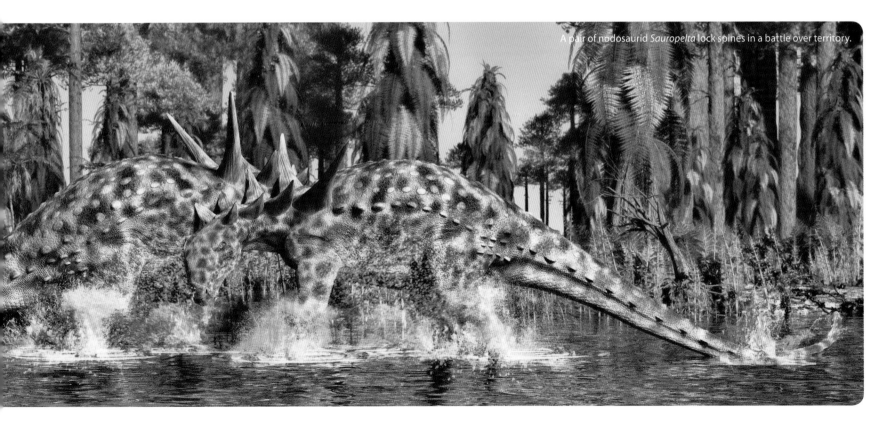

A pair of nodosaurid *Sauropelta* lock spines in a battle over territory.

EUROPE IN THE EARLY CRETACEOUS

During the Early Cretaceous, the European Archipelago was just off the eastern coast of North America. The shallow seas surrounding the islands allowed for some exchange of animals, but it also created areas of isolation that created new ecological niches. As a result, some of the dinosaurs from this area look quite similar to those from North America, while others adapted to look entirely different.

IGUANODON

When it comes to looks, *Iguanodon* isn't the most exciting animal. It doesn't have horns or spikes or a tall sail. But it is an important dinosaur for a couple of reasons. Formally named in 1825 by Gideon Mantell, it was just the second dinosaur described (after *Megalosaurus*, page 37). *Iguanodon* was also one of the three dinosaurs that Sir Richard Owen referenced in his original description of the Dinosauria. Finally, *Iguanodon* gives its name to a larger group of dinosaurs, the iguanodontia, which includes a number of closely related animals, such as *Mantellisaurus* and *Ouranosaurus*, but also includes the later and more derived duck-billed hadrosaurs.

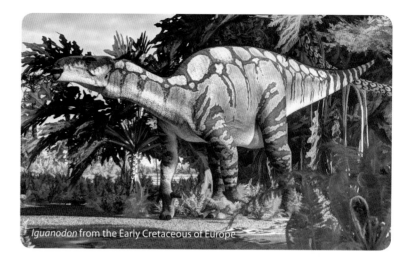

Iguanodon from the Early Cretaceous of Europe

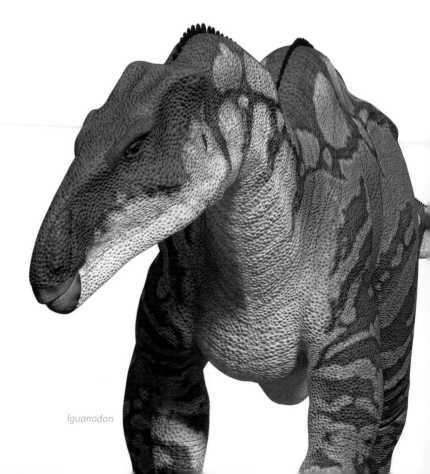

Iguanodon

THE WESSEX FORMATION

The Wessex Formation is located on the southern coast of England, and it has yielded numerous dinosaur remains, giving us a comprehensive view of the local ecosystem. The area supported a number of herbivores, including *Mantellisaurus*, an iguanodont closely related to *Iguanodon*, and the small ornithischian *Hypsilophodon*. The nodosaurid *Polacanthus* was also present and was a low-grazing herbivore, feeding on ferns and ground cover.

SOME NAMING TROUBLES

A little smaller than *Iguanodon*, *Mantellisaurus* is an iguanodont and its history is a little confusing. Because dinosaur remains are often scrappy or incomplete, it's not always easy to know whether you're looking at a member of the same species, or a different genus altogether. Over the years, the animal we now call *Mantellisaurus* has been labeled *Iguanodon* and *Dollodon*.

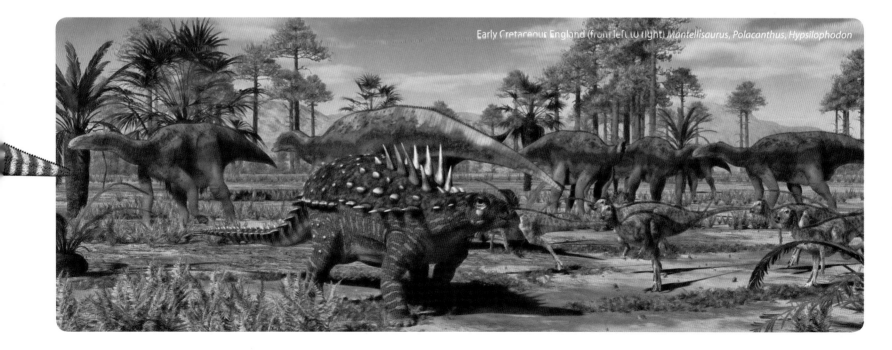

Early Cretaceous England (from left to right) *Mantellisaurus, Polacanthus, Hypsilophodon*

PREDATORS IN WESSEX

Wherever there are herbivores, there are predators to feed on them. At 25 feet long, *Neovenator* was one of the largest carnivores of its time and place, and it was a likely predator of *Mantellisaurus*. Despite the ability to study relatively complete remains, scientists have had a tough time determining just which line of theropods *Neovenator* belongs to. It was originally classified as a megalosaur, then later as a carcharodontosaur. Others have placed it as a megaraptor or an allosauroid. *Neovenator* shows characteristics of many established theropod groups, so its exact classification is a challenge.

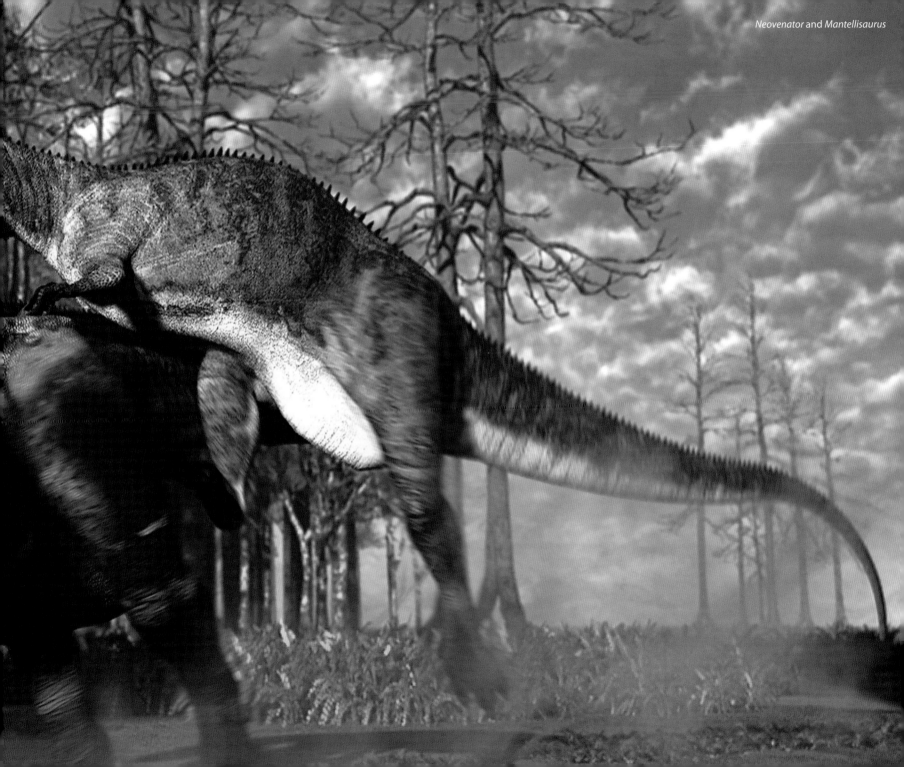

GREAT BRITAIN'S HEAVY CLAW

Early Cretaceous England also had one of the most bizarre meat-eating dinosaurs ever discovered. The remains of *Baryonyx* were discovered in England in 1983. The name *Baryonyx* means *"heavy claw,"* a reference to the massive, 12-inch-long claw on the first finger of this dinosaur's hand. Reaching 25 feet long, *Baryonyx* was a spinosaur, a member of the family of theropods that includes *Spinosaurus*. *Baryonyx* featured a long, narrow skull that was lined with finely serrated teeth. Prior to the discovery of *Baryonyx*, the skulls of spinosaurs were not well known, and they were assumed to be similar to those of other theropods. *Baryonyx* introduced scientists to the long, crocodile-like jaws we now know were common in spinosaurs. Fish scales found in the stomach region of its skeleton indicate that *Baryonyx* hunted either in the water or near it, and that it fed on fish, as well as small ornithopods. Remains attributed to *Baryonyx* have also been found in Spain.

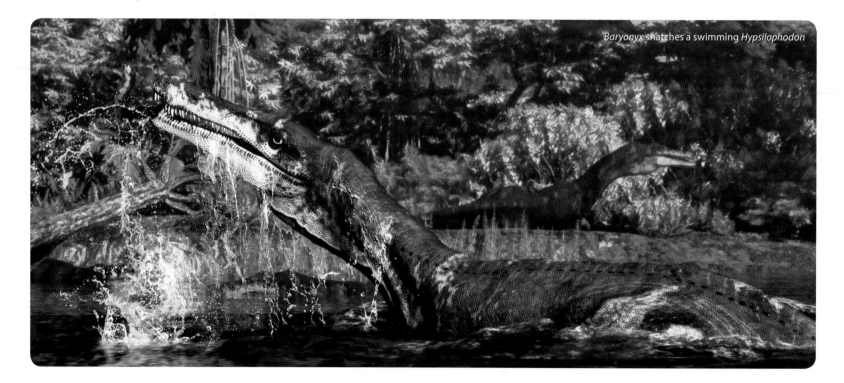

Baryonyx snatches a swimming *Hypsilophodon*

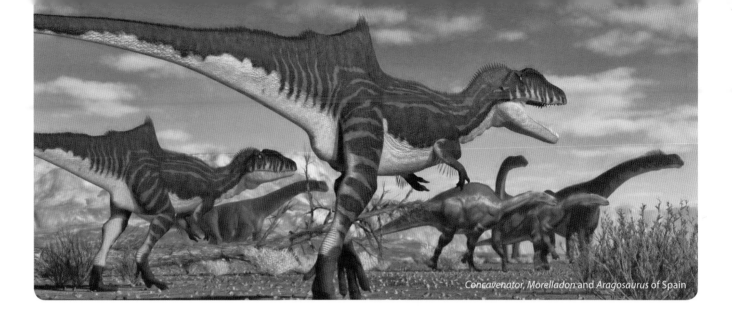
Concavenator, Morelladon and *Aragosaurus* of Spain

DINOSAURS IN SPAIN AND PORTUGAL

Spain and Portugal (known as Iberia when combined) have yielded remarkable dinosaur fossils for quite some time. During the Barremian Stage of the Early Cretaceous (129–125 million years ago), Iberia was a large island off the east coast of North America. Some of the dinosaurs that evolved there were quite unique.

At 20 feet long, *Concavenator* was a bit smaller than *Baryonyx* and was a member of the carcharodontosaurs, a group then flourishing on the southern continents. *Concavenator* is distinguished by a strange pointed fin or hump on its back, which may have been used for display or possibly as a form of thermal regulation. *Concavenator* was also found to have bumps along its lower arm bone (the ulna) that correspond with similar bumps (quill knobs) that are found on bird wings. Quill knobs are anchor points for wing feathers, so their presence on *Concavenator* implies that it may have had some form of protofeather covering, though not all scientists agree with this interpretation of the bumps.

The iguanodont *Morelladon* is a fairly new discovery, described in 2015. *Morelladon* was a medium-sized iguanodont about 20 feet long, and it too had a tall sail on its back. The sauropod *Aragosaurus* reached lengths of 60 feet and was similar in appearance to *Camarasaurus* from the earlier Jurassic period of North America. Both of these animals may have been potential prey for *Concavenator*.

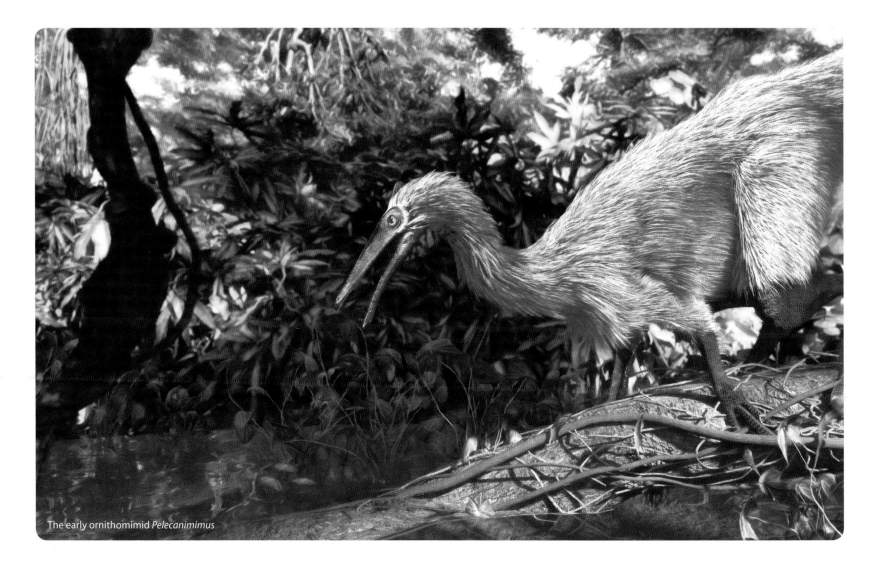

The early ornithomimid *Pelecanimimus*

AN EARLY OSTRICH MIMIC

A primitive ornithomimid, *Pelecanimimus* was another inhabitant of Early Cretaceous Spain. The ornithomimids were the ostrich-like dinosaurs made famous by *Gallimimus* in the movie *Jurassic Park*. *Pelecanimimus* was much smaller—six feet long—and had a small, pointed soft-tissue crest at the back of its head. It also had a throat pouch, like that of a pelican, inspiring its name. Unlike most other ornithomimids, *Pelecanimimus* also had teeth—and a lot of them. Its 220 small, pointed teeth are the most numerous of any theropod dinosaur.

MEANWHILE, IN AFRICA

In the early Cretaceous in Africa, a predator very similar to *Baryonyx* existed. *Suchomimus* is so closely related to *Baryonyx* that some scientists consider them the same animal, and they probably had a similar lifestyle. *Suchomimus* had taller back vertebrae than *Baryonyx*, and as a result, it had a hump or a low sail on its back, but other than that, they looked much alike.

Remains of *Suchomimus* have been found at a location in northern Africa called the Elrhaz Formation. The Elrhaz is an interesting site because it supported an unusually high number of large carnivores, all in one location. In addition to *Baryonyx*, there was the enormous *Carcharodontosaurus*, the long-legged *Deltadromeus*, and *Spinosaurus*, an animal that was probably the most massive predator in history.

While we don't know for certain that *Suchomimus* actually spent time swimming and pursuing its prey in water, there is evidence that at least some of the spinosaurs had developed aquatic habits.

Carcharodontosaurus

Suchomimus fishing

THE MIGHTY *SPINOSAURUS*

Over the years, we thought we'd developed a pretty good picture of what *Spinosaurus* looked like. Then, in 2014, a discovery was announced that blew all that out of the water. Or, more appropriately, blew it *into* the water. A much more complete skeleton was found, and it showed that *Spinosaurus's* back legs and hips were much, much smaller than those of other theropods. In fact, its back legs were too short for it to have walked effectively on land. *Spinosaurus*, it seems, was aquatic!

In and of itself, this isn't a crazy theory. Throughout the history of life on Earth there have been several examples where terrestrial life has returned to the sea to take advantage of the resources available there. Whales and dolphins are examples of mammals that returned to the water, and plesiosaurs, mosasaurs and ichthyosaurs are reptiles that did the same. But remember, none of those are dinosaurs. *Spinosaurus* is the first and, so far, the *only* example of a dinosaur that developed an aquatic lifestyle.

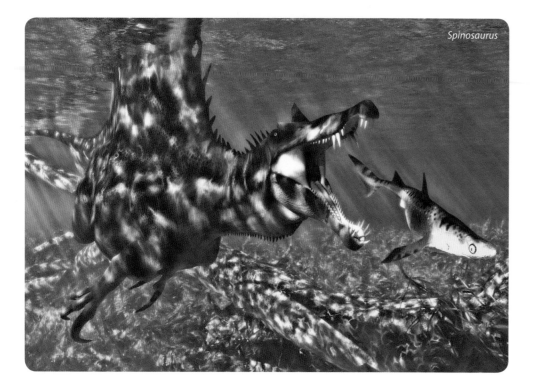

Spinosaurus

ANOTHER MASSIVE PREDATOR

Carcharodontosaurus came close to rivaling *Spinosaurus* in size, possibly reaching 44 feet in length and weighing 12 tons. *Carcharodontosaurus* had a more terrestrial lifestyle than *Spinosaurus*, so the two probably didn't compete for food, but that wouldn't have been the case with *Deltadromeus*, a 25-foot-long predator that had extremely long legs and was built for speed. It's not hard to imagine these two predators facing off over the sauropods and ornithopods they both preyed upon in northern Africa.

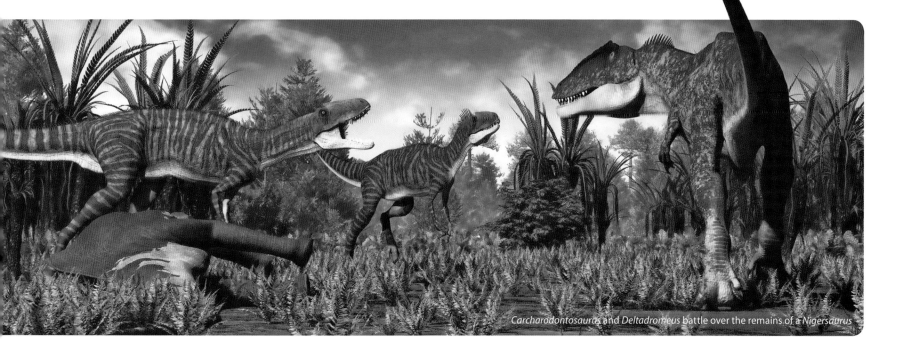

Carcharodontosaurus and *Deltadromeus* battle over the remains of a *Nigersaurus*

ABUNDANT PREDATORS AND PREY

It's highly unusual to find this many predators living in one area at the same time. Usually there aren't enough prey animals to support this many large carnivores. But there appears to have been ample prey in northern Africa during the Early Cretaceous.

At 33 feet long, *Nigersaurus* was small for a sauropod. Its squared-off skull was packed with more than 500 thin, needle-like teeth, all located at the very front of the jaws. When we find dinosaurs with elaborate dental structures like those seen in *Nigersaurus*, we call them dental batteries. It's assumed that dental batteries evolved to help dinosaurs cope with selective feeding strategies. In the case of *Nigersaurus*, its thin, needle-like teeth would have been perfect for grazing on low-growing ground cover.[10] In fact, *Nigersaurus* has been called "the Cretaceous Lawn Mower" because of its unique dentition. Different types of dental batteries developed in the ceratopsians and the hadrosaurs to help them cope with different feeding strategies.

Lurdusaurus was a massive, 30-foot-long iguanodont with a heavy, low-slung body that was very different from the iguanodonts in Europe. Despite being slightly shorter in length than *Nigersaurus*, *Lurdusaurus* may have been two tons heavier.

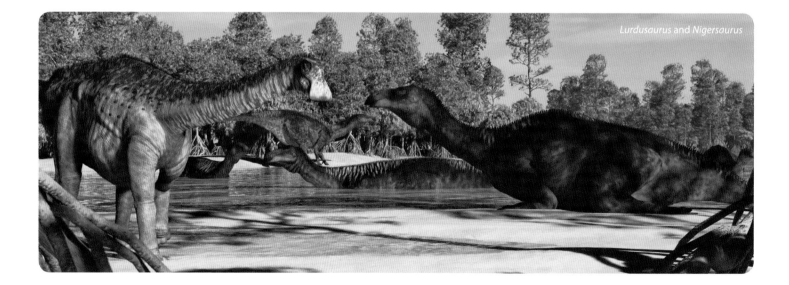

Lurdusaurus and *Nigersaurus*

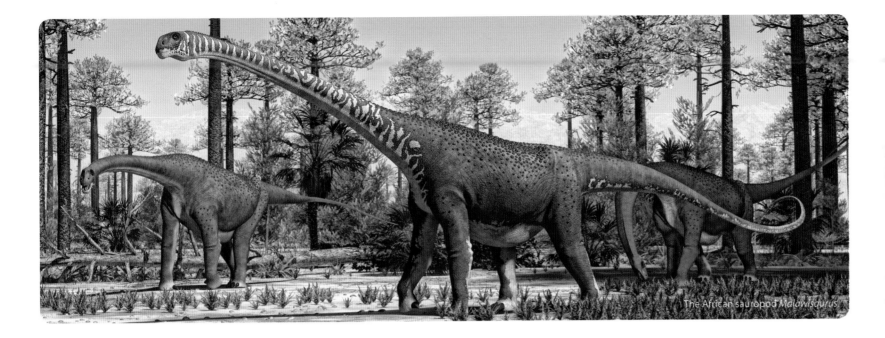

The African sauropod *Malawisaurus*

Malawisaurus was another sauropod that lived in Africa at the same time as *Nigersaurus*, but its remains were found in Malawi, so it seems unlikely it crossed paths with any of the Elrhaz predators (see page 95). At around 52 feet long, *Malawisaurus* was another fairly small sauropod. One of the most exciting things about *Malawisaurus* is the discovery of its skull. Sauropod skulls are fairly small and weak, made of thin bones with lots of openings in them. As a result, they rarely fossilize with the rest of the skeleton. Any time a sauropod skull is found, it greatly increases our understanding of these magnificent animals and their lifestyles.

OTHER SPINOSAURS AROUND THE WORLD

During the Early Cretaceous, the strange spinosaurs roamed across a wide range. The amusingly named *Irritator* was found in South America. It earned its name because illegal fossil dealers had faked parts of the fossil. When it eventually made its way into the hands of scientists, it proved incredibly difficult for researchers to figure out what parts were real and what parts were faked by the poachers. It was only after they had successfully completed that work that the scientists could analyze and announce their find.

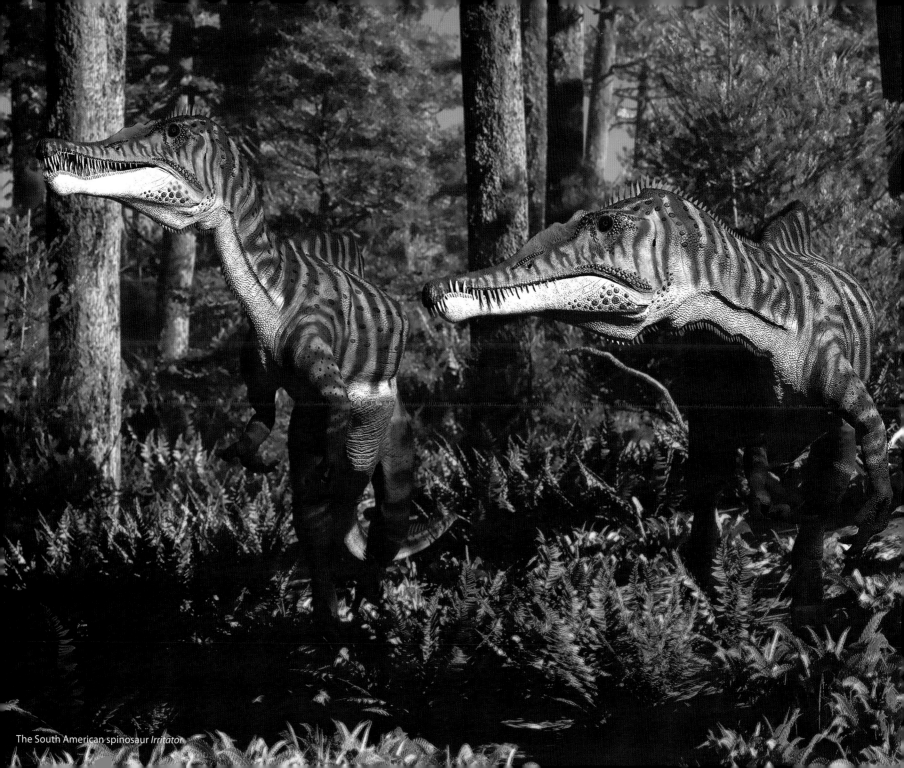

The South American spinosaur *Irritator*

Another piscivorous (fish-eating) spinosaur lived in what is now Laos in southeast Asia. *Ichthyovenator* means "fish hunter" and its tall sail had a strange notch at the center that split the sail in two.

Though they were a very wide-ranging group of animals, the spinosaurs were remarkably short-lived. Based on the fossil evidence we have so far, they had gone extinct by the Santonian Stage of the Late Cretaceous, about 86 million years ago.

Ichthyovenator

Ichthyovenator

A FOSSIL WONDERLAND

A little ways north of where *Ichthyovenator* was hunting, fossils were discovered at what would become one of the most important dinosaur-bearing rock formations ever found.

The Yixian and Jiufotang Formations in northeastern Liaoning Province of China are home to the Jehol Biota—an accumulation of exquisitely preserved fossils that record an entire ecosystem over a period of 13 million years. The sites contain the fossils of many small birds, early tyrannosaurs, the primitive horned dinosaur *Psittacosaurus*, larger ornithopods, sauropods, pterosaurs and mammals. The area primarily consisted of lake deposits that were frequented by volcanic ash fall, enabling extremely fine preservation to occur. But most importantly, the formations have also provided a record of early feathered dinosaurs, providing the first incontrovertible evidence that at least some dinosaurs bore feathered coverings, and helping to establish the evolutionary relationship between dinosaurs and birds.

One dinosaur from the Jehol Biota that had feathers and wings was *Microraptor*. And not only did it have wings, it had *four* of them—one on each arm and also one on each leg! This seems to have been common among the dinosaurs that were closely related to birds; several others have been found with this four-winged arrangement. *Microraptor* was capable of some degree of powered flight in addition to gliding and being able to run across the forest floor.

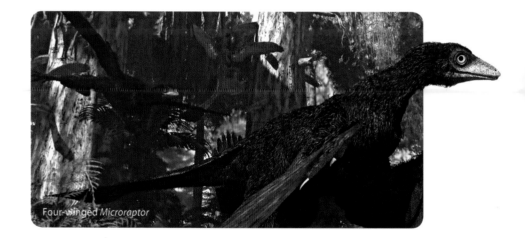

Four-winged *Microraptor*

In 2012 a study was done to analyze microscopic fossilized cells in *Microraptor's* feather. These cells, called melanosomes, showed that *Microraptor* was likely all black in color, much like a modern crow.[11, 12]

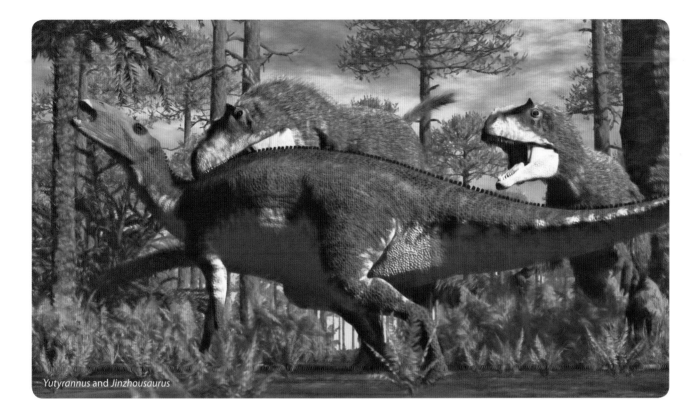

Yutyrannus and Jinzhousaurus

A LARGE TYRANNOSAUR, WITH FEATHERS

Small dinosaurs weren't the only ones with feathers in the Jehol Biota. *Yutyrannus* is the largest dinosaur found so far with a protofeather coating. Protofeathers were different from the feathers on modern birds. They were simple, downy structures that would have given the dinosaur an almost hairy appearance. Evidence of protofeathers has been found on fossils from a lot of small dinosaurs from the Jehol Biota. But *Yutyrannus* was big. Twenty feet long and an early tyrannosaur, *Yutyrannus* still retained three fingers on each hand, but the arrangement of its skull bones and the shape of its teeth identify it positively as a tyrannosaur. *Yutyrannus* had long protofeathers covering nearly all of its body and a pair of small crests along the top of its snout.

Jinzhousaurus was a primitive hadrosaur that could reach lengths greater than 20 feet and is the largest ornithopod found so far within the Jehol Biota.

DINOS DOWN UNDER

Australian dinosaurs haven't gotten as much attention as those from other parts of the world, but that's beginning to change. *Australovenator* was a graceful, vicious hunter that was 20 feet long. It was a member of the megaraptor family of theropods and distinguished by its enormous thumb claws; megaraptors shouldn't be confused with the raptors and deinonychosaurs, which also had enormous claws, but on their feet. The remains of *Australovenator* were found at the same place as the titanosaur *Diamantinasaurus*, which could reach lengths of up to 50 feet. The *Diamantinasaurus* skeleton was nicknamed "Matilda" in honor of the Australian folk song "Waltzing Matilda," while *Australovenator* has been nicknamed "Banjo" after the composer of the song, Banjo Paterson.

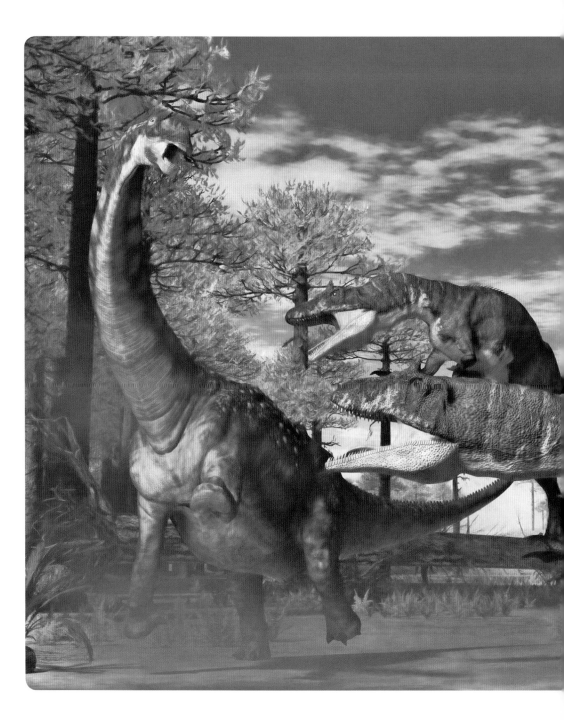

The Australian dinosaurs *Diamantinasaurus* and *Australovenator*

AUSTRALIA'S *IGUANODON*

Australia has been a challenging land for paleontologists, and she has not given up her fossils easily. One animal that has emerged from Australia's past is the 26-foot-long ornithopod *Muttaburrasaurus*. Discovered in 1963 near the town of Muttaburra, this iguanodont is distinguished by an enlarged, hollow structure on the top of its nose called a bulla nasalis. Scientists think this may have been used for display or to produce some sort of sound.

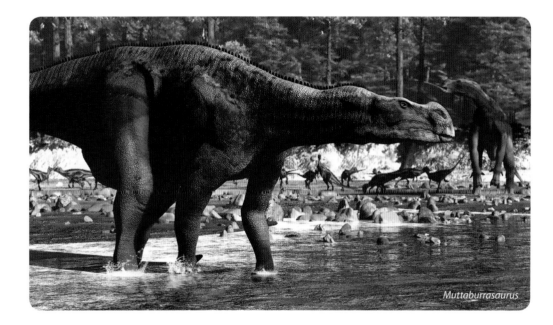

Muttaburrasaurus

LATE CRETACEOUS DINOSAURS

The Late Cretaceous began about 100 million years ago. At this time, narrow embryonic seas separated most of the continents, and this allowed life to further diversify and evolve.

At this point, the fauna of Gondwana was strikingly different from that of North America, Europe and Asia. The northern continents featured the tyrannosaurs, the ceratopsians and the hadrosaurs, while the southern continents were dominated by the carcharodontosaurs, the abelisaurs and the titanosaurs.

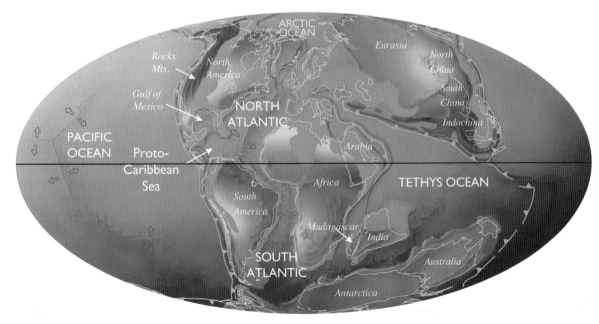

World map showing the position of continents around the start of the Late Cretaceous (paleogeographic map by C.R. Scotese)

Giganotosaurus

GIGANOTOSAURUS

The South American carcharodontosaur *Giganotosaurus* is closely related to its African relative *Carcharodontosaurus* but it is a little larger, reaching 43 feet in length and weighing in at more than 20,000 pounds. It wasn't the only massive predator from Gondwana; South America's carcharodontosaurs all reached massive sizes and had huge skulls lined with blade-like teeth that were perfect for slashing and tearing huge chunks of flesh from their victims. Their powerful arms ended in three-fingered hands bearing long, sharp claws. Living alongside this massive killer was the small, birdlike dromaeosaur *Buitreraptor*, which had a long, narrow snout and hunted small lizards and mammals.

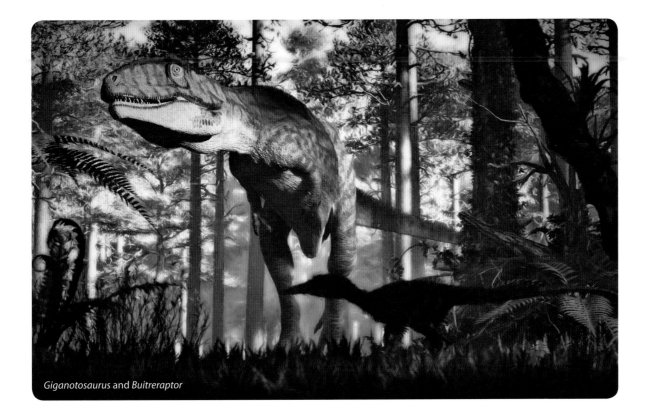

Giganotosaurus and *Buitreraptor*

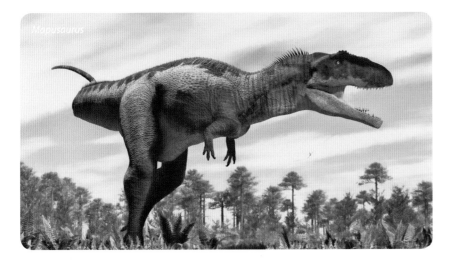

Mapusaurus

MAPUSAURUS

Mapusaurus was another giant carcharodontosaur from South America. Slightly smaller than *Giganotosaurus*, *Mapusaurus* lived a few million years later. The remains of *Mapusaurus* were found in a bone bed containing the remains of at least seven individuals. Some have interpreted this as an indicator of pack behavior, while others think the animals were brought together by some natural disaster, like a flood or a drought.

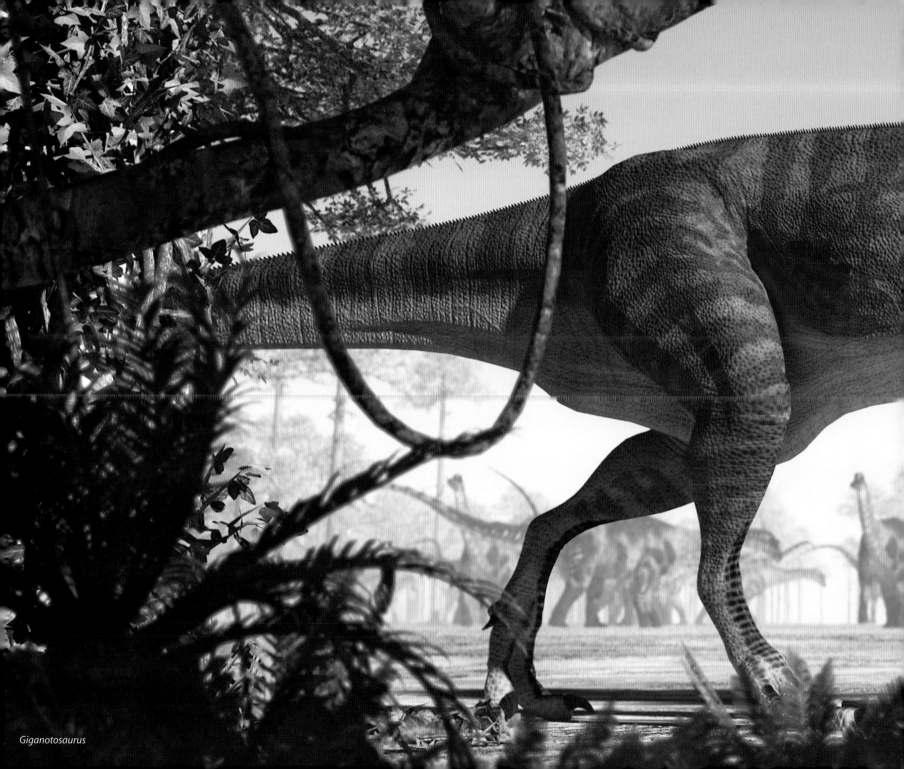

Giganotosaurus

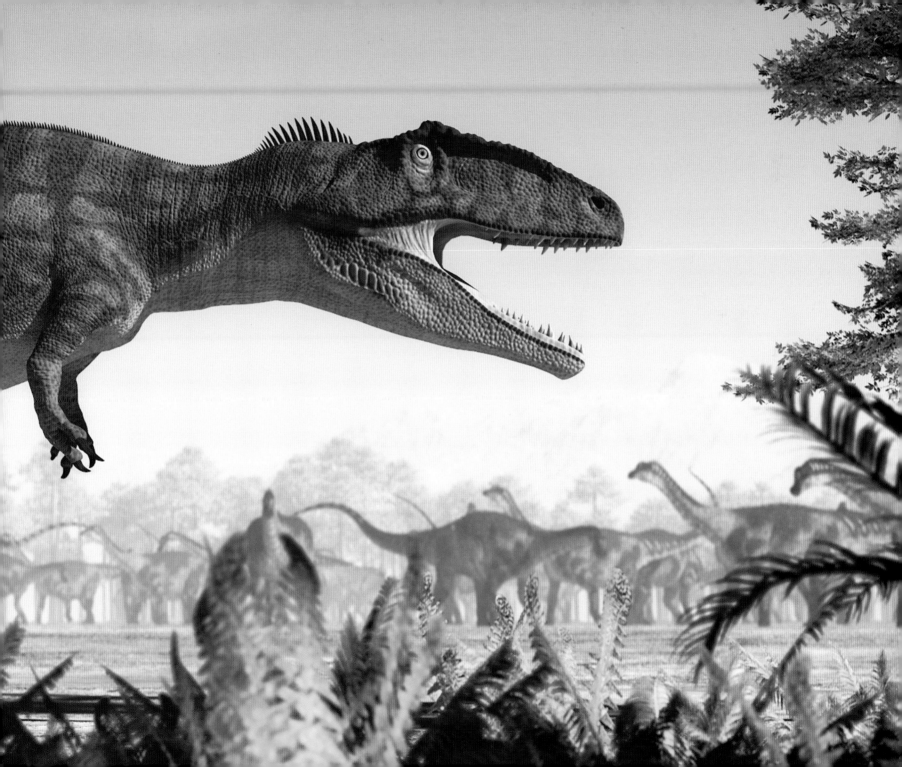

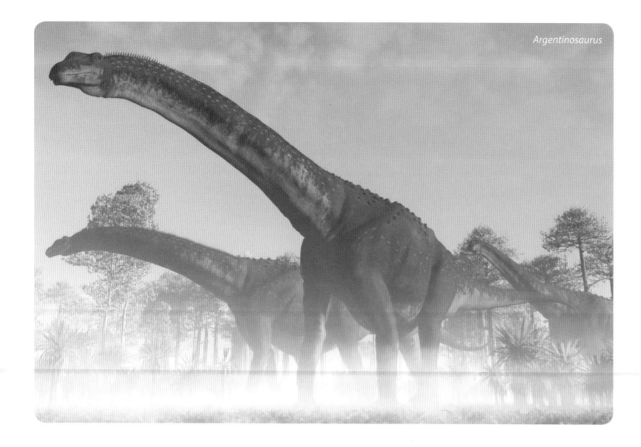

Argentinosaurus

ARGENTINOSAURUS: PERHAPS THE BIGGEST PREY POSSIBLE

Mapusaurus may have been the only predator large enough to prey on *Argentinosaurus*, one of the largest land animals ever found on Earth.

Argentinosaurus was one of the titanosaurs, the last surviving members of the sauropods, and a group that survived all the way to the end of the Cretaceous. Titanosaurs show a huge amount of variation in their size and in details of their anatomy. We know *Argentinosaurus* from only a few bones, some vertebrae, ribs, and, most notably, a thigh bone that measures nearly four feet long. Using these partial remains, we can compare them to other, more complete titanosaurs in order to estimate how big *Argentinosaurus* was. Over the years, different people have come up with different results using this method, but researchers seem to have settled on a length somewhere between 98 and 115 feet, and a weight between 80 and 90 tons.

ANOTHER GIANT TITANOSAUR

Argentinosaurus wasn't the only giant titanosaur. During the early Late Cretaceous, gigantic titanosaurs dominated Gondwana. Many species seem to have reached lengths in excess of 100 feet and weighed more than 80 tons (160,000 pounds). The titanosaurs differed from the earlier sauropods, as they had shorter tails and extremely wide bodies. Titanosaurs had such a wide stance that they can be identified from their trackways (footprints) alone. Another distinguishing feature of titanosaurs was the presence of body armor; it occurred in the form of bony scutes that covered their backs. We don't know if all had this armor; however, there are enough examples that have been found with armor to suggest that it was common.

Futalognkosaurus was another gigantic titanosaur that lived in South America a little later than *Argentinosaurus*, but it was still in the same enormous size class.

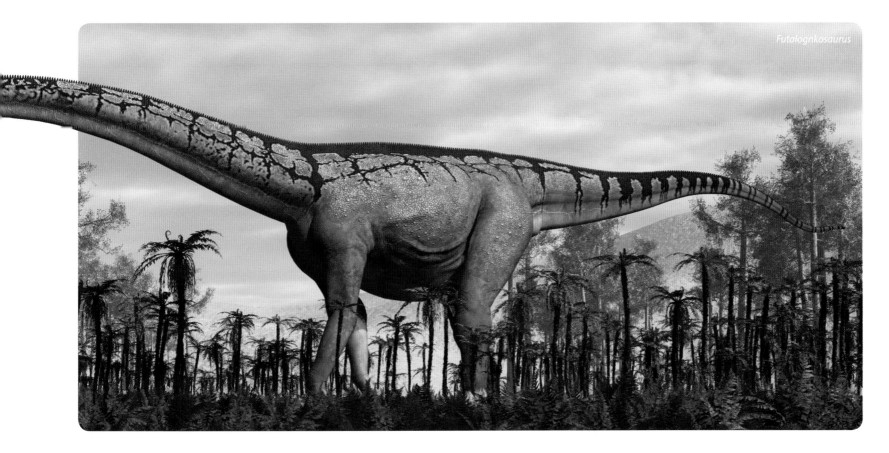

Futalognkosaurus

THE CARNIVOROUS BULL

Like the spinosaurs and the carcharodontosaurs, the abelisaurs first appear in the Early Cretaceous, and they were the other major group of theropods that dominated Gondwana during this time. Smaller than the carcharodontosaurs, they rarely exceeded 30 feet in length and had shorter, boxier skulls. They also possessed some extremely primitive features, such as four-fingered hands. Like the distantly related tyrannosaurs, the abelisaurs had almost comically short arms, but unlike those of tyrannosaurs, abelisaur arms were not only small but weak and nearly useless (tyrannosaur arms, in comparison, were incredibly strong). In some abelisaur species the lower arms seem to have atrophied completely and become mere stumps.

Carnotaurus is a South American abelisaur, and it has gained some notoriety. At 20 feet long, *Carnotaurus* wasn't the biggest abelisaur, but it was quite fearsome looking, thanks to the long, sideways horns above its eyes. Its horns also inspired its name, which means "meat-eating bull."

Carnotaurus is known from very complete remains, including some skin impressions. Generally speaking, the skulls of abelisaurs were weak, so they probably went after smaller prey, like the small ornithischians that populated the area. This smaller prey would have also explained why the abelisaurs remained relatively small, especially compared to the carcharodontosaurs. *Carnotaurus* lived during the Maastrichtian period at the end of the Cretaceous.

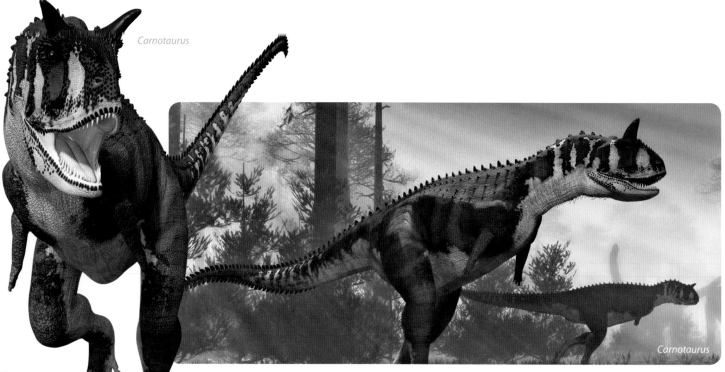

Carnotaurus

Carnotaurus

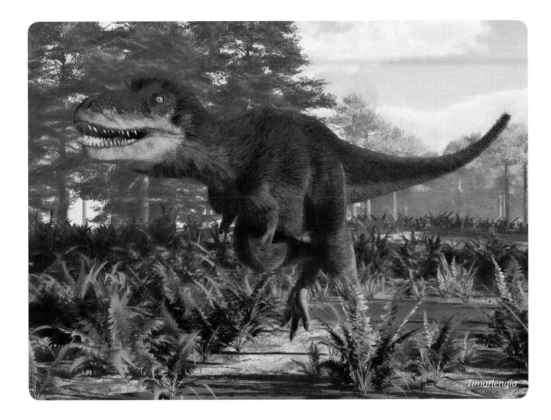

Timurlengia

TIMURLENGIA: ADVANCED TYRANNOSAURS TAKE SHAPE

For quite some time, scientists have been perplexed by how and when tyrannosaurs went from being the small, agile hunters like *Guanlong* (see page 46) to becoming the gigantic predators that dominated the end of the Cretaceous. The discovery of *Timurlengia* helped answer some of those questions, filling in a gap of 20 million years in the tyrannosaur fossil record.[13]

At 13 feet long, *Timurlengia* was mid-sized, falling in between the small tyrannosaurs of the Jurassic and the 30–40-foot-long kings that would come later. Its fossils have provided scientists with a wealth of information on how tyrannosaurs evolved. For instance, *Timurlengia's* brain case has evidence of the enhanced sensory capabilities (smell, vision, etc.) associated with the advanced tyrannosaurs, showing these traits developed before the tyrannosaurs got really big.

DINOSAURS IN MADAGASCAR

The island of Madagascar separated from the Indian landmass about 88 million years ago. As a result, the life forms on Madagascar evolved independently from those on other continents. Over the past 15–20 years, discoveries on the island have given us a look at the unique animals that evolved there during the Late Cretaceous.

At "just" 55 feet long, *Rapetosaurus* is a fairly small titanosaur, but it is remarkable for being the most complete titanosaur fossil found to date (including the skull!). Its discovery and the completeness of its remains have given us new insights into titanosaur physiology.

At the same location where *Rapetosaurus* was discovered, a new, unusual theropod was found as well. *Masiakasaurus* is part of an obscure line of predators called noasaurs, which are related to the abelisaurs. At 6½ feet long, *Masiakasaurus* wouldn't be particularly remarkable, if not for its unusual jaws and teeth. The lower jaw is procumbent, which means it curves down dramatically near the tip and its front teeth point forward. *Masiakasaurus's* upper jaw curves up a bit, but not nearly as dramatically as in the lower jaw. Unlike the true abelisaurs, its arms weren't short, and its hands had three fingers, instead of the four seen in abelisaurs. At this time, no one knows quite why *Masiakasaurus* developed these unique characteristics or whether it was to fulfill a specialized feeding strategy or to cope with some other unusual aspect of its environment.

Rahonavis was a small, bird-like deinonychosaur that lived in Madagascar. Despite appearing much later in the fossil record, *Rahonavis* was closely related to *Archaeopteryx*.

Around 20–23 feet long, *Majungasaurus* was a moderately-sized abelisaur, and it is known from several skeletons. *Majungasaurus* was unique because it had a short, spiked horn at the top of its head and particularly thick and bumpy bones around its snout, which may have supported some kind of fleshy or keratinous display structure.

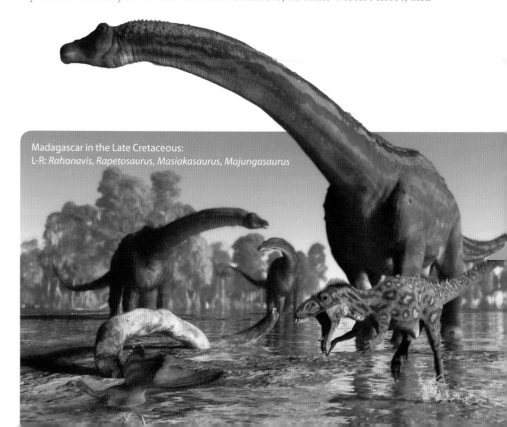

Madagascar in the Late Cretaceous:
L-R: *Rahonavis, Rapetosaurus, Masiakasaurus, Majungasaurus*

WOMEN IN PALEONTOLOGY

Rapetosaurus from Madagascar is notable for another reason. It was discovered and named by two women: Dr. Catherine Foster and Dr. Kristina Curry Rogers. Dinosaurs aren't just "a guy thing." Girls are into dinosaurs, too. Some of the top dinosaur scientists (paleontologists) in the world are women. In fact, one of the first fossil hunters, and one of the most important, was a woman.

Mary Anning explored the beaches and cliffs of her native England back in the early nineteenth century, and her discoveries were instrumental to our understanding of ancient life and inspired much of the subsequent fossil hunting that followed.

Teresa Maryanska is a Polish paleontologist who described a number of dinosaurs in the 1970s, including *Saichania*, *Homalocephale* and *Barsboldia*.

Sue Hendrickson discovered the largest *Tyrannosaurus rex* ever found, and it has been nicknamed "Sue" in her honor.

Dr. Mary Schweitzer is the paleontologist who discovered soft-tissue remains in a 65 million-year-old *Tyrannosaurus rex* leg bone.

Drs. Celina and Marina Suarez are twins who discovered a little meat-eating dinosaur and named it *Geminiraptor*.

And there are many, many more. Brilliant, enterprising women have been at the forefront of paleontological exploration and research from the start, and they've been active in all areas of the field, from using cutting-edge technologies and engaging in back-breaking excavation techniques to coming up with novel theories and explanations that help us increase our understanding of the lives of dinosaurs.

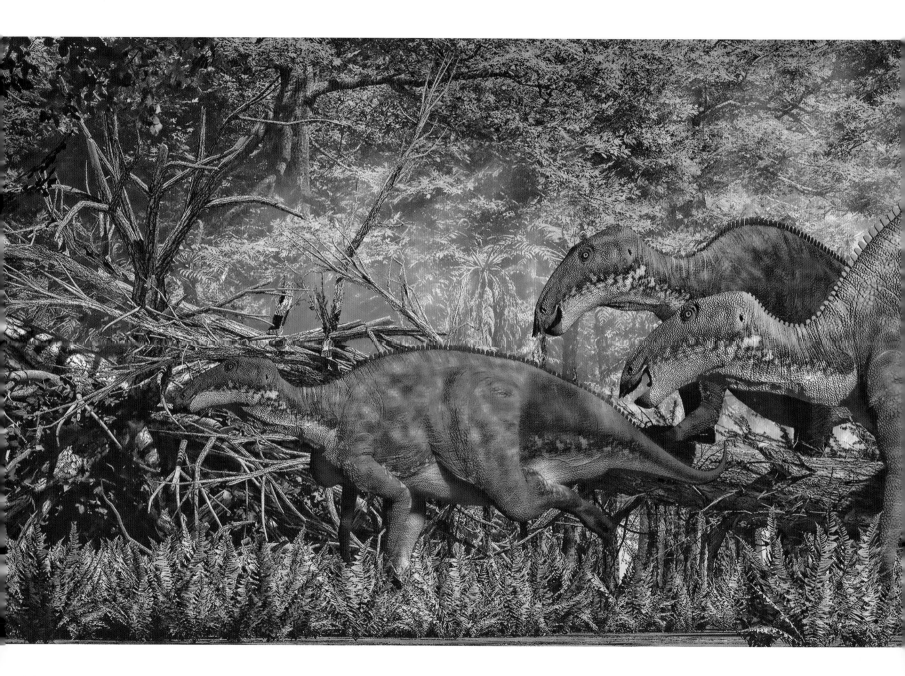

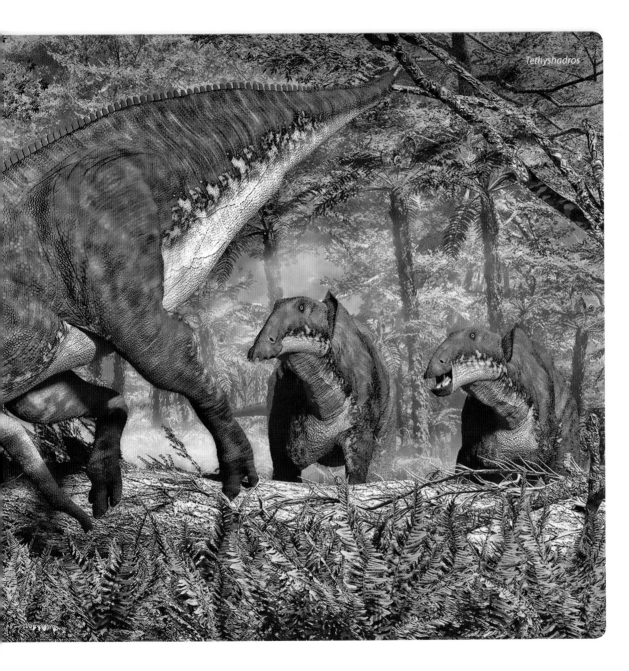

Tethyshadros

DINOS IN ITALY

In the Late Cretaceous, island dwarfism continued on the European Archipelago. *Tethyshadros* was a primitive hadrosaur that only reached 13 feet long and lived in what is now Italy. All hadrosaurs have beaks at the end of their snouts, but the beak of *Tethyshadros* is unique because it's extremely long and has an irregular, scalloped edge. It's also an important find because there aren't many dinosaurs known from Italy. Fragmentary remains of a large predator from the early Jurassic have been found; these have been informally dubbed *Saltriosaurus*. A much more complete find of the theropod *Scipionyx* dates to the early Cretaceous. The specimen of *Scipionyx* is a juvenile, and it is notable because it's one of the best-preserved dinosaurs ever discovered, with impressions of its soft tissues and even its internal organs.

THE LATE CRETACEOUS IN ASIA

The Late Cretaceous of Asia was home to some of the strangest products of dinosaur evolution that scientists have yet discovered. The evocatively named Flaming Cliffs of Mongolia are one of the most productive dinosaur sites in the world. Starting with the 1923 joint American-Mongolian expeditions under the direction of Roy Chapman Andrews, the fossils recovered from the area have sparked the public imagination and introduced the world to some of the most iconic dinosaurs.

Velociraptor is one of the most familiar dinosaur names, but most people have a false impression of the dinosaur's appearance. Unlike the depiction in popular media, *Velociraptor* was a rather small, turkey-sized animal. It did possess a huge (relatively) killing claw on the second toe of each foot. It was also smart, for a dinosaur, but nowhere near as smart as is depicted in the movies. One thing the movies did get right was that *Velociraptor* was a hunter. It undoubtedly preyed on small animals like lizards and early mammals, but it also hunted larger prey, like the ceratopsian *Protoceratops*.

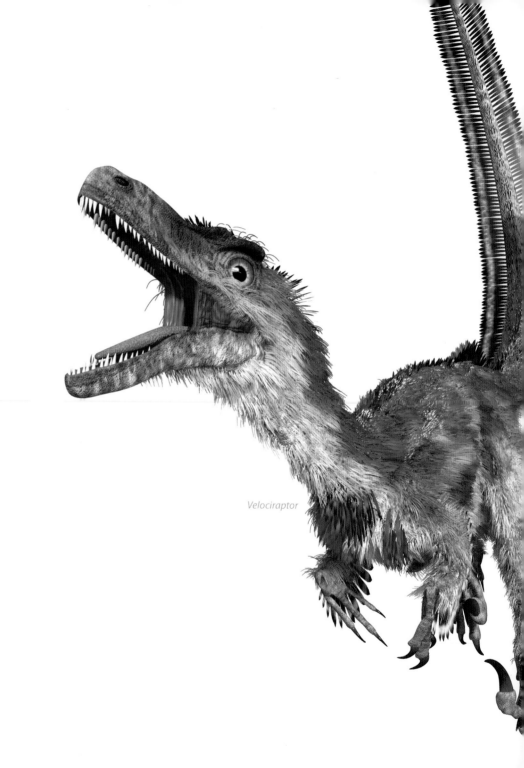

Velociraptor

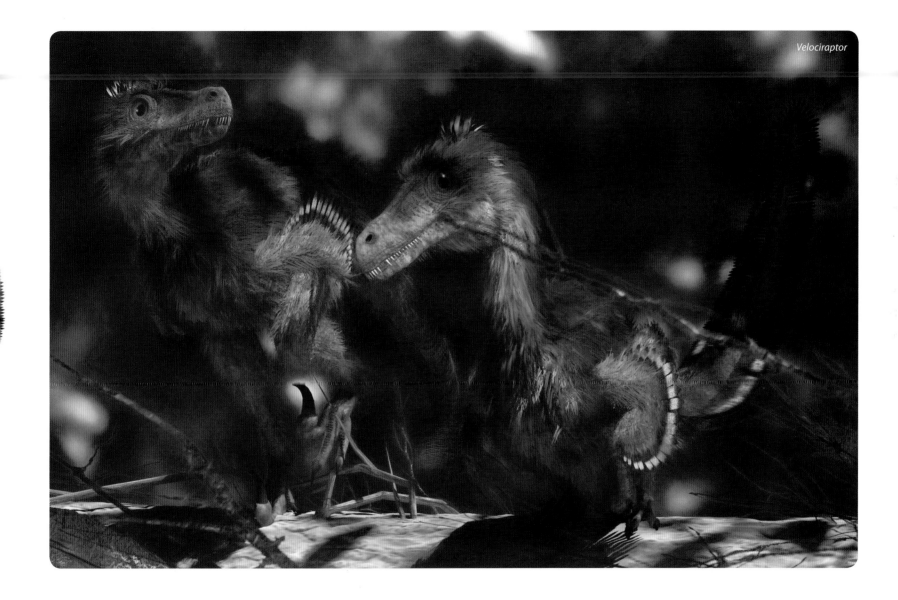

Pinacosaurus

HEAVY ARMOR

Pinacosaurus is one of the best known of all ankylosaurs. *Pinacosaurus's* tail was stiffened with rods, but flexible at the base, giving it a powerful swing and making it an impressive weapon against predators. A pavement of bony armor covered its entire back, making it virtually impenetrable. Bone beds have been found of several juvenile *Pinacosaurus* who all died pointing in the same direction. It seems that the animals were all on the move when a sandstorm came up and buried them, literally killing them in their tracks. Unlike their nodosaur cousins, true ankylosaurs have a tail club as well as a wide beak, evidence of a generalist feeding strategy. They likely were grazers, snapping up whatever bits of vegetation they came upon.

Pinacosaurus

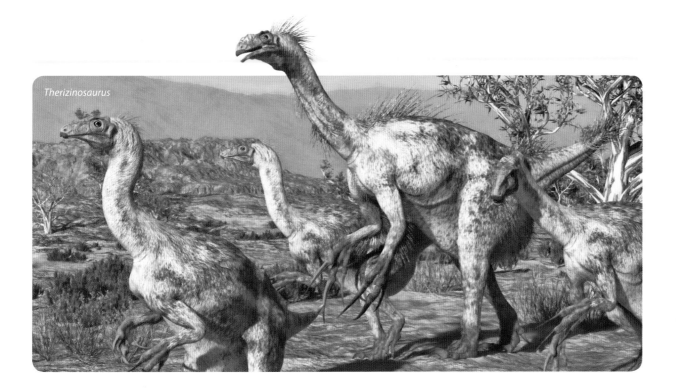

Therizinosaurus

MASSIVE CLAWS

The therizinosaurs represent one of the weirdest lineages in dinosaur evolution. Therizinosaurs were theropods, belonging to the line of bipedal, meat-eating dinosaurs that included *Tyrannosaurus*. But therizinosaurs were plant eaters. Instead of the curved, blade-like teeth of most theropods, therizinosaurs had small, leaf-shaped teeth well-suited for cropping plants. They also developed huge, pot-bellied guts that would have processed the plant material they ate. *Therizinosaurus* is the largest therizinosaur, measuring 33 feet in length, and it featured a long neck, long arms, and truly enormous claws on its hands. Its claws are the largest known in the animal world, measuring an incredible *three feet long*. Despite their wow-factor, we're not quite sure why it had these huge claws. They may have helped it to pull down tree branches to reach leaves. It's also possible that, in addition to plants, *Therizinosaurus* ate insects and used its large claws to rip open termite mounds or insect nests.

But as weird as it was, *Therizinosaurus* wasn't the strangest dinosaur in Late Cretaceous Asia. That honor belongs to an animal that represented a huge scientific mystery for nearly 50 years.

THE STRANGEST DINOSAUR

If you were to take pieces from all the dinosaurs that ever existed, mix them up in a bag, and randomly pull out one piece at a time to construct a dinosaur, you probably wouldn't come up with something weirder than *Deinocheirus*. For over 50 years, *Deinocheirus* was an enigma that was only known from its 8-foot-long arms and hands. Then in 2013 came the announcement that two new specimens had been discovered. Finally, the entire picture of *Deinocheirus* was complete. And what a picture it turned out to be! *Deinocheirus* is an ornithomimid, the group of "ostrich dinosaurs" that includes *Gallimimus* and *Struthiomimus*, but its physiology is wildly different from any other ornithomimid found to date. First off, it's huge—36 feet long. That's tyrannosaur size! And it sports a large hump or sail on its back. Finally, unlike the short skulls of most ornithomimids, *Deinocheirus* had an extremely long skull, more than 3 feet in length, and it ended in a broad, spoonbill-like beak. Evolution produced a lot of weird dinosaurs, but in *Deinocheirus* it created arguably the weirdest of them all.

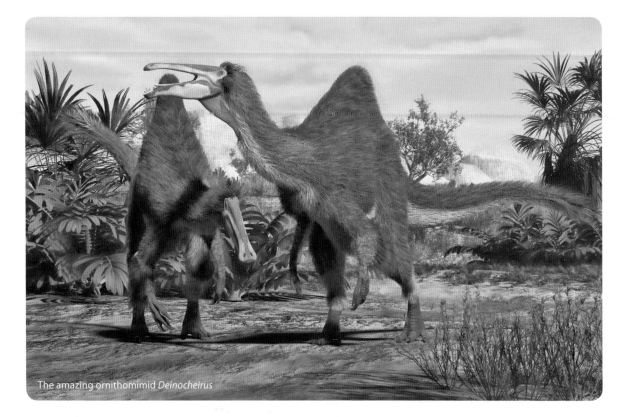
The amazing ornithomimid *Deinocheirus*

THE GIANT SWAN

Scientists suspect that the hadrosaurs evolved in Asia and spread later to North America and Europe. *Olorotitan* lived in what is now Russia, and it was a spectacular hadrosaur, sporting a dramatic, fan-shaped head crest and a long, graceful neck. *Olorotitan's* name, which means "giant swan," reflects this feature. The family of hadrosaurs with the dramatic head crests are called lambeosaurines, and they were the crown princes of the dinosaurs. Their elaborate head crests took on an unimaginable variety of shapes and sizes. The lambeosaurines were common across Asia and North America during the late Cretaceous.

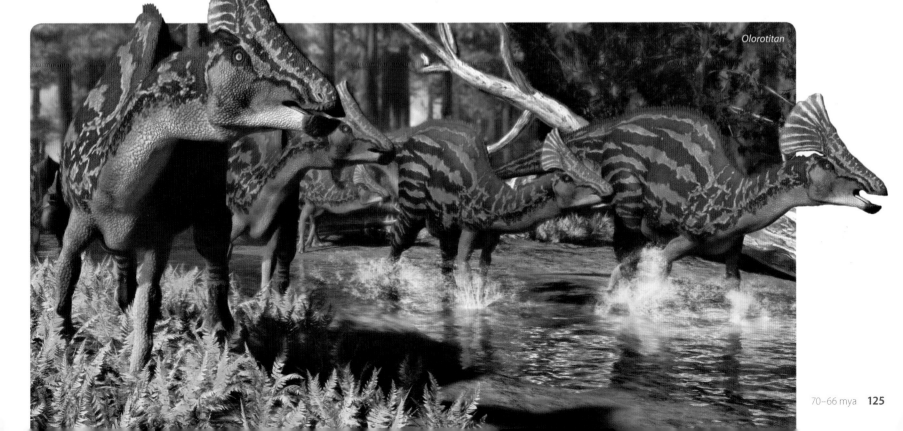

Olorotitan

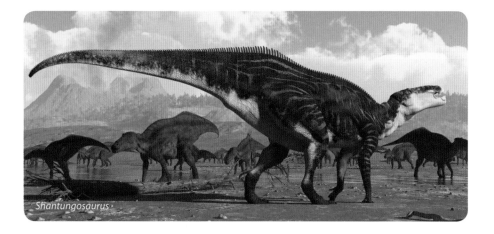
Shantungosaurus

THE BIGGEST HADROSAUR

Olorotitan was a large hadrosaur, but it was nothing compared to *Shantungosaurus*, the largest hadrosaur that's been found. *Shantungosaurus* was a colossus, reaching 54 feet long. It also appears to have been a herding animal, as remains of multiple individuals have been found together at sites in China.

THE TYRANNOSAURS

While the abelisaurs and carcharodontosaurs roamed Gondwana, the tyrannosaurs were the top predators on the northern continents. *Alioramus* was not a big tyrannosaur, but it was unusual in that it had a long, pointed snout. *Alioramus* also had an irregularly shaped crest along the top of its skull. Like its bigger tyrannosaur relatives, *Alioramus* had developed the shorter arms and two-fingered hands that we've come to associate with the group.

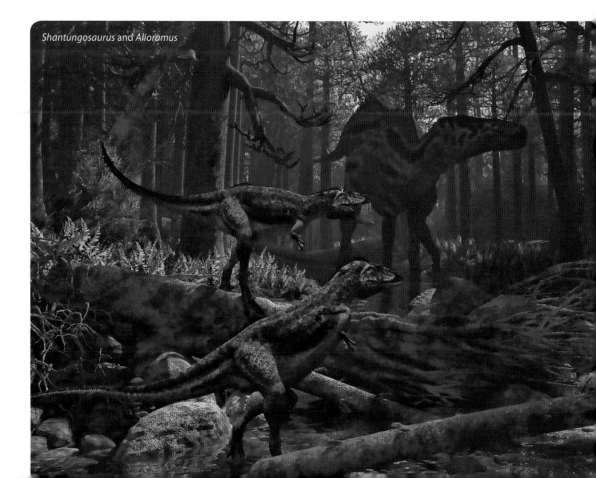
Shantungosaurus and *Alioramus*

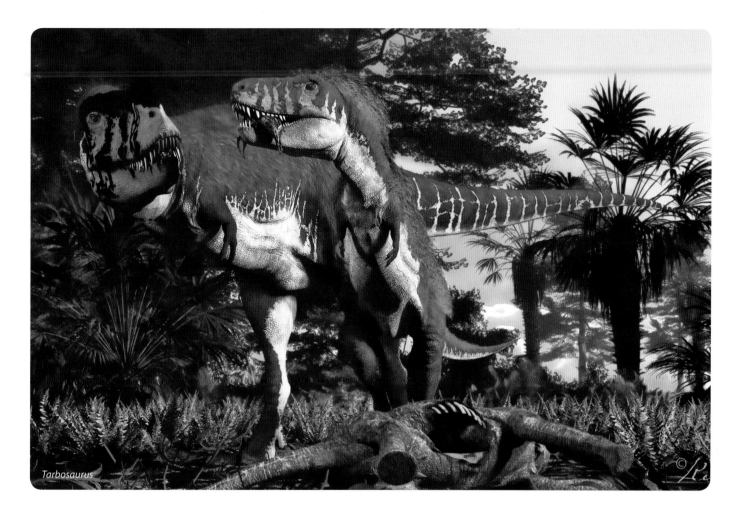

Tarbosaurus

THE BIGGEST TYRANNOSAUR IN ASIA

Tarbosaurus is the biggest tyrannosaur we've found in Asia. It was very similar to the North American *Tyrannosaurus rex* though it lived a little bit earlier and was a little smaller, coming in at around 36 feet. It was also a little more lightly built and had a narrower skull. We've found remains of both adult and juvenile *Tarbosaurus*, so we have a pretty good idea of what its growth cycle was like. *Tarbosaurus* would have been an incredibly powerful carnivore, and it was an apex predator in Asia.

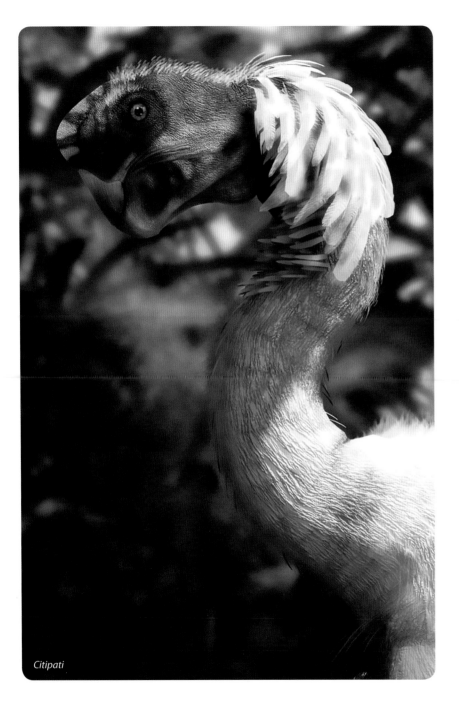

Citipati

ALMOST—BUT NOT QUITE—A BIRD

The oviraptors were about as close to birds as you can get without actually being a bird. *Citipati* is one of the best known of the group. It featured a tall crest on its head that may have varied by age or sex, and a strange, box-like skull that made it look a bit like a parrot. *Citipati* was fairly small, just 6 feet long, and it brooded its eggs by sprawling out on top of them, much as modern birds do. We know this because we've found fossils of *Citipati* in such a position. It appears the animal died suddenly while incubating its eggs, possibly as a result of a sandstorm or a collapsing sand dune.

Caudipteryx, from the Early Cretaceous of Asia, is one of the most primitive oviraptors, and was even smaller than *Citipati*, measuring just one meter (three feet) in length.

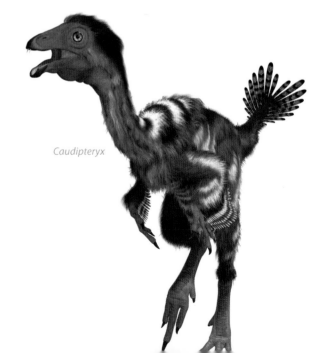

Caudipteryx

DINOSAURS OF APPALACHIA

Appalachia was the landmass formed from the eastern half of North America while the continent was split by the Western Interior Seaway (the western half was Laramidia). There aren't as many dinosaurs known from Appalachia as there are from Laramidia. This is not because there were fewer dinosaurs, but rather because most of the dinosaur-bearing rock formations in the eastern half of the continent are extremely difficult to get at. Over time, they have been covered over by deep layers of sediment and vegetation and eroded by glaciation, wind and water. There are, however, a few sites that have been productive for dinosaur discoveries, including New Jersey, Maryland and Alabama. Most of the dinosaur fossils that have been found from Appalachia are very fragmentary, and so we don't have a good idea of what these dinosaurs would have looked like. Some of the finds include the tyrannosaur *Appalachiosaurus*, the nodosaur *Niobaraurus*, the prosauropod *Anchisaurus*, and the first hadrosaur (and the namesake for the group), *Hadrosaurus*.

The description of *Eotrachodon* was published in 2016. Its discovery and the analysis of the other hadrosaurs from Appalachia has prompted a reconsideration of the origins of the hadrosaurs, with some researchers believing that Appalachia may be the ancestral home of all hadrosaurs, though this has yet to be confirmed.[14] *Eotrachodon* did not have a crest, and though we have not yet found its full skeleton, it is assumed to have been around 30 feet long.

The Appalachian ornithopod *Eotrachodon*

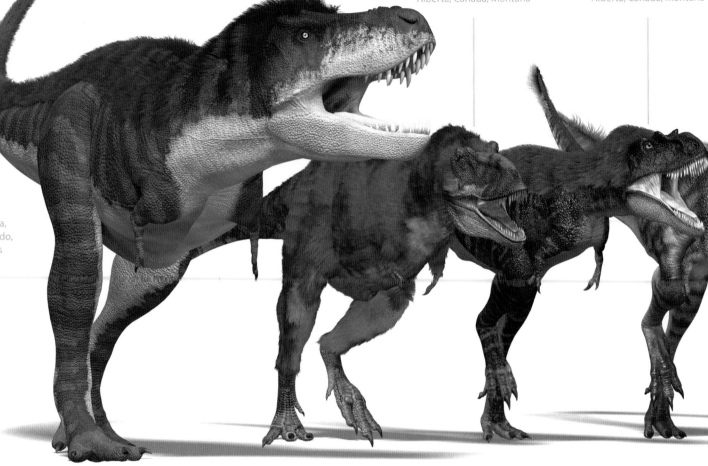

Daspletosaurus torosus
"Frightful Lizard"
30 feet
Middle Campanian
Alberta, Canada; Montana

Albertosaurus sarcophagus
"Alberta Lizard"
27 feet
Early Maastrichtian
Alberta, Canada; Montana

Tyrannosaurs rex
"Tyrant Lizard"
40 feet
Late Maastrichtian
Alberta, Canada; Montana,
Dakotas, Wyoming, Colorado,
Utah, New Mexico, Texas

TYRANNOSAURS IN NORTH AMERICA

The Late Cretaceous of North America was the domain of the tyrannosaurs. By this time in Earth's history the allosaurs were gone, as were the carcharodontosaurs and the megalosaurs, and no other large predators existed. The tyrannosaurs flourished, ranging from Texas to Alaska, and on both sides of the Western Interior Seaway.

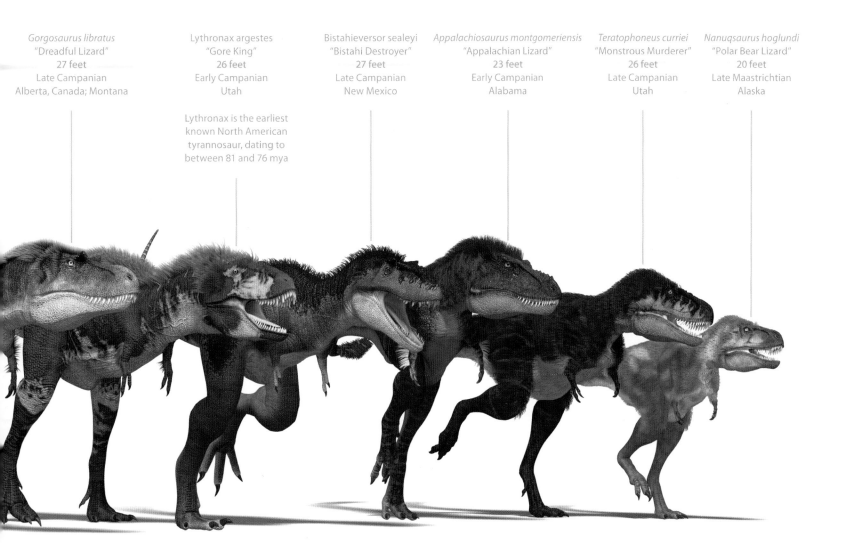

Gorgosaurus libratus
"Dreadful Lizard"
27 feet
Late Campanian
Alberta, Canada; Montana

Lythronax argestes
"Gore King"
26 feet
Early Campanian
Utah

Bistahieversor sealeyi
"Bistahi Destroyer"
27 feet
Late Campanian
New Mexico

Appalachiosaurus montgomeriensis
"Appalachian Lizard"
23 feet
Early Campanian
Alabama

Teratophoneus curriei
"Monstrous Murderer"
26 feet
Late Campanian
Utah

Nanuqsaurus hoglundi
"Polar Bear Lizard"
20 feet
Late Maastrichtian
Alaska

Lythronax is the earliest known North American tyrannosaur, dating to between 81 and 76 mya

Most people know *Tyrannosaurus rex*, but the tyrannosaur line offers much more than one genus. Ten genera of tyrannosaur have been discovered across North America (though one, *Dryptosaurus*, is known only from fragmentary remains). They ranged in size from 20 to 42 feet, but even the smallest were savage killing machines armed with powerful jaws and bone-crushing teeth. One of the best things about tyrannosaurs is their names, which translate to things like "Gore King," "Horrible Lizard," "Destroyer," and "Frightful Lizard."

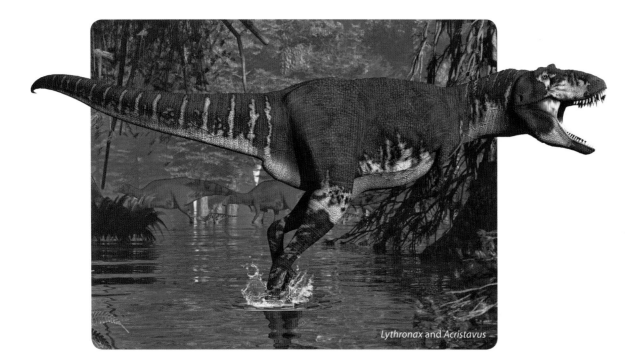

Lythronax and *Acristavus*

THE GORE KING

Lythronax means "Gore King," and it's one of the newest tyrannosaurs discovered. It's also the earliest tyrannosaur known from North America. It was discovered in Utah, at a site known as the Grand Staircase-Escalante National Monument, which has become a hotbed for Late Cretaceous dinosaur research. The site has provided us with a complete picture of a Campanian Stage ecosystem. The remains of amphibians, lizards, turtles and crocodiles have been found there, in addition to fossilized remains of plants and *a lot* of dinosaurs. The site is divided into two subsections. The Wahweap Formation is the older part, and that is where *Lythronax* came from.

Living alongside *Lythronax* was the primitive hadrosaur *Acristavus*. *Acristavus* was one of the non-crested *saurolophine* hadrosaurs. Saurolophines had head ornamentation, but it was limited to soft-tissue crests and small spikes, unlike the elaborate head crests of the lambeosaurine hadrosaurs. *Acristavus* was a fairly wide-ranging animal, with remains found in Utah and also in Montana.

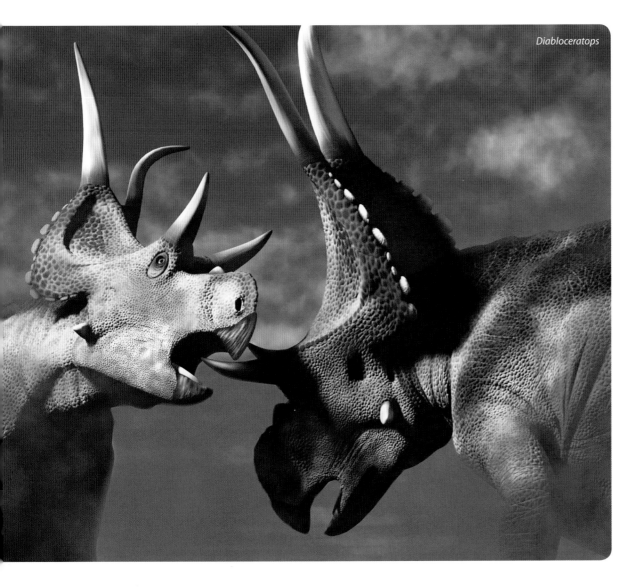

Diabloceratops

DEVIL-HORNED FACE

One of the most fascinating aspects of the animals found at the Grand Staircase site is that they are just a little different from those that lived in Canada at the same time. It seems the area was periodically cut off from the northern part of the continent, and as a result unique forms evolved. The ceratopsian *Diabloceratops*—the name means "Devil-Horned Face"—is one of the earliest advanced ceratopsians (the ones with elaborate neck shields and horns) known from North America. It was a typically sized ceratopsian, 14 feet long and weighing a little over a ton. Its neck collar was unique because it was narrow at the top and sported two long, thin, outward-pointing spikes.

THE KAIPAROWITS FORMATION

The slightly younger Kaiparowits Formation makes up the other part of the Grand Stair-case-Escalante site, which has yielded a virtual zoo of new dinosaurs. The top predator here was a tyrannosaur named *Teratophoneus* (page 131), whose name translates to "Monstrous Murderer," and which lived alongside the hadrosaurs *Parasaurolophus* and *Gryposaurus*, both of which are also known from a similar time period in Canada, but the species from the Kaiparowits Formation were a little different. *Parasaurolophus cyrtocristatus* was found in the Kaiparowits Formation, but had a shorter crest than other *Parasaurolophus* species, and its crest curved back tightly over its head.

Ceratopsians are represented in the Kaiparowits Formation as well. *Nasutoceratops* has been called "the big nosed ceratopsian" because its nasal bones are highly arched. It also carried a pair of long horns above its eyes; these horns pointed forward like a bull's.

Utahceratops was one of the biggest ceratopsians of its time, measuring 23 feet in length.

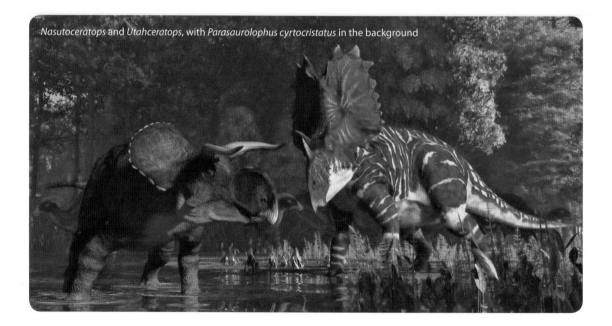

Nasutoceratops and *Utahceratops*, with *Parasaurolophus cyrtocristatus* in the background

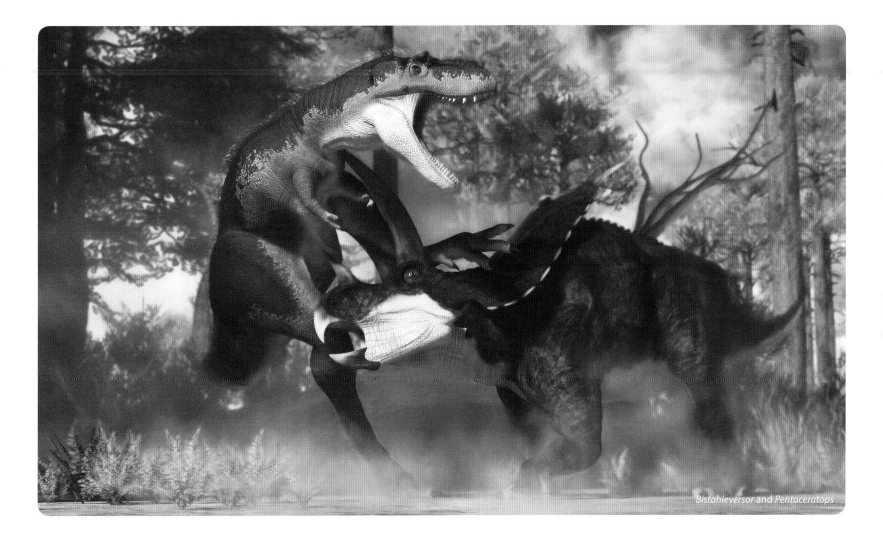

Bistahieversor and *Pentaceratops*

THE DESTROYER

Another fearsome predator lived a short distance away in what is now New Mexico. *Bistahieversor* is known from both adult and juvenile remains. Its name translates to *"Bistahi Destroyer"; Bistahi* is the Navajo name for the area where the fossil was found. It was there that *Bistahieversor* battled it out for dominance with the large ceratopsian *Pentaceratops*, whose enormous neck shield gave it one of the largest heads of all known terrestrial animals, coming in at seven feet long (the name *Pentaceratops* means "five-horned face," a reference to the three horns on its shield and nose, and the two small "jugal" horns coming out from its cheeks).

NORTH AMERICA'S LAST SAUROPOD

The last titanosaur to appear in North America is *Alamosaurus*. For most of the Late Cretaceous, there were no sauropods found on the continent. About 70 million years ago they reappeared in the American Southwest in the form of *Alamosaurus*. No one knows why they disappeared for so long, or why they reappeared. Some theories suggest that they immigrated from South America after the Isthmus of Panama appeared. Other researchers believe they immigrated from Asia across the Bering Land Bridge. Still others think that the titanosaurs never actually disappeared, but that we haven't found their remains yet.

Alamosaurus was one of the giants, and it may have reached lengths of 100 feet. Remains have been found across the southwest United States, and as far north as Utah. *Alamosaurus* is not named for the famed Alamo Mission in Texas. Rather, its name is a reference to the Ojo Alamo Formation in New Mexico where the first remains were found.

Kritosaurus was a member of the saurolophine hadrosaurs, the hadrosaurs without crests. *Kritosaurus* is distinctive because of its enlarged nasals (nose bones), which gave it a "Roman nose" profile. We don't have a complete skeleton of *Kritosaurus*, but based on its three-foot-long skull, it was probably 30–33 feet in length.

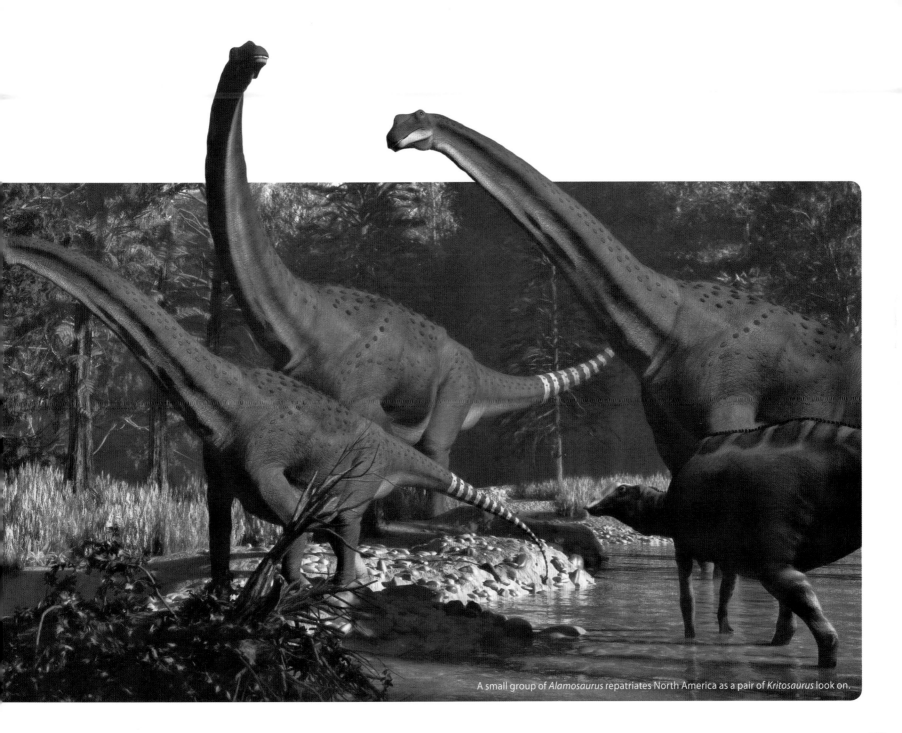

A small group of *Alamosaurus* repatriates North America as a pair of *Kritosaurus* look on.

CRESTED HADROSAURS OF NORTH AMERICA

In the northern mid-west of the US and Canada, there are a number of formations that have yielded extraordinary dinosaur remains from the Late Cretaceous. These sites have given us some of our most iconic dinosaurs, including the tyrannosaurs *Daspletosaurus*, *Albertosaurus* and *Gorgosaurus*, as well as an incredible array of crested hadrosaurs: the lambeosaurines who evolved elaborate, hollow head crests. At that time in northern North America, there were no titanosaurs, so the hadrosaurs were the largest herbivores. It's here that the familiar, tube-crested *Parasaurolophus* species lived, along with the helmet-crested *Hypacrosaurus*, and the hatchet-shaped crested *Lambeosaurus*.

The hollow head crests of the lambeosaurines were ingenious adaptations that allowed species to recognize one another, even from a distance, and they may have provided a resonating chamber through which species could call out to one another. The hollow crests were filled with air passages that connected with the dinosaur's nasal bones. If they made sounds, and there's no reason to believe they didn't, these chambers would have amplified their calls across the forests.

Parasaurolophus

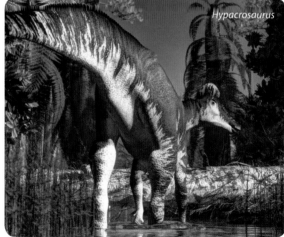
Hypacrosaurus

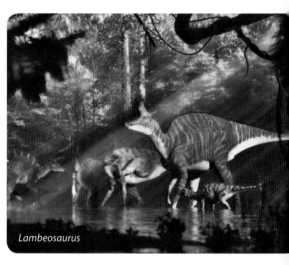
Lambeosaurus

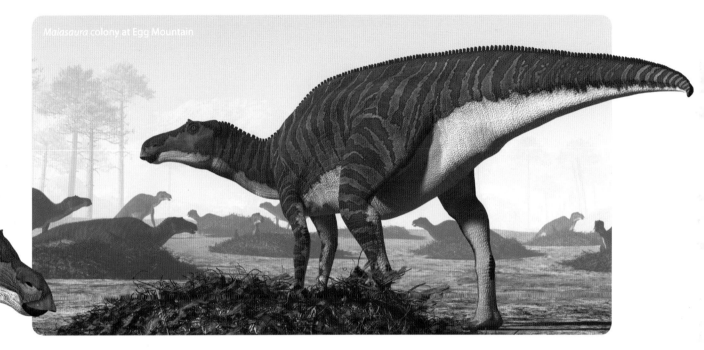

Maiasaura colony at Egg Mountain

Maiasaura

EGG MOUNTAIN

A hadrosaur that lived in Montana has become famous despite its rather plain appearance. *Maiasaura's* name translates to "good mother lizard." Its remains were found at a site named Egg Mountain, which was once a huge nesting ground. The area is littered with fossils of nests, eggs, and the bones of *Maiasaura* individuals of all ages. It's an incredibly important site because it was there that paleontologists discovered the first concrete evidence that dinosaur parents cared for their young. From the juvenile (and even embryonic) remains, it was clear that *Maiasaura's* bones were not well developed when they hatched, and they would not have been able to leave the nest and find food on their own. The only way they could have survived was if a parent brought them food. *Maiasaura* were too big to sit on their nests and brood their eggs, so they covered their nests with dead vegetation that would rot over time, providing additional heat that incubated the eggs.

THE CERATOPSIANS

No dinosaur epitomizes brute force like the ceratopsians. Whereas sauropods and even ornithopods evoke a sense of grace, ceratopsians are like police blockades: solid, stoic and impenetrable. Yet their crazy headgear sometimes borders on the absurd, like court jester hats placed on castle guards. Over the years we've given ceratopsian species equally absurd names to describe their ornamentation. Names with meanings like "medusa horn face (*Medusaceratops*)," "devil horn face (*Diabloceratops*)," "decorated horned face (*Kosmoceratops*)," "spine face (*Spinops*)" and "wild horn face (*Bravoceratops*)."

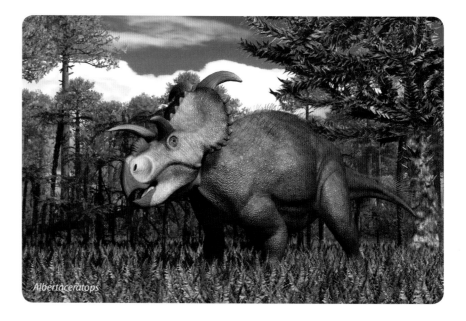

Albertaceratops

Like the hadrosaurs, most ceratopsians looked pretty similar if you ignored their heads; this has led researchers to conclude that variation in head ornamentation developed to make it easier for individual species, or sexes, to recognize each other. They likely also served as defensive adaptations, whereby the shields protected their otherwise vulnerable necks, while the horns provided more active protection, as needed. Ceratopsian horns may have also played a role in battles for dominance or mates between rivals within the same species, with combatants locking their horns (as is the case with many modern deer).

Albertaceratops was around 16 feet long and belonged to the centrosaurine group of ceratopsians. The centrosaurines specialized in the ornamentation on their noses, developing either extremely long nasal horns, or as with *Albertaceratops*, lumps of bone in place of the nose horn. These centrosaurines also tended to have shorter horns over their eyes, and their neck shields were shorter but more elaborately decorated, featuring spikes and hooks. *Albertaceratops* was a unique centrosaurine, as it had fairly long horns above its eyes.

A TEN-HORNED BEAST

Medusaceratops looks a bit like *Albertaceratops*, but it is actually from a different line of ceratopsians, the chasmosaurines, which typically had shorter nose horns, longer brow horns and longer neck shields. While *Medusaceratops* is a chasmosaurine by virtue of its skull anatomy, it does have a few features that make it a bit of an outlier among its group. In particular, it sports a lump of bone on its nose and no less than 10 horns along the rim of its neck shield, inspiring its discoverers to name their find after the Greek monster with the head of snakes.

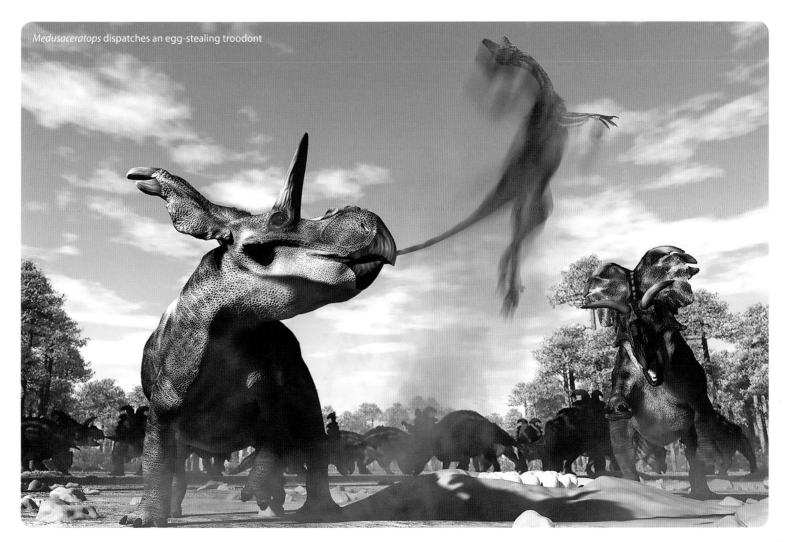

Medusaceratops dispatches an egg-stealing troodont

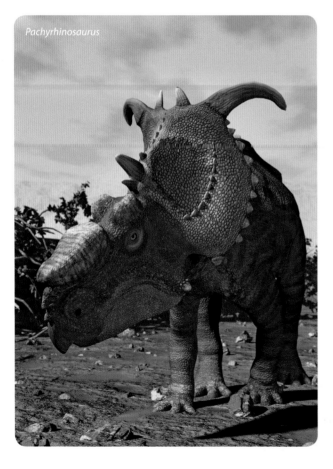

Pachyrhinosaurus

POLAR DINOSAURS

Pachyrhinosaurus has become a well-known dinosaur in recent years, largely due to its depiction in popular media. It was a long-lasted ceratopsian, with species surviving from the Campanian Stage well into the Maastrichtian Stage of the Cretaceous. It was also a polar dinosaur, meaning its remains have been found inside the Arctic Circle. In recent years, a lot of research has been done in Alaska, and as a result, we've discovered that there were many dinosaurs that lived along the northern fringes of the continent. In addition to *Pachyrhinosaurus*, remains of *Edmontosaurus*; the small carnivore *Troodon*; and a unique, small tyrannosaur named *Nanuqsaurus* (see page 131) have all been found along Alaska's North Slope.

Pachyrhinosaurus is a centrosaurine, and one that took the notion of a "lump of bone on the nose" to a whole new level. The nasal boss, as this lump of bone is called, was a huge, flattened mass covered in bumps and grooves and pits. It grew so large that in some cases it blended in with the bony lumps above the animal's eyes. At one time, it was thought that the mass may have been the base for an enormous nasal horn, but many examples of *Pachyrhinosaurus* have been found and none of them have a horn, so that does not seem to have been the case.

STYRACOSAURUS

Styracosaurus was one of the most heavily adorned centrosaurines. It had long, curved horns on its shield and a large spike on its nose; incredibly, the horn may have grown up to two feet long.

The horns we see on the fossil skulls of ceratopsians are actually horn cores, that is, they're the bony bases of the horn. In life, each of these horns and/or bosses would have been covered in keratin and would have been much larger. Unfortunately, keratin doesn't preserve or fossilize well, so we don't have any examples to see how big the horns actually got.

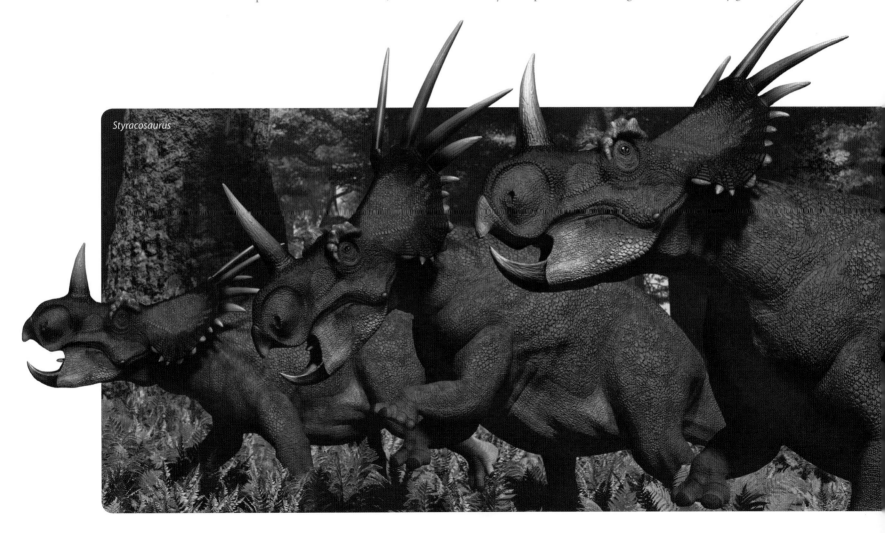

Styracosaurus

CLASSIC CONFRONTATIONS

It's a scene that's been repeated countless times in images and movies: the battle between a horned dinosaur and a tyranno-saur. From a paleontological perspective, these fictional confrontations are well grounded. As far back as the Late Jurassic, when both these types of dinosaurs were first evolving with the likes of the primitive tyrannosaur *Guanlong* (page 46) and the basal ceratopsian *Yinlong*, they shared the landscape, and undoubtedly clashed. There's ample evidence of damage done to ceratopsian bones by the teeth of tyrannosaurs, including chomped horns and punctured neck shields.

Gorgosaurus lived a bit earlier than *T. rex* and was a bit smaller and lighter. It shared its environment with *Styracosaurus* and a host of other ceratopsians. The extent to which it actively hunted horned dinosaurs, as opposed to feeding opportunistically on carcasses, is unclear.

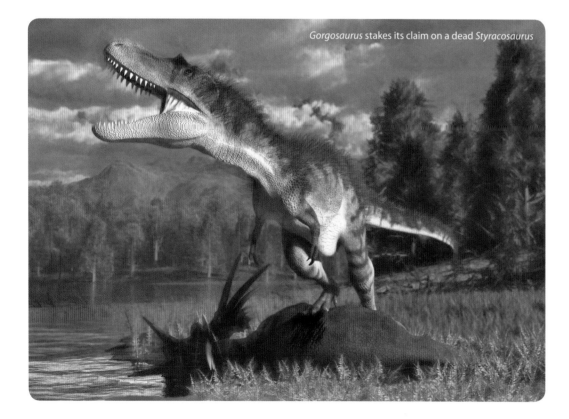

Gorgosaurus stakes its claim on a dead *Styracosaurus*

NECK SHIELDS

The neck shields of ceratopsians are interesting structures. While they would have provided a degree of protection against predators, they were actually fairly thin; this was likely an adaptation that helped keep down their weight. As such, these shields could have been easily pierced or damaged by the large tyrannosaurs that preyed on ceratopsians. In addition to being thin, the shields of all ceratopsians (except *Triceratops*) have two large holes on either side called fenestrae, which lightened the shield even more. In life these fenestrae would have been covered in skin, so they wouldn't have appeared as openings in the shield.

Rubeosaurus was similar to *Styracosaurus*, but the horns on its shield were shorter while the one on its snout was enormous and more curved.

Skull of the ceratopsian *Styracosaurus* showing the fenestrae in the shield

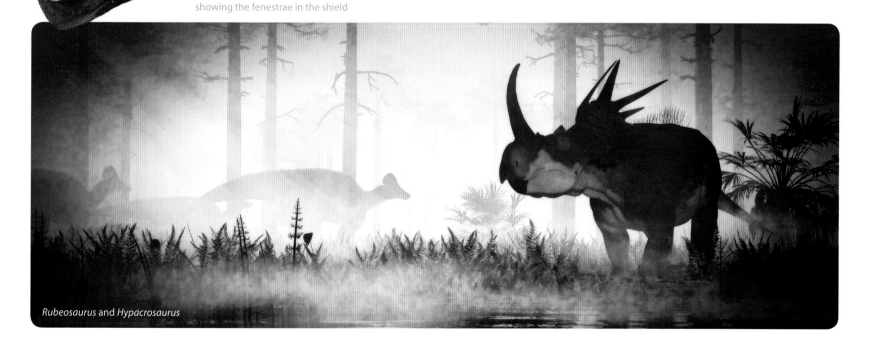

Rubeosaurus and *Hypacrosaurus*

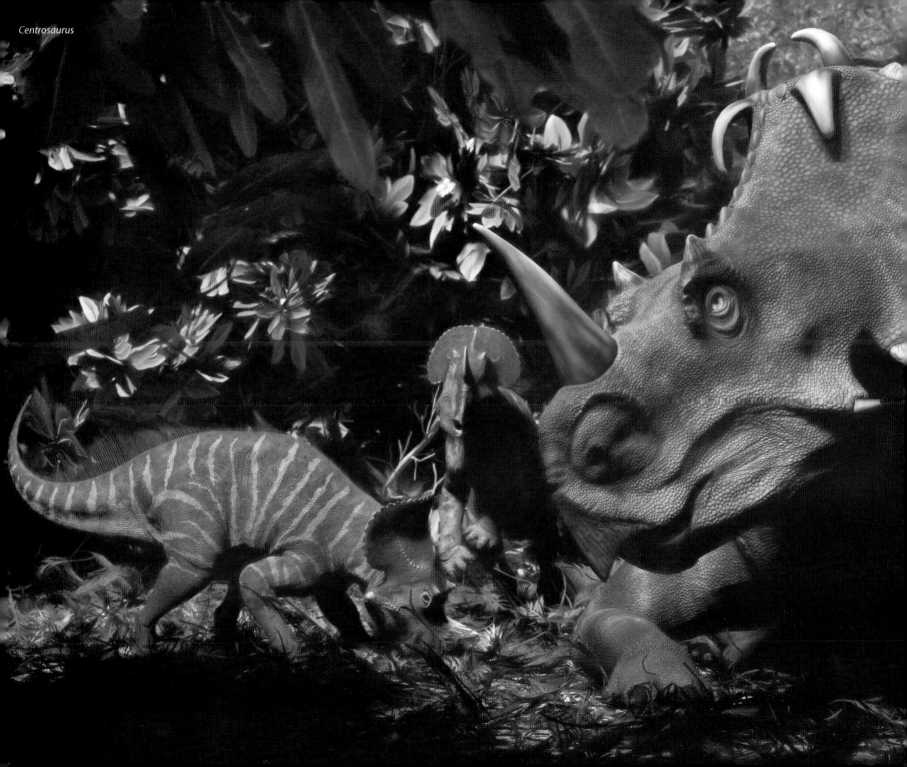

CENTROSAURUS MASS GRAVES

As we discussed earlier, mass death assemblages, or "bone beds" of dinosaurs have been found all around the world. One such location in Alberta, Canada, represents such an extreme accumulation of animal remains; it has been dubbed a "mega bone bed." The site, outside of Hilda, Alberta, records fourteen separate mass deaths containing the remains of thousands of *Centrosaurus*. After years of analysis, scientists have concluded that the site records animals that drowned while trying to cross a flooded river. The fourteen individual sites may record different years when herds of *Centrosaurus* were migrating. Similar scenes occur today in Africa where thousands of wildebeests perish attempting to cross rivers during migration.

Centrosaurus's neck shield was elaborately rimmed with small hooks and hornlets, and it boasted a large, curved horn on its nose. Many older publications list a dinosaur called *Monoclonius*, which is similar in appearance to *Centrosaurus*. *Monoclonius* is only known from very fragmentary remains. Today it is considered a *nomen dubium*, and it's most likely the same animal as *Centrosaurus*.

CHASMOSAURUS

Chasmosaurus is actually named for the fenestrae in its shield; its name means "opening lizard," and it is the dinosaur for which the chasmosaurine line of ceratopsians is named. At 16 feet long and 2 tons, it was an average-sized ceratopsian and it lived alongside *Parasaurolophus* and the other hadrosaurs that lived in Alberta, Canada, during the late Cretaceous. Over the years, there have been many different species of *Chasmosaurus* named, but most of these have since been assigned to unique genera. The only two species now recognized are *Chasmosaurus belli* and *Chasmosaurus russelli*.

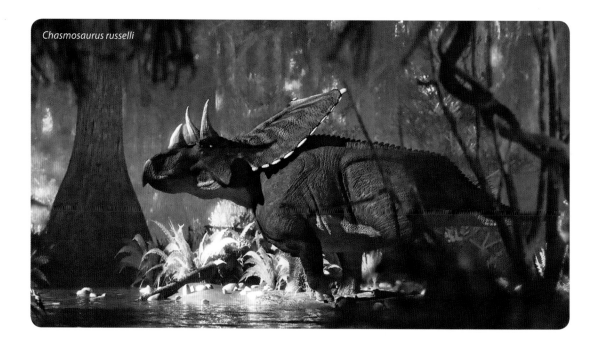
Chasmosaurus russelli

THE LAST DINOSAURS

The last few million years of the Cretaceous in North America provide us with some of our most familiar and beloved dinosaurs. This was the realm of *Tyrannosaurus* and *Triceratops*. In addition, the "duckiest" of the duckbills—*Edmontosaurus*—lived during this time, as did the dome-headed *Pachycephalosaurus*.

Tyrannosaurus

TYRANNOSAURUS REX

There's probably been more written about *Tyrannosaurus rex* than any other dinosaur. And for good reason. It was a remarkable predator. And while it wasn't the largest meat-eating dinosaur (*Spinosaurus*, *Carcharodontosaurus* and *Giganotosaurus* were all larger), its combination of size, strength and power have made it perhaps the most famous of all dinosaurs and has captured people's imagination for more than 100 years.

Much has been made of *Tyrannosaurus's* "puny" arms and two-fingered hands. But an analysis has shown that, though small, these arms were incredibly powerful, capable of lifting up to 439 pounds each. Still, they were so short they couldn't even reach the animal's head, and the joints of the arms and shoulders had very limited ranges of motion. So what were they used for? Some have speculated they were used to hold onto a mate during copulation; others think they may have been used in getting up from a lying-down position. They also may have held onto struggling prey—like massive meat hooks—while its head and jaws dealt their lethal blows.

When it comes to *T. rex*, one question comes up again and again: Was it a predator or a scavenger? The debate has gone on for quite a while now. The answer, most likely, is *yes*. *Tyrannosaurus* was probably an opportunistic feeder, taking carrion when it was available, but it also would have hunted when need and opportunity arose.

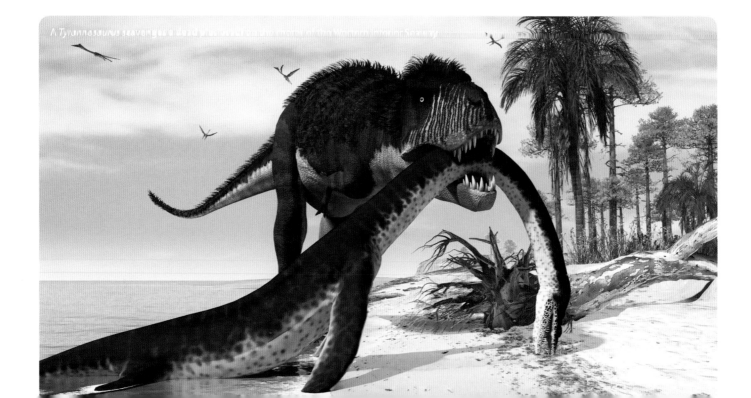

A *Tyrannosaurus* scavenges a dead sauropod.

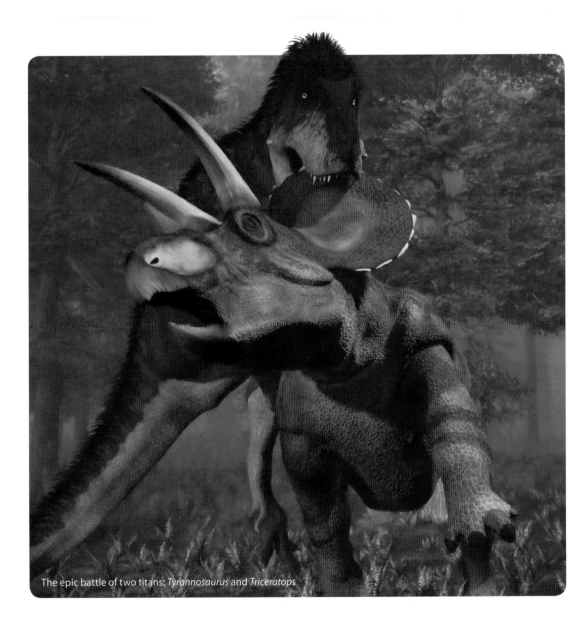

The epic battle of two titans: *Tyrannosaurus* and *Triceratops*

T. REX: THE HUNTER

Most of us want to believe that *Tyranno-saurus* was a predator. Its such a grand, imposing figure, so heavily loaded with lethal weapons, that it seems a waste for that all to go toward scavenging. There's ample evidence that *Tyrannosaurus* was an active hunter. An *Edmontosaurus* skeleton has been found with a bite taken out of its tail, and the teeth marks match *Tyranno-saurus* (incidentally, the bones show that the wound healed, so the *Edmontosaurus* survived the attack). There are also records of teeth marks on *Triceratops* neck and skull bones, which show that the two engaged in battle. A recent analysis has even revealed how *Tyrannosaurus* may have killed and fed on *Triceratops*: After mortally wounding a *Triceratops*, *Tyrannosaurus* would have literally ripped the head off *Triceratops* by pulling on its frill to get at the meaty neck muscles it protected.

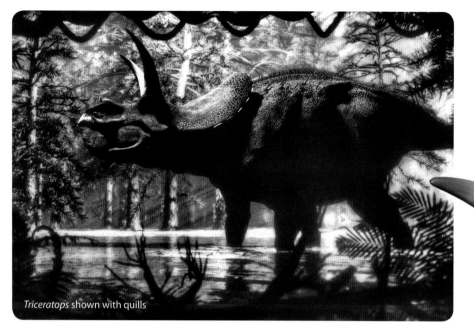
Triceratops shown with quills

THE MIGHTY TRICERATOPS

Triceratops is probably the most familiar of all the ceratopsians (the horned dinosaurs). Built like a rhinoceros but bigger than an elephant, *Triceratops* didn't have the most elaborate shield. It also lacked the fenestrae, the holes present in the shields of all other ceratopsians, which meant that it had the strongest shield of all ceratopsians and it offered the greatest defense against predators. A recent *Triceratops* discovery named "Lane" included skin impressions, and showed that in addition to the normal scales that covered most of its body, *Triceratops* also had a number of extremely large scales along its back and sides that had strange, tall pointed centers. It's been proposed that these were anchor points for large quills that may have adorned the animal. *Triceratops* may have had feathers, too!

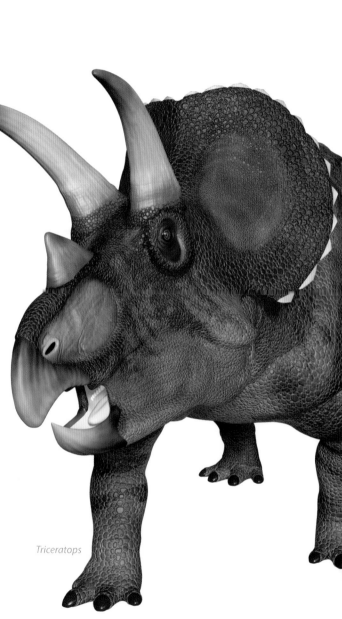
Triceratops

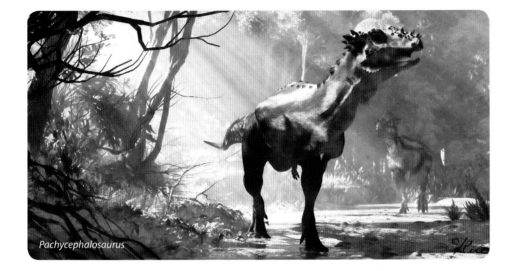
Pachycephalosaurus

THE DOME HEADS

The pachycephalosaurs were latecomers to the world of dinosaurs, only appearing in the last 15–20 million years of the Cretaceous (there are a few possible pachycephalosaurs from the Late Jurassic, but these have yet to be confirmed). The pachycephalosaurs were wide-bodied, bipedal herbivores, but their thickened skull is what made them really notable; and it's almost impossible to overstate how thick these skulls were. *Pachycephalosaurus* skulls were up to 10 inches thick. Some paleontologists have theorized it used its thick head to engage in head-butting rituals, like deer and rams do today. There's evidence both to support that idea and to refute it.

Pachycephalosaurus was the largest pachycephalosaur, reaching fifteen feet. Two other smaller pachycephalosaurs from the same time period, *Stygimoloch* and *Dracorex*, may actually be juvenile *Pachycephalosaurus*.

FLAT-HEAD HADROSAURS

By the end of the Cretaceous all of the hadrosaurs with elaborate head crests had become extinct in North America. In their place, the flat-headed hadrosaurs thrived. *Edmontosaurus* is the "classic" duck-billed dinosaur that we've come to know. Though a number of species lived during the Late Cretaceous, *Edmontosaurus regalis* was an early form that existed during the Campanian period. There have been a few *Edmontosaurus* mummies discovered that included fossilized impressions of its skin. One revealed it had a soft-tissue crest on its head, not unlike a rooster's comb.

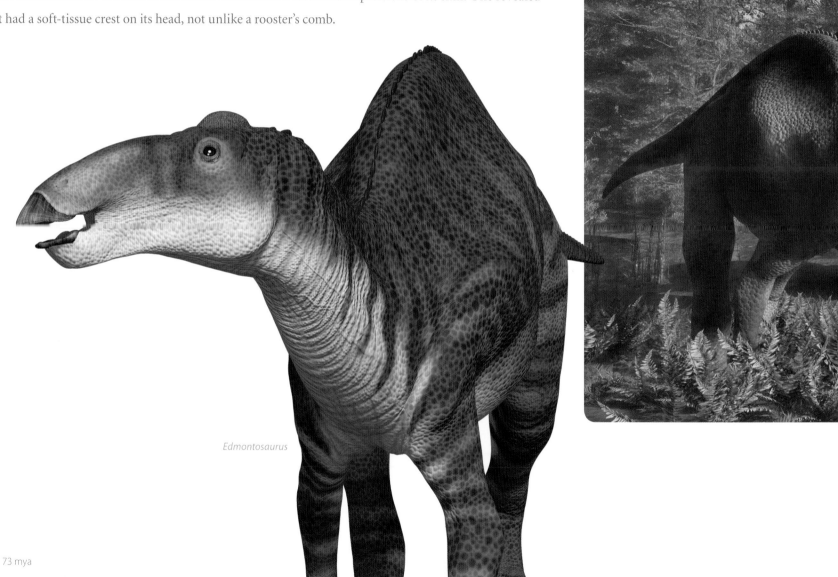

Edmontosaurus

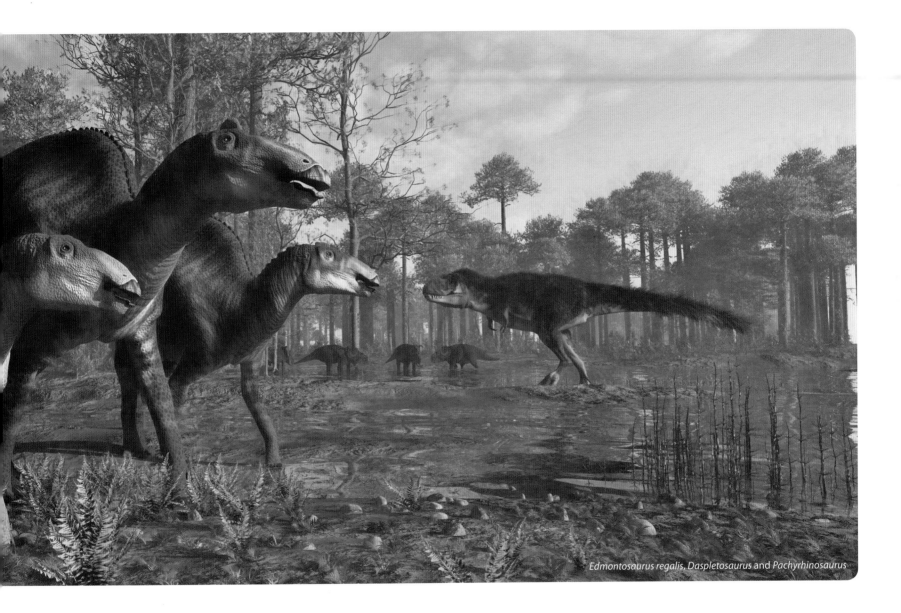

Edmontosaurus regalis, Daspletosaurus and *Pachyrhinosaurus*

A DUCK IN NAME ONLY

Edmontosaurus annectens is the species with the longest, flattest, "duckiest" head. Up until the 1970s, it was assumed that an animal that looked like a duck must act like a duck, so *Edmontosaurus* was usually shown wading in swamps, feeding on soft aquatic vegetation. Since then, we've come to understand that *Edmontosaurus* was a thoroughly terrestrial animal that fed on tough vegetation, including conifers. The beaks of hadrosaurs were actually nothing like the bills on modern ducks. Hadrosaur beaks were short, just covering the end of their snouts, and tough enough to crop and shear off tough vegetation, including pine needles.

Throughout the years, the name for *Edmontosaurus annectens* has changed several times; it's been known as *Trachodon, Claosaurus, Diclonius, Edmontosaurus, Anatosaurus, Anatotitan*, then *Edmontosaurus* again. Confusingly, these are all the same animal, but as new studies are conducted and new discoveries are made, dinosaur names often change.

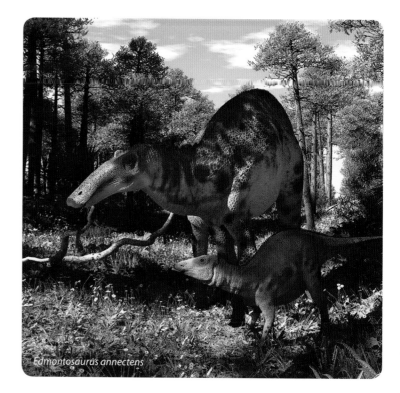

Edmontosaurus annectens

DAKOTARAPTOR

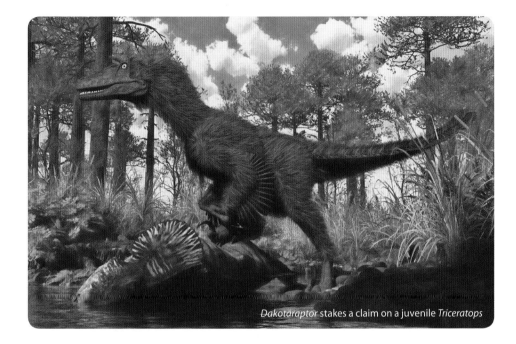

Dakotaraptor stakes a claim on a juvenile *Triceratops*

The discovery of *Dakotaraptor* was announced in 2015, and it's an important and exciting discovery for a couple reasons. First, it's one of the largest dromaeosaurs (the "raptor" dinosaurs) that we know of–measuring around 16 feet long. Secondly, it's the only large member of that group that survived until the end of the Cretaceous, which means that it lived alongside *Tyrannosaurus*, *Triceratops* and *Edmontosaurus*. This is important because for a long time, we didn't know of any medium-sized predators from the end of the dinosaur era in North America. There were a lot of small dromaeosaurs running around, animals that ranged in size from 3–6 feet, and then there was *Tyrannosaurus* at 42 feet. But there wasn't anything in the middle. The discovery of *Dakotaraptor* helps us fill a gap in our understanding of the late-Cretaceous ecosystem and gives us a much fuller picture of this dynamic environment.

THE K-PG EXTINCTION

One day around 66 million years ago, things went really, really bad. A giant asteroid, as big as Mount Everest, slammed into the Yucatan Peninsula in Mexico and wiped out the non-avian dinosaurs.

Or at least that's the popular wisdom.

The K-Pg extinction (*K* is the letter scientists use for the Cretaceous Period, and *Pg* represents the subsequent Paleogene time period) has been one of the most challenging mysteries in science. The discovery of a huge impact crater near Chicxulub, Mexico, beneath the Yucatan Peninsula seemed to provide concrete evidence that, as many had already suspected, an asteroid impact caused the extinction.

The theory goes something like this: The asteroid collision triggered a number of cataclysmic events. There would have been a resulting tsunami, possibly worldwide in scope, and this would have killed all life along the continental coasts for hundreds of miles inland. Burning debris from the blast would have been ejected into the atmosphere, then rained back down from the sky, setting the landscape ablaze and touching off a so-called "pyrosphere"—a worldwide inferno that would have incinerated much of inland life. The resulting ash from the pyrosphere, along with tiny particles of ejected debris, would have choked the atmosphere, cutting off much of the sunlight, killing much of the plant life and destroying the food chain.

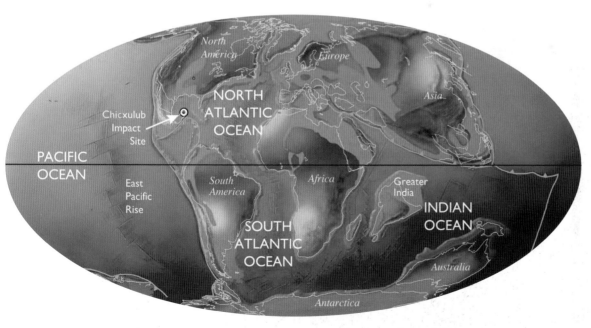

World map showing the location of continents at the K-Pg (formerly the K-T) boundary (paleogeographic map by C.R. Scotese)

Toxic micro-particles from the impact and resulting firestorms would have returned to Earth in the form of acid rain, poisoning the waters and killing off life in fresh water and saltwater alike.[15]

That's a horrifying and convincing scenario, but there are some arguments against the theory that the asteroid impact alone was responsible for the worldwide catastrophe.

First, it's a fact that an asteroid struck the Earth 66 million years ago in Mexico. We have evidence of that, not only with the impact crater, but with a layer of the rare element iridium, which is found all over the world in rocks at the K-Pg boundary. Even more tellingly, iridium is rare on Earth, but it is a common component in asteroids.

But the resulting pyrosphere is a little more difficult to prove. There is widespread evidence in North America of a layer of charcoal right at the K-Pg boundary that coincides with the asteroid collision, and it supports the theory that there were massive wildfires. But the charcoal is not consistent around the world. There's also no concrete evidence of worldwide water toxicity.

There's also the problem of what survived the extinction and what didn't. Non-avian dinosaurs died out, but avian dinosaurs—the birds—didn't. Crocodilians survived, but the marine reptiles and pterosaurs didn't.

Another theory suggests that something happening on the other side of the planet around the time of the asteroid impact also played a role. In an area of India known as the Deccan Traps, geologists have found evidence of one of the most devastating volcanic flows ever recorded. The lava flows there were once more than a mile thick and covered an area of 193,000 square miles, larger than California.[16] These eruptions may have lasted for 30,000 years. Some believe that these eruptions and the resulting toxic gases they expelled were enough to poison the atmosphere worldwide and cause the K-Pg extinction.

Some people even think the two events are related, that the impact from the asteroid may have triggered the volcanic eruptions on the other side of the planet.

More and more, scientists believe that it wasn't one or the other, but rather the combined effect of these two events that may have caused the extinction. Given the close proximity of these two events—each a global disaster in their own right—it's highly likely that the combined effect was a lethal "one-two punch" from which larger life could not recover.

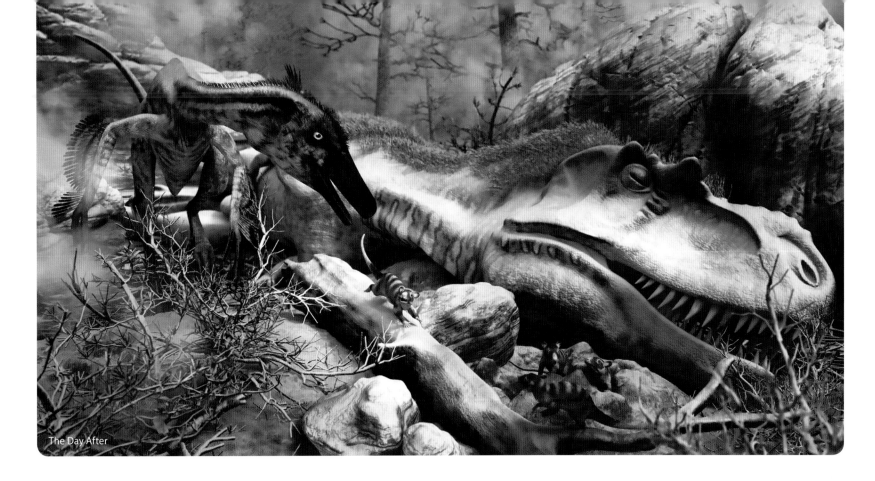
The Day After

THE DAY AFTER

We'll never know exactly how events unfolded in the waning hours of the Cretaceous, but the world that was left behind would have been devastated and a merciless environment for the creatures that survived. Some larger dinosaurs would have survived the initial destruction, only to perish when the food chain didn't rebound quickly enough to support them. Despite having made it through an epic cataclysm, they were still doomed.

In a world of scant resources, small size would have quickly become an evolutionary advantage. The same is true for animals with a generalist feeding strategy, especially one that enabled them to scavenge on carcasses. Parental care and nurturing could also have been an advantage in the harsh new world. At the time, there was one group of animals that was uniquely positioned with all of these advantages to make the best of a very bad situation: mammals.

Index of Dinosaurs and Other Mesozoic Animals

Albertaceratops

About the Author

James Kuether has been a corporate executive, a consultant for Fortune 500 companies and an executive coach. He is a professional artist whose paintings and photographs hang in galleries and private collections around the globe. He is an amateur fossil hunter and a life-long dinosaur enthusiast. His paleoart has appeared online and is frequently featured in *Prehistoric Times* magazine. James divides his time between his home in Minnesota and consulting with non-profit organizations in Southeast Asia.

Attributions

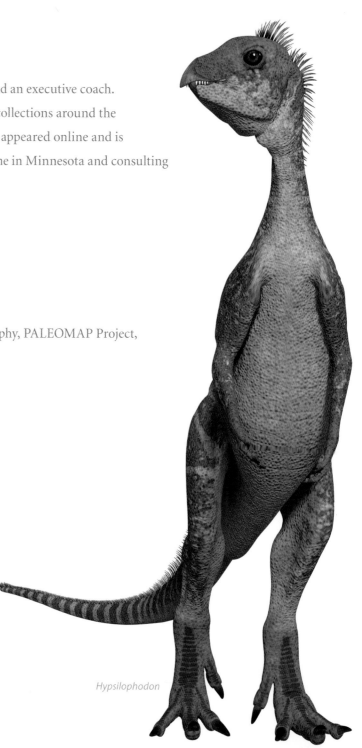

Hypsilophodon

Citations

[1] Benton, M.J. *When life nearly died: the greatest mass extinction of all time.* London: Thames & Hudson, 2005.

[2] Bergstrom, Carl T. and Lee Alan Dugatkin. *Evolution.* New York: Norton, 2012.

[3] Sahney, S. and Benton, Michael. "Recovery from the most profound mass extinction of all time." *Proceedings of the Royal Society B: Biological Sciences.* 275 (1636): 759–65. 2008.

[4] Zanno, L. E, et al. "A new North American therizinosaurid and the role of herbivory in 'predatory' dinosaur evolution." *Proceedings of the Royal Society B: Biological Sciences.* 276 (1672): 3505–3511. 2009.

[5] Baier, Johannes. "Der Geologische Lehrpfad am Kirnberg." *Jahresberichte und Mitteilungen des Oberrheinischen Geologischen Vereins.* (93): 9-26. 2011.

[6] Royal Botanic Gardens, Sydney. "The Wollemi Pine—a very rare discovery." Archived from the original on 2005-03-23. http://web.archive.org/web/20050323093506/http://www.rbgsyd.gov.au/information_about_plants/wollemi_pine

[7] Dixon, Dougal, *The World Encyclopedia of Dinosaurs & Prehistoric Creatures.* Page 187. Lorenz Books, 2008.

[8] Dowd, Jake. "Dinosaur Long Neck Uncovered in China." *GuardianLV.* January 31, 2015.

[9] Lautenschlager, Stephan. "Estimating cranial musculoskeletal constraints in theropod dinosaurs." *Royal Society Open Science.* http://rsos.royalsocietypublishing.org/content/2/11/150495. 2015.

[10] Holtz, Thomas R. Jr. *Dinosaurs: The Most Complete, Up-to-Date Encyclopedia for Dinosaur Lovers of All Ages.* New York: Random House Books for Young Readers, 2010.

[11] Wilford, John Noble. "Feathers Worth a 2nd Look Found on a Tiny Dinosaur." *The New York Times.* March 8, 2012.

[12] Li, Quanguo. "Reconstruction of *Microraptor* and the Evolution of Iridescent Plumage." *Science.* (335): 1215–1219. 2012.

[13] Stephen L. Brusatte, et al. "New tyrannosaur from the mid-Cretaceous of Uzbekistan clarifies evolution of giant body sizes and advanced senses in tyrant dinosaurs." *Proceedings of the National Academy of Sciences of the United States of America.* 113 (13): 3447-3452. 2016.

[14] Prieto-Marquez, Albert, et al. "A primitive hadrosaurid from southeastern North America and the origin and early evolution of 'duck-billed' dinosaurs." *Journal of Vertebrate Paleontology.* (2): 36. 2016.

[15] Pope, K.O., et al. "Meteorite impact and the mass extinction of species at the Cretaceous/Tertiary boundary." *Proceedings of the National Academy of Sciences of the United States of America.* 95 (19): 11028–11029. 1998.

[16] Chu, Jennifer. "What really killed the dinosaurs? Before an asteroid wiped out the dinosaurs, Earth experienced a short burst of intense volcanism." MIT News Office: December 11, 2014.

Pronunciations

Acristavus: (AK-riss-TAY-vus) "non-crested grandfather"

Acrocanthosaurus: (AK-roe-kan-thoe-SAWR-us) "high-spined reptile"

Alamosaurus: (Al-ua-moh-SAWR-us) "Ojo Alamo reptile"

Albertaceratops: (Al-bur-tah-SEH-rah-tops) "Alberta horned face"

Albertosaurus: (Al-bur-toe-SAWR-us) "Alberta reptile"

Allosaurus: (AL-uh-SAWR-us) "different reptile"

Amphicoelias: (Am-fee-SEE-lee-us) "double hollow"

Anomalocaris: (Ah-NAHM-ah-loe-KARE-us) "abnormal shrimp"

Ankylosaurus: (AN-kye-loe-SAWR-us) "fused reptile"

Apatosaurus: (ah-PAT-uh-SAWR-us) "deceptive reptile"

Aquilops: (ah-KWILL-ops) "eagle face"

Araucaria: (Air-ow-KEHR-ee-ah) "named for the Chilean province of Arauco"

Archaeopteryx: (ar-kee-OP-ter-ix) "ancient wing"

Archelon: (ARE-kell-on) "ruling turtle"

Argentinosaurus: (AHR-gen-TEEN-uh-SAWR-us) "Argentina reptile"

Australovenator: (Aw-straw-loe-VEHN-ah-tor) "southern hunter"

Baryonyx: (Bah-ree-ON-ix) "heavy claw"

Bennettitales: (Beh-net-TIT-tayls)

Bistahieversor: (Bis-tah-hee-eh-VER-sore) "Bistahi destroyer"

Bjuvia: (JOO-vee-ah)

Bothriolepis: (Bo-three-oh-LEP-is) "trench scale"

Brachiosaurus: (BRACK-ee-uh-SAWR-us) "arm reptile"

Brontosaurus: (BRAHN-tuh-SAWR-us) "thunder reptile"

Buitreraptor: (Bwee-tree-rap-tore) "vulture raider"

Calamites: (Kal-ah-MYTES)

Camarasaurus: (kuh-MARE-uh-SAWR-us) "chambered reptile"

Camptosaurus: (KAMP-tuh-SAWR-us) "bent or flexible reptile"

Carcharodontosaurus: (kar-kar-oh-DON-tuh-SAWR-us) "shark-tooth reptile"

Caudipteryx: (kaw-DIP-tur-ix) "tail feather"

Carnotaurus: (kahrn-uh-TAWR-us) "meat-eating bull"

Centrosaurus: (sen-troe-SAWR-us) "pointed reptile"

Cetiosaurus: (Seh-tee-oh-SAWR-us) "whale reptile"

Chasmosaurus: (Kaz-moe-SAWR-us) "cleft reptile"

Citipati: (Sih-tih-PAT-ee) "funeral pyre lord"

Clidastes: (klee-DAS-tees) "locked vertebrae"

Coelacanth: (SEE-lah-kanth) "hollow spine"

Coelophysis: (see-loe-FYE-sees) "hollow form"

Compsognathus: (kohmp-sawg-NATH-us) "elegant jaw"

Concavenator: (kohn-kah-VEHN-ah-tore) "humped back hunter from Cuenca"

Cryolophosaurus: (kry-oh-low-foe-SAWR-us) "frozen crested reptile"

Cycad: (SYE-kad)

Cymbospondylus: (sim-boh-SPON-dih-lus) "boat spine"

Dacentrurus: (day-sen-TROO-rus) "very sharp tail"

Dakotaraptor: (dah-KOE-tah-RAP-tore) "thief of Dakota"

Daspletosaurus: (das-PLEET-oh-SAWR-us) "frightful reptile"

Deinocheirus: (dye-nuh-KYE-rus) "terrible hand"

Deinonychus: (dye-NON-ik-us) "terrible claw"

Deltadromeus: (del-tah-DROE-mee-us) "delta runner"

Dendrerpeton: (den-DRER-peh-tun) "tree creeper"

Desmatosuchus: (dez-Mat-oh-SOO-kus) "link crocodile"

Diabloceratops: (dee-Ab-loe-SEHR-ah-tops) "devil horn face"

Diamantinasaurus: (dee-ah-MAN-teen-ah-SAWR-us) "Diamantine River reptile"

Dicksonia: (dik-SOE-nee-ah)

Dicroidium: (dye-KROY-dee-um)

Dilophosaurus: (dye-LOH-fuh-SAWR-us) "two-crested reptile"

Dimetrodon: (dye-MET-roe-don) "two measures of teeth"

Dimorphodon: (dye-MORE-foe-don) "two-form tooh"

Diplocaulus: (dyp-loe-CAWL-us) "double caul"

Diplodocus: (dih-PLOD-uh-kus) "double beam"

Dipterus: (dihp-TEHR-us) "two wings"

Doedicurus: (doe-eh-DIK-ur-us) "pestle tail"

Dolichorhynchops: (dol-lee-kor-RYNE-kops) "long-nosed face"

Dollodon: (DOLL-loe-don) "Dollo's tooth"

Doryaspis: (door-ee-AS-pis) "dart shield"

Drinker: (DREEN-ker) "for Edward Drinker Cope"

Dryosaurus: (Dry-oh-SAWR-us) "tree reptile"

Dryptosaurus: (Drip-toe-SAWR-us) "tearing reptile"

Dunkleosteus: (Dun-klee-AWS-tee-us) "Dunkle's bone"

Edmontosaurus: (ed-MON-tuh-SAWR-us) "Edmonton reptile"

Einiosaurus: (EYE-nee-oh-SAWR-us) "buffalo reptile"

Eolambia: (Ee-oh-LAM-bee-ah) "dawn Lambe" (after paleontologist Lawrence Lambe)

Eoraptor: (Ee-oh-RAP-tore) "dawn thief"

Epanterias: (eh-pan-TEHR-ee-us) *"buttressed vertebrae"*

Eremotherium: (Eh-reh-moe-THEE-ree-um) "solitary beast"

Eudimorphodon: (You-dih-MOR-foe-don) "true two-formed tooth"

Europasaurus: (Yu-ROPE-ah-SAWR-us) "European reptile"

Eustreptospondylus: (You-strep-toe-SPON-dih-lus) "true well-curved vertebrae"

Fruitadens: (FROO-tah-dens) "Fruita tooth"

Futalognkosaurus: (Foo-tuh-long-koe-SAWR-us) "giant chief reptile"

Gallimimus: (Gal-ih-MIME-us) "rooster mimic"

Gargoyleosaurus: (Gar-goy-lee-oh-SAWR-us) "gargoyle reptile"

Gasosaurus: (gas-oh-SAWR-us) "gas lizard"

Geminiraptor: (geh-mih-nye-RAP-tore) "twins thief"

Giganotosaurus: (JI-gi-no-to-SAWR-us) "giant southern reptile"

Gigantspinosaurus: (Jye-gant-spy-no-SAWR-us) "giant spine lizard"

Giraffatitan: (ger-AF-uh-TYE-ten) "giant giraffe"

Gorgonopsia: (gore-gawn-OP-see-ah) "Gorgon face"

Gorgosaurus: (GORE-guh-SAWR-us) "fierce reptile"

Gryposaurus: (grip-oh-SAWR-us) "hook-nosed reptile"

Guanlong: (gwahn-lawng) "crown dragon"

Herrerasaurus: (her-RAIR-oh-SAWR-us) "Herrera's reptile"

Hesperornis: (hes-per-OR-nis) "western bird"

Homalocephale: (hoe-mah-loe-SEF-ah-lee) "even head"

Huayangosaurus: (hoo-ay-ang-oh-SAWR-us) "Huayang reptile"

Hypacrosaurus: (hih-pak-roh-SAWR-us) "near the highest reptile"

Hypsilophodon: (hip-sil-AWE-foe-dawn) "Hypsilophus tooth"

Icthyovenator: (ick-thee-oh-VEN-ah-tore) "fish hunter"

Iguanodon: (ih-GWAHN-oh-don) "iguana tooth"

Irritator: (EAR-ih-tay-tor) "one that irritates"

Jinzhousaurus: (jin-zoo-SAWR-us) "Jinzhou reptile"

Kentrosaurus: (KEN-troh-SAWR-us) "sharp-point reptile"

Lambeosaurus: (LAM-bee-oh-SAWR-us) "Lambe's reptile"

Leshansaurus: (leh-shahn-SAWR-us) "Leshan reptile"

Lesothosaurus: (leh-soh-thoh-SAWR-us) "Lesotho reptile"

Liliensternus: (lih-lee-ehn-STURN-us) "Ruhle von Lilienstern's one"

Liopleurodon: (lye-oh-PLUR-oh-don) "smooth-sided tooth"

Lurdusaurus: (lur-du-SAWR-us) "heavy reptile"

Lycaenops: (lye-CAN-ops) "wolf face"

Lystrosaurus: (list-roh-SAWR-us) "shovel reptile"

Lythronax: (LYE-thrown-ax) "gore king"

Macrauchenia: (mak-row-CHEN-ee-ah) "long llama"

Macrotaeniopteris: (mak-row-ten-ee-OP-ter-is)

Magnolia: (mag-NOH-lee-ah)

Maiasaura: (MY-ah-SAWR-ah) "good mother reptile"

Majungasaurus: (mah-jun-gah-SAWR-us) "Majunga dome"

Malawisaurus: (mah-law-ee-SAWR-us) "Malawi reptile"

Mamenchisaurus: (mah-men-chih-SAWR-us) "Mamenxi reptile"

Mantellisaurus: (man-tell-ih-SAWR-us) "Gideon Mantell's reptile"

Mapusaurus: (mah-poo-SAWR-us) "earth reptile"

Masiakasaurus: (mah-see-ah-kah-SAWR-us) "vicious reptile"

Massospondylus: (mass-oh-SPON-dih-lus) "longer vertebrae"

Medusaceratops: (meh-DOO-sah-SER-ah-tops) "Medusa horned face"

Megalosaurus: (meh-gah-loh-SAWR-us) "great reptile"

Metriacanthosaurus: (meh-trih-ah-can-thoh-SAWR-us) "moderately spined reptile"

Microraptor: (MY-kroh-rap-tore) "small theif"

Miragaia: (MEER-uh-guy-EE-uh) "Miragaia (the town where the remains were found)"

Monoclonius: (MAH-noh-CLONE-ee-us) "single sprout"

Monolophosaurus: (mah-noh-loff-oh-SAWR-us) "single-crested reptile"

Morelladon: (mor-ELL-ah-don) "Arcillas de Morella tooth"

Mosasaurus: (MOH-sah-SAWR-us) "Meuse River reptile"

Moschops: (MOE-shops) "calf face"

Muttaburrasaurus: (MOO-tuh-burr-ah-SAWR-us) "Muttaburra reptile"

Nasutoceratops: (nah-soo-teh-SER-ah-tops) "large nosed horned face"

Neovenator: (nee-oh-VEN-ah-tore) "new hunter"

Nigersaurus: (NEE-jer-SAWR-us) "Niger reptile"

Olorotitan: (OH-loe-roe-TYE-tan) "giant swan"

Omeisaurus: (OH-may-SAWR-us) "Omeishan Mountain reptile"

Opabinia: (oh-pah-BYN-ee-ah) "from the Opabin Pass"

Ornithischian: (or-nyth-ISH-ee-an) "bird-hipped"

Ouranosaurus: (oor-ahn-oh-SAWR-us) "brave reptile"

Pachycephalosaurus: (PAK-ee-sef-ah-low-SAWR-us) "thick-headed reptile"

Pachypteris: (pak-ip-TARE-is)

Pachyrhinosaurus: (PAK-ee-RYE-noe-SAWR-us) "thick-nosed reptile"

Parasaurolophus: (PAR-ah-sawr-AWL-oh-fus) "near saurolophus"

Pelecanimimus: (pel-eh-can-ih-MIME-us) "pelican mimic"

Pentaceratops: (PEN-tah-SEHR-ah-tops) "five-horned face"

Pikaia: (pik-AY-ah) "from Pika Peak"

Pinacosaurus: (pin-ak-oh-SAWR-us) "plank reptile"

Plateosaurus: (PLAY-tee-oh-SAWR-us) "broad lizard"

Plesiohadros: (plee-zee-oh-HAD-rose) "near Hadrosaur"

Polacanthus: (pohl-ah-CAN-thus) "many spikes"

Postosuchus: (poest-oh-SOOK-us) "Post crocodile"

Proganochelys: (pro-gan-OH-kel-iss) "early shell"

Protoceratops: (proe-toe-SEHR-ah-tops) "first horned face"

Pteranodon: (teh-RAN-oh-dawn) "toothless wing"

Pteraspis: (teh-RAS-pis) "wing shield"

Pterodactylus: (teh-roe-DAK-tih-luss) "winged finger"

Quetzalcoatlus: (ket-zahl-kwat-lus) from Quetzalcoatl (Aztec feathered serpent god)

Rahonavis: (rae-hoe-nay-vis) "cloud bird"

Repenomanus: (reh-peh-no-MAN-us) "reptile mammal"

Rapetosaurus: (rah-pay-toh-SAWR-us) "giant reptile"

Rhamphorhynchus: (ram-foh-RIHN-kus) "beak snout"

Rubeosaurus: (roo-bee-oh-SAWR-us) "bramble reptile"

Saichania: (sye-chan-EE-ah) "beautiful one"

Saltriosaurus: (sahl-tree-oh-SAWR-us) "Saltrio, Italy, reptile"

Saurischian: (sahr-ISH-ee-an) "lizard hipped"

Sauropelta: (sahr-oh-PEL-tah) "reptile shield"

Sauroposeidon: (sahr-oh-poe-SYE-don) "reptile of Poseidon"

Scipionyx: (sih-pee-ON-ix) "Scipio's claw"

Seeleyosaurus: (see-lee-oh-SAWR-us) "Seeley's reptile"

Seismosaurus: (SIZE-moe-SAWR-us) "quake reptile"

Sequoia: (seh-KWOY-ah)

Shantungosaurus: (shahn-tun-gah-SAWR-us) "Shantung reptile"

Shonisaurus: (show-nih-SAWR-us) "Shoshone Mountain reptile"

Shunosaurus: (shoo-noe-SAWR-us) "Shu reptile"

Sinosauropteryx: (SYE-no-sawr-OP-ter-ex) "Chinese reptilian wing"

Spinosaurus: (SPY-nuh-SAWR-us) "spine reptile"

Stegosaurus: (STEG-uh-SAWR-us) "roof reptile"

Stenopterygius: (sten-op-ter-IH-gee-us) "narrow wing"

Styracosaurus: (stih-RAK-uh-SAWR-us) "spiked lizard"

Styxosaurus: (stix-oh-SAWR-us) "River Styx reptile"

Suchomimus: (soo-koe-MIME-us) "crocodile mimic"

Supersaurus: (soo-per-SAWR-us) "super reptile"

Tanystropheus: (tan-is-TROE-fee-us) "long strap"

Tarbosaurus: (tar-boe-SAWR-us) "terrifying reptile"

Tempskya: (temp-SKYE-ah)

Tenontosaurus: (ten-on-toe-SAWR-us) "sinew reptile"

Tethyshadros: (teth-is-HAD-rose) "Tethys Sea Hadrosaur"

Thalassodromeus: (tha-lass-oh-DROE-mee-us) "sea runner"

Therizinosaurus: (THER-ih-zin-oh-SAWR-us) "scythe reptile"

Torvosaurus: (tore-voe-SAWR-us) "savage reptile"

Triceratops: (try-SAIR-uh-tops) "three-horned face"

Tylosaurus: (tye-loe-SAWR-us) "knob reptile"

Tyrannosaurus: (tye-RAN-uh-SAWR-us) "tyrant lizard"

Utahceratops: (yoo-tah-SEHR-ah-tops) "Utah horned face"

Velociraptor: (veh-loss-ih-RAP-tor) "swift seizer"

Williamsonia: (will-yum-SOE-nee-ah)

Wollemia: (woe-LEM-ee-ah)

Yangchuanosaurus: (yang-chwan-oh-SAWR-us) "Yangchuan reptile"

Yutyrannus: (YOO-tie-RAN-us) "feathered tyrant"

Zhenyuanopterus: (zen-yoo-an-OP-tehr-us) "Zhenyuan wing"

Archaeopteryx

Related Resources

BOOKS

DK Publishing, *Prehistoric Life: The Definitive Visual History of Life on Earth*. (Reprint edition.) New York: DK Publishing, 2012.

Brett-Surman, Michael K. et al. The Complete Dinosaur, 2nd Edition. Bloomington: Indiana University Press, 2012.

Csotonyi, Julius. *The Paleoart of Julius Csotonyi*. London: Titan Books, 2014.

Holtz, Thomas R., Jr. and Luis V. Rey. *Dinosaurs: The Most Complete, Up-to-Date Encyclopedia for Dinosaur Lovers of All Ages*. New York: Random House Books for Young Readers, 2007.

Paul, Gregory S. *The Princeton Field Guide to Dinosaurs*. Princeton: Princeton University Press, 2010.

Dixon, Dougual. *World Encyclopedia of Dinosaurs & Prehistoric Creatures: The Ultimate Visual Reference To 1000 Dinosaurs And Prehistoric Creatures Of Land, Air And Sea From The Triassic, Jurassic And Cretaceous Eras*. Leicester: Lorenz Books, 2008.

Malawisaurus

WEBSITES & BLOGS

PLOS One (academic papers on paleontological research and discoveries)
journals.plos.org/plosone/browse/dinosaurs

Species New to Sciences (the latest discoveries of new species, including dinosaurs and prehistoric animals)
novataxa.blogspot.com

Laelaps/National Geographic (Brian Switek's blog on prehistoric life)
phenomena.nationalgeographic.com/blog/laelaps/

The Dinosaur General List (The most comprehensive and up-to-date list of dinosaur species available anywhere)
www.polychora.com/DINOLIST.pdf

Theropoda (Andrea Cau's blog covers the latest research on theropods. In Italian, but a rough English translation is available)
theropoda.blogspot.com

Glossary

Adaptation: A physical change in an organism in response to environmental, ecological or some other stimulus.

Anapsid: A group of animals identified by their lack of holes or fenestrae in their skull.

Angiosperm: The group of plants that includes leafy trees, flowering plants and grasses. Evolved in the Jurassic period but did not become common until the Late Cretaceous.

Appalachia: The eastern half of North America during the Cretaceous period when the continent was split by the Western Interior Seaway.

Archosaur: The group of "ruling reptiles" that includes dinosaurs, pterosaurs, rauisuchids, aetosaurs, crocodilians, birds and others.

Avemetatarsalia: A group of animals comprised of dinosaurs, some dinosaur ancestors and pterosaurs. It describes animals that are more closely related to birds than to crocodiles.

Bone bed: A fossil site comprised of the remains of many animals, either of the same or different species.

Bone wars: The competition between Edward Drinker Cope and Othniel Charles Marsh to find dinosaur remains in the American West between 1877 and 1892.

Cold-blooded (see Ectothermic)

Conifer: A group of gymnosperm, cone-bearing plants that includes pines, firs and others.

Coprolite: The fossilized remains of animal excrement.

Diapsid: An animal that has two holes or fenestrae in each side of its skull for the attachment of muscles. Includes crocodiles, lizards, snakes, birds and dinosaurs.

Dinosauria: The formal name given to the group of animals classified as dinosaurs as described by Sir Richard Owen in 1842.

Ectothermic (cold-blooded): The condition of an animal whose body temperature fluctuates with its surrounding temperature and gets its heat from external resources (i.e., the sun).

Endothermic (warm-blooded): The condition of an animal that maintains a constant body temperature (metabolism) and generates heat from internal processes (i.e.: the processing of food).

Evolution: The process whereby an organism changes into a new genus or species through the processes of adaptation and natural selection.

Exoskeleton: An external covering that supports an animal's body. Examples include the shells of mollusks and the chitin in insects and other arthropods.

Fossil: The mineralized remains of a long-dead organism.

Genus: A group of related plants or animals that may contain multiple species.

Gondwana: The southern part of the supercontinent Pangea. Included what is now South America, Africa, Madagascar, India, Antarctica and Australia.

Gymnosperm: The group of plants that includes conifers, cycads, ginkgoes and gnetales.

Ilium: The largest bone of the hip. Present in most tetrapods.

Index fossil: The remains of an extinct plant or animal that are used to comparatively date the age of rocks.

Ischium: One of the bones of the pelvis in most tetrapods.

Laramidia: The western half of North America during the Cretaceous Period when the Western Interior Seaway split the continent in half.

Laurasia: The northern portion of the supercontinent Pangea that comprised present-day North America, Europe and Asia.

Mammal-like reptile: A group of extinct primitive synapsid reptiles. Examples include *Lystrosaurus* and *Dimetrodon*.

Mass death accumulation: The deposit of a large number of animals that all died at the same place, either at the same time or over a long period.

Ornithischian: One of the two major groups of dinosaurs (the other being saurischians). Ornithischians are characterized by the presence of beaks and a "bird-like" hip, where the

pubis bone points backwards toward the tail. Includes ceratopsids (horned dinosaurs), thyreophorans (armored dinosaurs), pachycephalosaurs (dome-headed dinosaurs) and ornithopods.

Ornithopod: A sub-group of ornithischian dinosaurs. Includes the small, bipedal herbivores such as *Lesothosaurus* and *Hypsilophodon*, and the larger iguanodonts and hadrosaurs.

Osteoderm: A bony plate embedded in the skin of an animal, typically covered in keratin.

Paleontology: The study of ancient life, typically that which existed prior to the start of the Holocene epoch (11,700 years ago).

Paleozoic Era: The era of time in Earth's history before the Mesozoic and after the Proterozoic, covering a span from 541 to 252 million years ago. Includes the Permian, Carboniferous, Devonian, Ordovician and Cambrian periods.

Phanerozoic Eon: The most recent and current geologic time eon in Earth's history. The eon begins around 540 million years ago, and covers the Paleozoic, Mesozoic and Cenozoic eras up to the present.

Plate Tectonics: The geological process that describes the movements of the Earth's crust and upper mantle.

Protofeather: The informal term for simple, hollow filaments that covered the bodies of some dinosaurs. These are much simpler and more primitive structures than the complex display or pennaceous feathers seen on modern birds.

Pseudosuchia: A group of animals consisting of living crocodilians and all archosaurs more closely related to crocodilians than to birds. Examples include living alligators and crocodiles, and the extinct rauisuchians such as *Postosuchus*, and aetosaurs such as *Desmatosuchus*.

Pubis: One of the three bones that comprise the hip. In dinosaurs, the orientation of the pubis helps to identify whether it is an ornithischian (bird-hipped) or a saurischian (lizard-hipped).

Rauisuchian: A primitive group of large archosaurian reptiles that carried their legs directly beneath their bodies (an upright stance), and may have been largely bipedal. Examples include *Postosuchus*, *Prestosuchus* and the sail-backed *Arizonasaurus*.

Saurischian: One of the two major groups of dinosaurs (the other being ornithischians). Saurischians are characterized by the presence of a "lizard-like" hip, where the pubis bone points either down or forward. Includes sauropods (such as *Brontosaurus*, *Diplodocus* and *Argentinosaurus*), prosauropods (such as *Plateosaurus*) and theropods (*Tyrannosaurus*, *Therizinosaurus* and birds).

Sauropods: Quadrupedal saurischian (lizard-hipped) dinosaurs characterized by large size (up to 30+ meters), and extremely long necks and tails. Sub-groups include the diplodicids, the mamenchisaurs and the titanosaurs, among others. Specific examples include *Brontosaurus*, *Mamenchisaurus* and *Cetiosaurus*.

Sedimentary rock: Rocks that are laid down by the deposit of minerals or organic materials in water. This may result from flooding, glaciers, and/or the natural flow of water in an environment. Sedimentary rock deposits are the most likely locations to find fossils.

Species: A classification of biological science that defines a group of animals capable of reproducing together.

Supercontinent: The term used to describe the condition when all of Earth's landmasses are brought together in one area through the process of plate tectonics.

Synapsid: An animal that has one hole or fenestra in each side of its skull for the attachment of muscles. Includes mammal-like reptiles, dicynodonts and mammals.

Tethys Sea (Tethys Ocean): An ancient ocean that existed between the continents of Laurasia and Gondwana during the Mesozoic era.

Tetrapod: An animal with four limbs. Includes both living and extinct amphibians, mammals, birds, reptiles, dinosaurs and some fish.

Theropod: A bipedal saurischian dinosaur. May be carnivorous, herbivorous or omnivorous. Includes the tyrannosaurs, therizinosaurs, dromaeosaurs, oviraptors, ornithomimids, birds and others.

Thyreophora: The group of ornithischian dinosaurs that includes the stegosaurs and the ankylosaurs. Characterized by being quadrupedal herbivores and sporting significant body armor, including plates, spikes and tail clubs.

Trace Fossil: Geological records of living activity. May include footprints, track ways, coprolites, burrows and others. Trace fossils are different from body fossils, which record parts of an animal's or plant's body.

Vertebrate: An animal with a backbone.

Warm-blooded (see Endothermic)

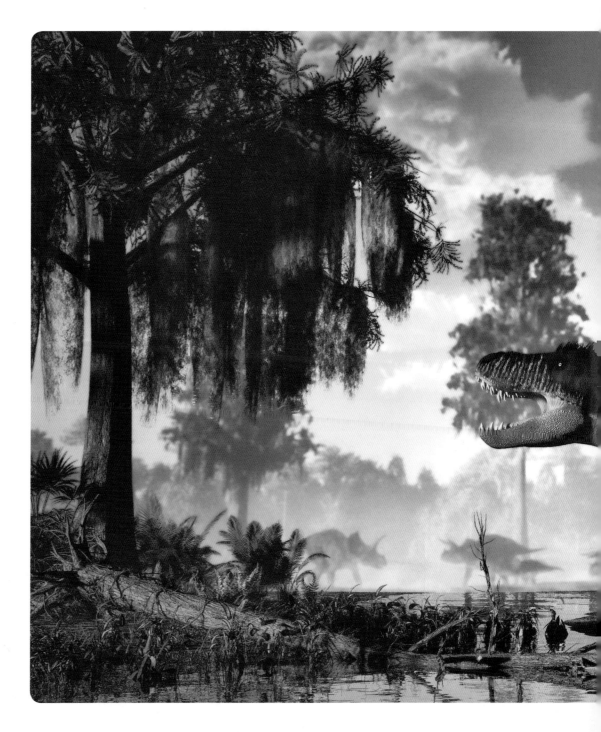

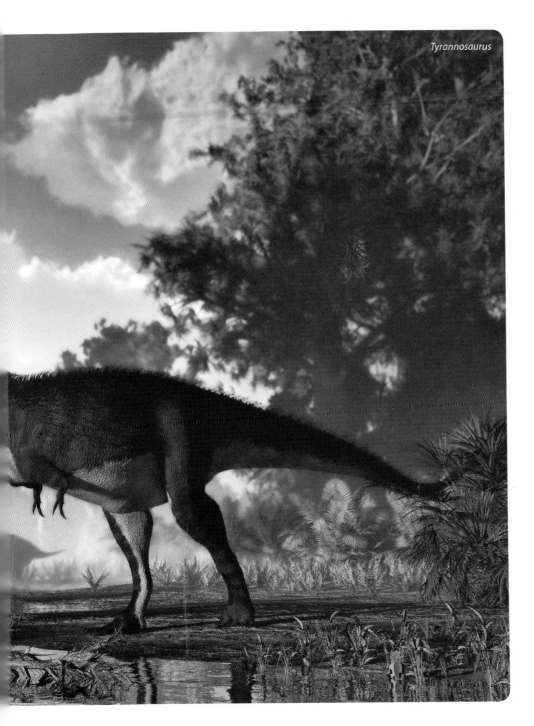
Tyrannosaurus

A Note From the Author

I was six years old when I saw my first dinosaur. My grandmother took me to the School of Mines Museum in Rapid City, South Dakota. I don't recall the trip there, or any kind of grand entrance where the doors opened and I stood in awe. What I do remember is a single moment, standing amid decades of dust and squeaky wooden floorboards, staring up at the skeleton of *Edmontosaurus*. The dark brown bones towered over me, and to this day, I swear that as I watched, I saw it breathe.

It's been over 160 years since the public stood in awe of the dinosaur reconstructions at London's Crystal Palace Park. Today we can find animatronic dinosaur displays at shopping malls and theme parks. Exhibitions of dinosaur skeletons grace even small museums and tour around the world. Yet as commonplace as dinosaurs are in popular culture, we're still as amazed today as our ancient ancestors were thousands of years ago when they marveled over the fantastic beasts they discovered in the ground. And for good reason. No imagined dragon or wizarding creature can come close to the majesty and power of the real animals that once walked on Earth. For all its creative potential, no human imagination could have dreamed up something as outlandish as *Deinocheirus* or *Stegosaurus*, and no nightmare is as fully formed as *Tyrannosaurus rex*.